BAUHAUS
SOURCE
BOOK

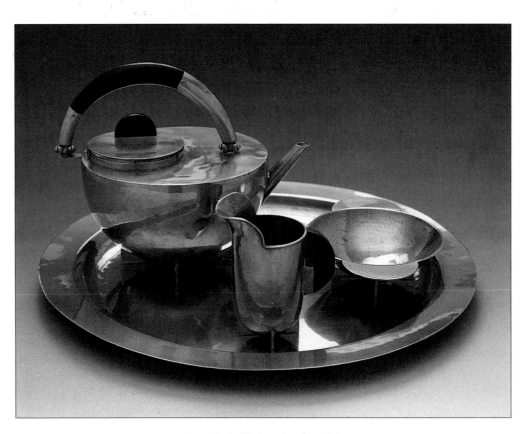

Tea service by Marianne Brandt. c.1924

BAUHAUS
SOURCE
BOOK

ANNA ROWLAND

Grange
BOOKS

A QUANTUM BOOK

Published by Grange Books
An imprint of Grange Books plc
The Grange
Grange Yard
London SE1 3AG

ISBN 1-84013-046-6

QUMBAU

This book was produced by
Quantum Books Ltd
6 Blundell Street
London N7 9BH

Printed in Singapore by Star Standard Industries Pte. Ltd

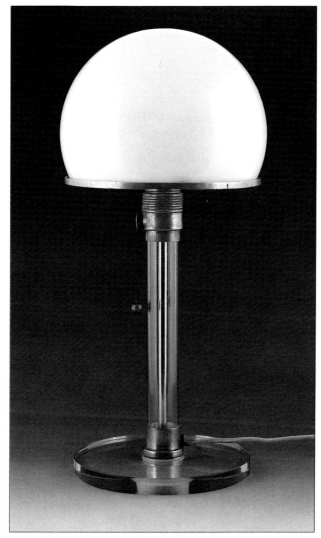

Wagenfeld/Jucker lamp, 1924

C O N T E N T S

CONTENTS

FOREWORD

In 1919 when the Bauhaus was founded, I was nine years old. I enrolled as a student at the Dessau Bauhaus in 1930 when Hannes Meyer was Director. Although many of the great names of the earlier Bauhaus – Gropius, Breuer, Bayer and Moholy-Nagy – had left by this time, I was privileged to have been able to study under some of the most important painters and teachers of the period, such as Kandinsky, Klee, Feininger, Albers and Schmidt, and the teachings of the Bauhaus entered my bloodstream.

The vast scope of Bauhaus activities makes it impossible to deal individually with all aspects of its work. Only my subjective recollections remain and even these have undergone selective filtration over a period of time.

As students we researched the principles that underlie the interrelationship of form and function. Every week we attended classes by Kandinsky and Klee. I have vivid recollections of the two masters and recall being overwhelmed by the wealth of stimulating readings and debates. In just a few months of my first term, Josef Albers was able to open my eyes and develop my tactile senses sufficiently to allow me to experience subject, material and even the work process as part of nature. The problem of form automatically arose during the work process since the aim was to adapt form to material. We also learned to use materials economically; I can still hear today Albers shouting, "You must find the right balance between cost and results!" Alongside countless experiments, we developed our own critical methods using entirely new values. The slogan "The Unity of Art and Craft" evolved into "The Unity of Art and Industry" and later into "The Unity of Art and Life".

In retrospect, the contribution of the Bauhaus to all areas of design is apparent. Advertising and graphics were given a new impetus. Walk-through room sets with type and graphics, pioneered by Joost Schmidt, became a part of the new display architecture. The use of photographs, simplified typography and photograms of which Moholy-Nagy and Herbert Bayer were great exponents, are commonplace today.

Architecture moved from the craft-based concepts of the early Bauhaus, towards the mass-produced functional housing that was characteristic during Hannes Meyer's Directorship at Dessau. Looking back on the stage work of the Bauhaus, with such productions as Oskar Schlemmer's Triadic Ballet, Hirschfeld-Mack's Reflective Illuminations, and the Mechanical Ballet of Kurt Schmidt, I realise how close we came not only to total performance (theatre in the round), but also to total art.

At Dessau the preoccupation with the mythical, which had characterised much of the work at Weimar, gave way to a greater emphasis on objectivity, with its clear, organic structures and emphatic rejection of the superfluous. Although the ethos of the school pervaded every aspect of our lives (the students wore specially designed collarless jackets and women students wore trousers and all had the same "functional" hairstyle), purism did not prevent us from enjoying parties where we would wear metallic or geometric masks and dance to the syncopated rhythms of the Bauhaus band.

My time at the Bauhaus (1930-3) coincided with a period of great pressure caused by the tensions between Utopian and real Socialism versus esoteric abstraction. These rival movements threatened to divide the students between Formalists and Functionalists. There was also intense pressure from outside the school, with the opposition to the school from the petit bourgeoisie and the growing threat of the Nazis. I now realise that it was only in the closed society of the Bauhaus that the full potential of the ideas of both students and masters could come to fruition.

In the vast context of the development of art and design during this century, it is in some ways extraordinary that there is such a continuing interest in the work of the Bauhaus, which after all existed for only 14 years. Perhaps Mies van der Rohe had the right answer when he said, "The Bauhaus was an idea. Only ideas last this long."

Kurt Kranz

INTRODUCTION

The Bauhaus is not a style; it is a collection of attitudes. This book intends not so much to demonstrate the elements of a Bauhaus style but to indicate the multiplicity and ambiguity of design at the Bauhaus. As a school, it was a shifting, contradictory melting pot, living a hand-to-mouth existence during a time of tremendous social, political and economic upheaval. Most of the objects and documents produced there have since been destroyed, and its ideas and ideals have been widely caricatured. It is now admired and disliked in equal measure.

The mere word "Bauhaus" conjures up the cold gleam of nickled tubular steel on cantilevered dining chairs; cuboid white buildings with flat roofs and metal window frames; table lamps conceived as formal compositions according to the elements of geometry; graphic layouts with heavy black rules, red points and sections of text set at 90 degrees; the puritanical austerity of the anonymous standard product. Above all, the Bauhaus is identified with functionalism, which is now seen as the eradication of ornament in favour of the austere beauty of the industrial aesthetic.

Its founder, the architect Walter Gropius (1883–1969), was a brilliant co-ordinator, encourager, catalyst and publicist. Although there were a number of other schools in Europe and the Soviet Union with radical programs, and although several enterprising manufacturers were reassessing the design of their products in the light of the post-war mood and the new materials that had become available, it is the Bauhaus that is remembered. It has had an enormous influence, transmitted through its publications, through its students' work in industry and, most important, through its work in education. It may sound cynical, but the very fact that the Bauhaus was finally closed down by the National Socialists in 1933 has guaranteed it a position of importance, particularly in the United States, where a great number of Bauhaus students and teachers settled following their enforced dispersal.

But the real reason the Bauhaus continues to invite debate, admiration and, on occasion, loathing is that it represents a celebrated, intensely idealistic attempt to come to terms with the problems of industrialisation. Its goal was the education of a new generation of designers who could heal the divisions in a society that was based on mass production and mass consumption and create in its place a cohesive, democratic culture. This unity would be achieved through the research and development of a coherent and universally applicable language of design. In turn, this language would be used to create definitive, standard forms for the objects of everyday life, which, being mass-produced, would be universally available and affordable. The guiding ideas of the Bauhaus were continually under revision and were the subject of considerable debate and uncertainty. The history of the school's development is complex. Its lifespan – 1919–33 – coincides exactly with that of the Weimar Republic. Both were born in the revolutionary upheavals that followed Germany's defeat in World War I and died at the outset of the Third Reich. The Bauhaus had three directors (Walter Gropius, Hannes Meyer and Ludwig Mies van der Rohe) and three locations (Weimar, Dessau and Berlin).

THE MANIFESTO

The Bauhaus was founded in Weimar (now in East Germany) by the amalgamation of the Academy of Fine Art and Henry van de Velde's School of Applied Art. Its intention, as stated in April 1919 in the ecstatically worded Manifesto with which Gropius attracted staff and students, was to unite the teaching of fine art, applied art and architecture in order to educate creative people capable of large-scale collaborative projects or "total works of art" (Gesamtkunstwerke). The name he chose for the school derived from "hausbau" meaning construction. Bauhaus implies not only building and construction but also reconstruction.

The Manifesto can be read as a plea for unity, collaboration, wholeness and re-integration. It implies a "fall from grace", the loss of an earlier state of innocent harmony, latterly disturbed by the division of labour inherent in mass production and by a catastrophic world war, which Gropius seems at this time to have connected with mechanisation. In particular, he lays the blame at the feet of the false and snobbish barriers erected between fine art, applied art and architecture. The Manifesto traces all three back to a common root – craft – and the common task – the creation of a total work of art. The emblem chosen to represent this is the great Gothic cathedral which is depicted in

Lyonel Feininger's profoundly Expressionistic woodcut (2), called "Cathedral", appeared as the frontispiece of the Bauhaus Manifesto in April 1919. The cathedral represents the Total Work of Art, the glorious product of communal effort. As Gropius puts it in the Manifesto: "Together let us desire, conceive, and create the new structure of the future, which will embrace architecture and sculpture and painting in one unity and which will one day rise toward heaven from the hands of a million workers like the crystal symbol of a new faith."

Hans Hoffman's materials study (1) (1921) comes from Johannes Itten's preliminary course. Such naturalistic studies were intended to develop sensitivity to the unique qualities of different materials, and to bring out the contrasts between them. Note the contrast of the lower end of the needle, shown dark against light, and the upper end, shown light against dark. Like nearly all preliminary course work, this study uses scrap materials.

BAUHAUS DIRECTORS

	1919	1925	1928	1930	1932	1933
WEIMAR	GROPIUS					
DESSAU		GROPIUS	MEYER	MIES		
BERLIN						MIES

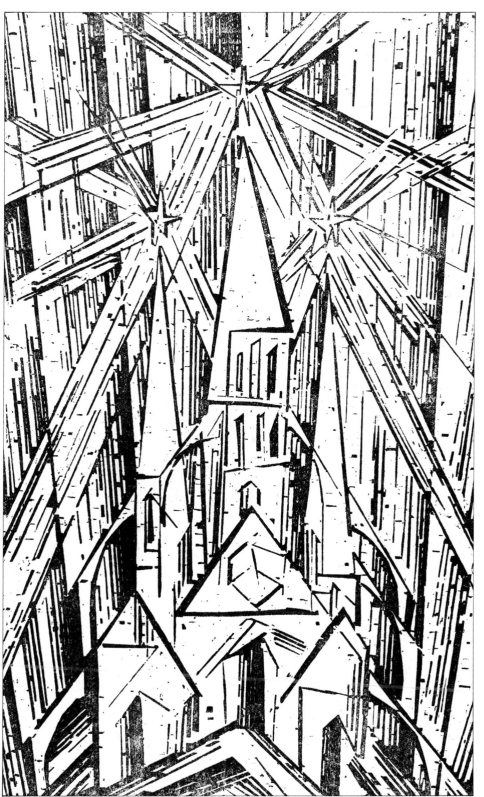

Lyonel Feininger's Expressionistic woodcut. The school which was to become synonymous with sobriety, restraint and a puritanical approach to design had its roots in profoundly romantic ideas, such as the concept of the total work of art, and wishful imaginings of medieval masons chiselling away in harmony.

Gropius's program for the Bauhaus was an inspired fusion of existing ideas, catalysed by the recent trauma of war and revolution. In calling for a return to craft as the basis for all creative work, he was drawing on a long tradition of design reform. The deep anxieties aroused by industrialisation were first felt in Britain at the height of its manufacturing power. From the mid-19th century onward, questions of design reform became a matter of urgent concern in Britain and were expressed by what came to be known as the Arts and Crafts. Movement, which drew on the work of thinkers such as John Ruskin (1819–1900) and William Morris (1834–96), who were also extremely influential in Europe. Rejecting the machine, they turned to craft, which brought not only personal satisfaction, but also represented dignity in labour, humanity, healing and wholeness.

The Arts and Crafts Movement contained a strong element of nostalgia for a pre-industrial "Merrie England" that never was, and, unlike the Bauhaus, it looked to craft as an alternative to the machine, not as a means of humanising its products. Craft was invoked as a response to fear of the machine and the depersonalisation and fragmentation which seemed inherent in the division of labour demanded by industrial manufacture. Influential ideals such as truth to materials arose in reaction to the confusing, distasteful spectacle of machine-made ornament aping handmade ornament.

At the turn of the century, the torch of reform was taken up in Germany. The anglophile architect Hermann Muthesius (1861–1927) founded the Deutsche Werkbund in 1907 in the hopes of uniting art, craft and industry to improve the standards of German manufactured products. Its members included Henry van de Velde (1863–1957), Walter Gropius and Peter Behrens (1868–1938), who as chief designer for the AEG (General Electric Company), was responsible for the first corporate identity program. In Germany the emphasis of the reform movement fell on education. Pioneers such as Friedrich Froebel (1782–1852) (the inventor of the kindergarten) had already introduced the concepts of creative play and learning through doing, which were to be influential in art education reform. In the 1880s a network of Kunstgewerbeschulen (schools of applied art) had been established to revive craftsmanship and reform design. There was a widespread conviction among the reformers that craft should be the foundation of all art education and that a student's education should begin with a general course that would offer the opportunity to explore innate talents freely and experiment in a number of different media.

Gropius drew on the ideas of the design reform movement but, believing that the Kunstgewerbeschulen had largely failed in their task, gave some aspects a more radical profile. The

difference between craft and art, according to the Bauhaus Manifesto, was not one of method but of inspiration, which came by the Grace of Heaven rather than through a school curriculum. Art itself could not be taught, whereas craft could; a thorough craft training would therefore be the basis of the Bauhaus. Craft terminology was adopted – apprentice, journeyman, master – and full apprenticeships were given, under the guidance of two masters, a Form Master and a Craft Master. To ensure a workmanlike attitude and avoid dilettantism (which Gropius greatly feared), apprentices were paid for their work and penalised for spoiling materials. Before students were allowed to enrol in a workshop, they were obliged to take the preliminary course. This was not an entirely new idea, but at the Bauhaus it was developed by teachers such as Johannes Itten (1888–1967) and Josef Albers (1888–1976) to such a pitch of refinement that its ideas now form the basis of every art school's foundation course. Its purpose was to enable the new student to shed preoccupations and conventional attitudes, and begin work afresh.

Gropius attracted to the school artists of international repute, such as Paul Klee (1879–1940) and Wassily Kandinsky (1866–1944). They were not only asked to act as Form Masters in the workshops but also to devise theoretical courses on the elements of form and the origins of creativity. Gropius appears to have believed it possible to transmit the insights and advances made in the realm of art to the realm of architecture and design, which he felt was lagging behind, trapped in 19th-century attitudes like a fly in amber. He was not alone among his contemporaries in believing it possible to discover the formal laws underlying creation and that, once discovered, these laws would be as universally applicable as the laws of science. The laws of form could be used to develop a design language appropriate for the 20th century that would be capable of creating products and environments of universal validity and appeal. As Gropius put it in The Theory and Organisation of the Bauhaus: "We must know both vocabulary and grammar in order to speak a language; only then can we communicate our thoughts. Man, who creates and constructs, must learn the specific language of construction in order to make others understand his ideas. Its vocabulary consists of the elements of form and colour and their structural laws."

STANDARDISATION OF FORM

Having been trained in the language of form, Bauhaus designers set about developing prototypes for the mass-production of definitive, standard forms for the objects of everyday life, basing their approach on the premise that people's practical needs are largely identical. Determined to reject all forms of applied ornament and pretentiousness, they would allow only one determining factor in their search: function. With the reformer's tendency toward shrill overstatement, the Bauhaus has suffered from being closely identified with functionalism, which is the belief that form follows function, and that beauty or "good form" can be

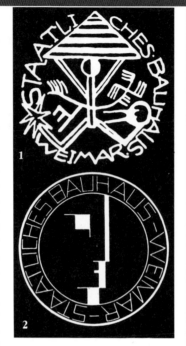

In 1922 the earlier, expressionistic Bauhaus seal (1) was replaced by Oskar Schlemmer's design: a generalised, geometricized image of Man. (2)

WALTER GROPIUS

Walter Gropius (1883–1969), founder and director of the Bauhaus, was born in Berlin. He trained as an architect and in 1907 joined the office of Peter Behrens, the pioneering head of design of the A.E.G.

In 1910 Gropius established his own practice and turned his attention to problems of mass-produced housing and equipment in 1911, with his gifted partner Adolf Meyer (1881–1929), he designed the Fagus factory at Alfeld, which is often seen as the first building to introduce the vocabulary of what was to be known as the International Style. Gropius became an active member of the Deutsche Werkbund, and he and Meyer made another radical statement in building a model factory and office building for the Werkbund exhibition in 1914. The experience of war brought a new politicisation, together with a new expressionism, to Gropius's theoretical work, and he became a member of a number of left-wing artists' organisations.

In 1919 he founded and was appointed director of the Bauhaus, a position he held until 1928. From 1928 to 1934 Gropius had a private practice in Berlin, but the rise to power of the Nazi party in Germany caused him to move to London, where he worked in partnership with E. Maxwell Fry. Together they designed the influential Impington Village College, near Cambridge (1936). In 1937 he left Britain for the more congenial climes of Harvard, where he formed The Architect's Collaborative (T.A.C.). He died a greatly respected architectural figure.

BAUHAUS STUDENTS

The Bauhaus had approximately 100 students at a time, and it was never easy to get a place. As the school's fame spread, students would, if necessary, walk across Europe to show their work. During the early years, a high proportion (roughly a quarter) were female (see Textiles). Some students were as young as 17; others had survived active service in World War I (a few died of their wounds while at the Bauhaus). Most were disoriented by the war and its aftermath; many had already trained elsewhere and were eager for something new.

The Bauhaus was an intense, stimulating working community, and its atmosphere did not suit everybody. A considerable number were rejected after six months on the basis of their performance in the preliminary course (see page 16), and a few left of their own accord. Some students objected to learning a craft skill, while others found the emphasis on collaboration difficult, along with the fact that the traditional hierarchies of the academy had largely been abolished.

Gropius introduced a system of student payment for workshop activity. This not only encouraged a mature attitude to work, but it also relieved the students' poverty. In the early years, they were frequently paid in kind, in clothes and food, the Bauhaus dining room being a vital source of food. This cafeteria was also the centre of the community and the scene of heated debates about life and art, and art and industry.

At Weimar many students wore a Bauhaus costume made from brightly dyed cast-off military uniforms. Those under the influence of Itten and Mazdaznan shaved their heads and wore an approximation of saffron robes. At Dessau the student profile became even more international, and Mazdaznan was replaced by increased political activity.

It can be disconcerting to discover that Bauhäusler remember not so much the stimulating lecture courses and so on but the major setpiece parties, with the whole school gyrating to the sound of the Bauhaus jazz band in full swing.

achieved by rejecting all imposed styles and concentrating solely on the purpose and use of the object in question.

In the recent backlash against Modernism in design, the functionalist approach has been seen as precisely what it strove to avoid being: just another imposed style, this time based on the geometric forms associated with the machine. However, the functionalist philosophy that developed in the Bauhaus workshops was never quite rigid enough to suit either its critics or its defenders. As we shall see, the Bauhaus adopted a curious kind of functionalism, far less rigid in practice than in theory and more subtle than is often suggested.

The Bauhaus passion for geometric form and primary colours was, on occasion, certainly capable of luring it onto the rocks of formalism. The purity of its ideals was also compromised by the simple desire to shock the bourgeoisie: to obliterate all that they held dear, threatening to oust their cozy, heavy, elaborate furniture and replace it with lightweight, multi-purpose, adaptable tools for modern life constructed in new hygienic materials. The characteristically moral tone of the war on ornament was, however, by no means confined to the Bauhaus. In 1908, for instance, the Viennese architect Adolf Loos, in an essay entitled Ornament and Crime, explicitly equated love of ornament with degeneracy.

THE WORKSHOPS

In terms of workshops production, the Weimar Bauhaus is conventionally portrayed as an ivory tower of theoretical debate and formal experimentation, with very little real achievement. However, despite the difficulties caused by the lack of materials

and spiralling inflation of the period, along with internal confusions and external antagonism, the Weimar workshops were considerably more active and productive than has been supposed. Although contact with industrial manufacturers was confined to the pottery workshop, every workshop was busy working to commission from the earliest days. It is a considerable blow to the conventional view of the Weimar Bauhaus to realise that it exhibited at trade shows and acquired a network of trade representatives. It also elaborated a pay and pricing system and struggled to establish a proper business structure for its productive activity. The limited company (Bauhaus GmbH) that resulted formed the basis of the Bauhaus's commercial success at Dessau.

During the Weimar period (1919–1924) Gropius's ideas changed more than he later cared to admit; while he had initially believed in the intrinsic value of craft, he now began to maintain that craft at the Bauhaus had never been more than a means to an end: preparing the student for collaboration with industry. A new slogan, "Art and Technology: a New Unity", was adopted, which caused considerable anxiety among the artists at the school, many of whom were not sure they wished to be united with technology.

From the time of the 1923 Bauhaus Exhibition onward, the workshops were under considerable pressure from the directors to produce and earn money. The lack of industrial manufacturers during the period of post-war reconstruction meant that the workshops themselves were forced to produce their models serially, becoming, in effect, cottage industries. Workshop teaching arrangements were extremely fluid

When the Bauhaus opened its new buildings in Dessau in December 1926, it was given wide press coverage both in Germany and abroad, much of it positive, some of it profoundly hostile. Das Illustrierte Blatt (3) was positive, referring to the school as "an academy for the alive person of today and tomorrow". Gropius's buildings were extremely photogenic and he was well aware of their propaganda value.
"Kubus" (4), a modular system of glass containers, was designed in 1938 for the Vereinigte Lausitzer Glaswerke by Wilhelm Wagenfeld, who was one of the best-known members of the Bauhaus metal workshop. "Kubus" expresses very well the Bauhaus goal of creating thoughtful standard forms for industrial production.

3

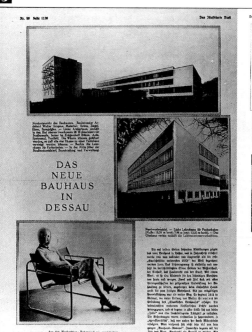
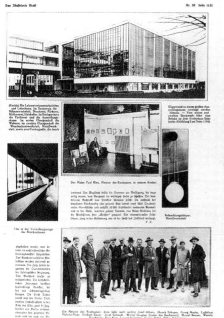
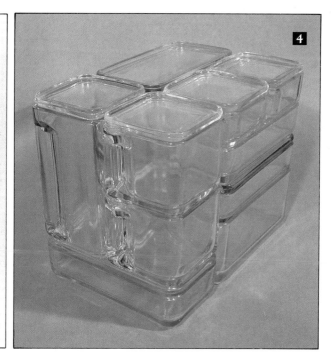

INTRODUCTION

throughout the Weimar period, and the workshops' function as production lines was not always easily reconciled with their educational role. This conflict was mirrored in the difficulties which arose between the Form and Craft Masters, the latter feeling that theirs was a less than equal partnership. Although the dual teaching system purported to break down the snobbish barriers between fine and applied art, the Form Masters were treated more favourably in terms of pay and conditions.

As a progressive school dependent on state funding, the Bauhaus was extremely vulnerable to shifts in the political situation. Its initiatives were widely experienced as provocative assaults on conservative, nationalist values. In 1924, the political composition of the Weimar parliament changed and the Bauhaus's contract was terminated.

THE MOVE TO DESSAU

In 1925 the Bauhaus found asylum in Dessau, which was a more industrial city, with a sympathetic mayor, Fritz Hesse. Hesse not only welcomed the Bauhaus but secured funds for a new school building, with extensive workshop facilities. A new generation of Masters came to the force and all the Bauhaus plans and ideals seemed, finally, to be coming to fruition. However, the move to Dessau was not in itself decisive in the school's development; it did not, as has sometimes been suggested, signal its immediate maturity and fruitful collaboration with industry. The first two years' work in Dessau were absorbed by the construction and equipping of the new school building and the associated public relations activity. In terms of workshop production, the school continued to live off its achievements in Weimar.

Gropius maintained that it was a measure of the success of the dual teaching system that at Dessau Craft Masters were no longer necessary, as the workshop leaders, who had themselves received the Bauhaus's dual training, could competently teach both the artistic and the technical aspects of their subject. However, in a number of cases the technical support of a traditional Craft Master was still needed; the difference was that at Dessau the Craft Master's contribution was not publicly acknowledged.

The Bauhaus's first large-scale successes in providing prototypes for industrial production occurred from 1928

onward, largely as a result of the concentrated efforts of certain workshop leaders such as László Moholy-Nagy (lighting design) and Hinnerk Scheper (wallpaper design). The change in the fortunes of the Bauhaus was also linked to the altered economic context. The desperate shortage of materials and the inflation that had made a mockery of attempts at serious business dealings with clients at Weimar had given way to a period of relative stability. The school's architectural projects also benefited from state backing for initiatives in mass housing.

The problems of running the school continued, however, and in 1928 Gropius, suddenly weary of the struggle, resigned in favour of Hannes Meyer (1889–1954), a Swiss architect who had recently been appointed to head the new architecture department. Meyer was a committed collectivist of resolute materialist outlook, and he took on the directorship in a spirit of reform. He was worried, indeed scathing, about the formalism and elitism he perceived in the work of the Bauhaus until then. All he claimed he could see at the inauguration ceremony of the Dessau Bauhaus was a hideous constructivist mannerism, enlivened only by dashes of female neurosis in the textile department. As he saw it, art was strangling life.

His brand of functionalism was extreme: he reduced not only design but everything on earth to the formula "function times economy". Building, he maintained, was not an aesthetic process but a question of technical organisation. His role at the Bauhaus is still controversial, particularly its political content or connotations. He reorganised the workshops into departments and tightened up the design methodology, asking the students to work in teams known as Arbeitsbrigaden (work brigades), rather than as individuals and to concentrate on the needs of the working class.

The Dessau authorities, concerned about what they saw as Meyer's increasing politicisation of the school, dismissed him abruptly in 1930, ostensibly for his support for striking miners. He was replaced by a very different architect, Ludwig Mies van der Rohe (1886–1969). Under his authoritarian directorship, troublesome, politically-minded students were removed and the Bauhaus became something like an academy of architecture.

In 1932, despite Mies's efforts to put up a neutral front, a right-wing victory in the Dessau parliament forced the Bauhaus to move on again. It re-emerged in a suburb of Berlin as a private institute owned by Mies. It was allowed only one term's work: in August 1933 the newly elected National Socialist Government, which viewed the Bauhaus as a hot-bed of "culture-bolshevism", sealed the doors for the final time.

THE LEGACY

The products and philosophy of the Bauhaus contain many ambiguities and contradictions. Chief among them was the fact that craft workshops were used in an attempt to develop industrial prototypes. In addition, geometry, thought to be the language of the machine, was used to symbolise mass production, even when the "mass-produced" effect was in fact achieved through hours of hand-labour. Finally, in a school

pledged to develop well-designed standard products for ordinary people, what was the metal workshop doing beating sheet silver into sugar and cream sets? In reality the Bauhaus clientèle were largely members of the professional middle class – teachers, architects, doctors and social democrat members of parliament.

Although it failed in its attempt to develop the definitive language for mass production, Bauhaus initiatives in the fields of lighting, furniture, textiles, wall-coverings and graphic design have all had far reaching effects, both positively, by inspiration, and negatively, by reaction. Its influence on design education is too widespread to be readily assessed. Its conception of the preliminary course has been absorbed in art schools right across the world. Indeed in some cases, by a horrible irony, Bauhaus principles have become a dogma as rigid as that of the academies.

In terms of ideals and theory, it will continue to invite reassessment. In the present pluralistic climate the Bauhaus goal itself may seem undesirable, even sinister, but the problems it was addressing still remain unsolved. There is a widespread ambivalence toward industry and mass production; we remain unclear whether technology should be our servant or our master, and whether design, as the interpreter of technology, should be serious or frivolous.

As the 20th century has progressed, it has become clear that the design language that has most frequently been found appropriate for mass production and mass consumption is one based not on Platonic beauty but on popular culture. Our present system of deliberate over-production makes it desirable to promote the appeal of endless novelty or synthetic nostalgia, rather than timeless, anonymous and classic products. One could even say that objects are now required to lend a spurious individuality to consumers who may be increasingly unsure they can muster any of their own. However, there will always be those attracted to the Bauhaus blend of understated classicism, high ideals and hopeless utopianism.

HANNES MEYER

Hannes Meyer (1899–1954), the "forgotten" director of the Bauhaus, was born in Basle, Switzerland. He studied building at Basle Technical School (1905–9) and continued his training at the School of Applied Art in Berlin, attending classes in town planning at the Technical University (1909–12). He developed a strong interest in town planning and land reform and in 1912–13 went to England to study the co-operative movement and the "garden cities" of Letchworth, Bourneville and Port Sunlight.

After military service (1914–16), Meyer worked for Krupp's Housing Welfare Office and built the Margaretenhohe housing estate in Essen. In 1919 he set up his own architectural practice in Basle and designed and supervised the foundation of the Freihof estate, the first full-scale co-operative housing estate in Switzerland. In 1924 he founded the Co-op Theatre, and he collaborated in a wide range of Co-op activities throughout Europe.

In 1926 he published The New World, a Modernist battle hymn filled with enthusiasm for all the manifestations of the modern age, from the light bulb to the portable record player. According to Meyer, the new age demanded standardisation, and a collective approach to building. By this time competition projects such as the Petersschule in Basle and the General Secretariat and Assembly Hall of the League of Nations in Geneva were winning Meyer and his partner, Hans Wittwer, a reputation for uncompromising Modernism.

In 1927 Gropius appointed Meyer head of the newly founded department of architecture at the Dessau Bauhaus. Meyer implemented his uncompromisingly functionalist views on architecture, alienating many of the existing teachers. He was appointed director in 1928 but was dismissed in 1930 for allegedly encouraging communism among the students. Since then his achievements at the Bauhaus have tended to be discounted, except in East Germany, where they have recently been reassessed.

Meyer departed angrily for the Soviet Union, hoping to find a more appreciative reception for his work. He became a professor at VASI, the Moscow School of Architecture, and was also chief architect for Giprovtus, the bureau responsible for buildings connected with higher education. He worked on town planning projects throughout the Soviet Union. In 1936 he returned to Switzerland and, in 1939, became Director of the Instituto del Urbanismo y Planificación in Mexico, where he worked until 1949. He remains a controversial figure in the development of modern architecture.

PRELIMINARY COURSE

The preliminary course was a compulsory six-month course for all new students. It served a number of purposes. In a very anti-academic way, the course offered an elementary visual education by experiment and discovery. In his essay "The Theory and Organisation of the Bauhaus" (1923), Gropius explained that its purpose was to "liberate the individual by breaking down conventional patterns of thought in order to make way for personal experiences and discoveries". Most students had already received more conventional training elsewhere, and the preliminary course enabled them to begin afresh, offering them, too, an opportunity to experiment with different materials and to make the right choice of workshop. It also served as a probationary period, since no one could enrol in a workshop without having passed it. Quite a high proportion of new recruits did not make the grade; others decided the Bauhaus was not for them.

The idea of learning through free experimentation and beginning again was not entirely new, but it was greatly developed and refined by Bauhaus teachers such as Johannes Itten, László Moholy-Nagy and Josef Albers.

Itten established the preliminary course at the Bauhaus. The exercises he devised sought to heighten the students' sensitivity to the different qualities of the materials they used through paired contrasts such as rough-smooth and coarse-fine. Many different techniques were used, from highly naturalistic pencil drawing to two- and three-dimensional collages of waste material (which appalled the education authorities, although waste materials were the only materials available at the time).

Itten's course also included the analysis of Old Master paintings, in which the emphasis was not on formal composition but on how the painting's underlying structure contributed to its significance. The teaching was informed throughout by Itten's commitment to the Mazdaznan cult; the students were asked to meditate and do group breathing exercises, and they were encouraged to make free rhythmic studies and abstract depictions of emotions.

When Moholy-Nagy took over responsibility for the course in 1923 the metaphysical and emotional aspects bequeathed by Itten were firmly excised, and the emphasis shifted to the development of the students' rational ability to analyse and construct. Using materials such as wood, sheet metal, glass and wire, the students were expected to develop their sense of space and equilibrium by making perfectly balanced, legible constructions.

From this time on, Josef Albers taught half of the course, making the nature and constructive potential of the material itself the subject. At Dessau his students worked largely with paper and scissors, folding and cutting, learning economy and the surprising structural and visual transformations that can be created in a flat sheet of white paper. Under his exacting guidance, they learned to analyse surfaces in terms of structure,

JOSEF ALBERS

Josef Albers (1888–1976), an imaginative and dedicated teacher, was born in Bottrop, Westphalia. He studied fine and applied art in Berlin, Essen and Munich, before enrolling at the Bauhaus in 1920, and he remained with it until its closure in 1933. He was active in the glass and carpentry workshops, but his outstanding contribution was to the development of the preliminary course.

In 1933 he left Germany to teach at Black Mountain College, North Carolina, where he remained until 1949. In 1950 he was appointed professor at Yale University, and he was an extremely influential disseminator of Bauhaus ideas in the US. His interest in the systematic investigation of colour and form became intensified in his later paintings, resulting in his most famous series of works, Homage to the Square, which was painted in the early 1960s.

He was married to Anni Albers (née Fleishmann), one of the most talented members of the Bauhaus textile workshop.

2

As preparation for free-rhythmic drawings such as Werner Graeff's (1) of 1920, Itten encouraged the students to use breathing exercises to aid concentration and shed inhibition. Bella Ullmann's study from Josef Alher's preliminary course (2) (1929–30) is an investigation into the optical qualities of the contrasting colours blue and yellow. Her design exploits the recessive quality of yellow and the advancing quality of blue to create a spatial effect.

1

facture (how it is made) and texture. They also investigated optical illusions. Albers became overall head of the preliminary course in 1928, while analytical drawing was taught by Wassily Kandinsky.

The preliminary course affected everything the students went on to do at the Bauhaus. It was extremely influential on their design activities in the workshops, and the enhanced sense of form they took with them gave Bauhaus products their distinctive feel without there being any imposed style.

The preliminary course has since been the basis of foundation courses all over the world. Unfortunately, where it has not been taught and developed with imagination, it has sometimes become as frozen a piece of dogma as the academic courses it sought to replace.

3

4

Paper was the main raw material for Albers's preliminary course; he encouraged the students to discover its constructive possibilities. (3) is a textural study in pasteboard by Reinhold Rossig (1929); (4) is an exercise in creating a three-dimensional form (c.1928).

Itten's preliminary course contained an element called "Analysis of Old Masters". (5) shows an analytical drawing by Itten of Meister Franke's "Adoration" (1920–1).

5

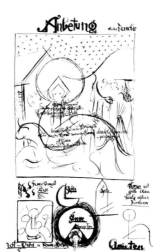

JOHANNES ITTEN AND MAZDAZNAN

Johannes Itten (1888–1967) was a charismatic teacher, whose personality came to dominate, then divide, the Bauhaus. Born in Switzerland, he trained as an elementary school teacher in Bern, but he decided to become a painter and enrolled at the École des Beaux Arts in Geneva, which he found very disappointing.

In 1916 he established a private art school in Vienna, where he developed a highly unconventional method of art education. He had become an interesting figure and Vienna's first abstract painter, and in October 1919 he was appointed to the Weimar Bauhaus, on the recommendation of Alma Mahler, Gropius's first wife. He swiftly gained control of the carpentry, metal, carving, stained glass and wall-painting workshops. Most importantly, he devised and taught the obligatory preliminary course. Itten was completely committed to Mazdaznan, one of the many cults that flourished during the Weimar Republic. Mazdaznan was (and still is) a bizarre life-system, founded on the ancient wisdom of Zoroaster. Itten incorporated it in his teaching at the Bauhaus, drawing heavily on its conception of polarity and introducing Mazdaznan breathing exercises for simultaneous relaxation and concentration.

He was soon surrounded by a devoted group of converts, who alienated the other Bauhäusler with their shaven heads, prayers, fasting and conviction of the insubstantiality of this world. Even the Bauhaus kitchen yielded to the Mazdaznan diet of garlic-flavoured mush. By the summer of 1921, the school was seriously divided. Irreconcilable differences in approach had arisen between Itten and Gropius, and Gropius could no longer tolerate Itten's hegemony. In 1922 Itten stopped teaching. Itten joined the Mazdaznan community at Herrliberg in 1923, and then ran his own school, the Itten-Schule, in Berlin from 1926 to 1934. In 1932 he became director of the School of Two-dimensional Design in Krefeld, where he educated designers for the textile industry. In 1938 the Krefeld school was closed by the National Socialists, and Itten moved to Holland and then to Zurich, where he was appointed Director of the Zurich Museum and School of Applied Art (1938–54). From 1943 to 1960 he was Director of the Zurich Textile College. He was also involved in museum work and in 1955 began to paint intensively once more. In 1961 he published The Art of Colour, for which he is internationally known.

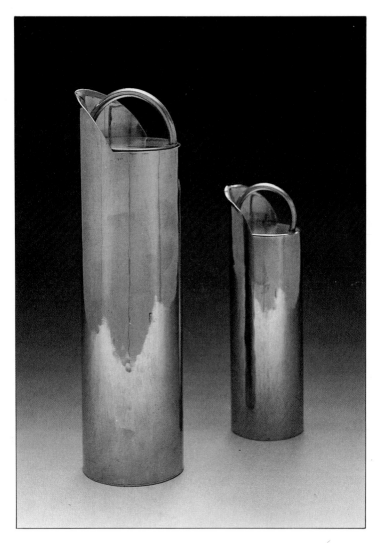

Tea caddies, designed by Wilhelm Wagenfield, 1924

CHAPTER • ONE
METALWORK

METALWORK

The metal workshop produced some of the best-known Bauhaus objects, and it eventually achieved considerable industrial success. Stylistically, its development is interesting, as it demonstrates very clearly the shift from craft to machine values that took place in the Bauhaus about 1923. The metal workshop became as enthusiastic about the quest for functionalism as the furniture workshop, and it was equally taken by the beauty of industrial materials transposed to a household context. The industrial success of the workshop's lighting fixtures owes a great deal to the leadership of László Moholy-Nagy (1895–1946), who managed in certain cases to achieve a genuine collaboration with manufacturers and thereby introduce into the workshop's agenda a real understanding of the manufacturing process.

The metal workshop's origins lay in jewellery and the applied arts. According to the original Bauhaus prospectus, the metal workshop intended to train "blacksmiths, locksmiths, founders and metal turners" as well as "enamelers and chasers", and the 1921 curriculum describes it as a place for training gold- silver- and copper-smiths. The first Craft Master was Naum Slutzky, a young Viennese jeweller, and Christian Dell, a craftsman of the older generation, became Craft Master of the main workshop in 1922.

Johannes Itten was the Form Master, and although he held several other positions within the Bauhaus, his influence on the metal workshop was strong, particularly as the apprentices had already been exposed to his approach to form during the

Progress in the Weimar metal workshop (1) was impeded by lack of equipment. This photograph, taken in 1923, shows only a couple of vices, a boring machine (by the door) and what is possibly a lathe in the rear room. It is hard to imagine prototypes for industrial production being developed in a workshop such as this. A number of objects can be identified: a liquor jug by Gyula Pap stands on the bench nearest the camera, and one of his candelabra is on the bench to the left of the door. The samovar on the rear bench by the window is by Karl Jucker.

1

obligatory preliminary course. Many of Itten's preliminary course exercises were concerned with texture and contrast; one can sense his influence in such objects as Slutzky's spherical copper casket of 1920. Hand tooling is used here on the soft copper to decorative effect; as a process it individualises a piece of work and emphasises the hand of the craftsman, who, literally, leaves his mark.

Few of the products of the early years have such simple, geometric forms. Most are wayward and characterful, even eccentric. This is particularly true of the pitchers and jugs, many of which have a liturgical character, redolent of the heady enthusiasm for the Mazdaznan cult of which Itten was effectively high priest at the Weimar Bauhaus. The bases of these vessels narrow dramatically to support spherical bodies; upper sections flare outward; long, thin spouts taper toward the opening; handles curl and, on occasion, even loop the loop.

Other strange objects emerged in the climate of the early years, including pierced-silver boxes by Lipovec, a pear-shaped, wobbly-contoured jug by Jahn, a censer and an ebony tower of brass and glass by Slutzky and a fantastic brass trophy by Christian Dell, incorporating the tusks of a wild boar as its handles. Objects of this type represent perfectly standard output for a Kunstgewerbeschule, from which the Bauhaus wished to distance itself completely. In 1925 the magazine Die Kunst commented on the current trend in Kunstgewerbeschulen: "an eruption of brass, a forest of standard lamps with thousands of different types of shade, and when the students are talking, every other word is 'cosmos'." The early Bauhaus metal workshop fits alarmingly well into this picture.

However, in 1923 the workshop's objectives were radically re-defined by its new Form Master, László Moholy-Nagy. It was Moholy-Nagy's conviction that the Bauhaus should think in terms of the collective and set its sights on mass production. Craft values were to be replaced by machine values.

Despite this shift in orientation, contact with industry was not achieved for many years. This was partly the result of the long and laborious nature of training in metalwork along with the workshop's lack of equipment, and partly the result of a certain ambiguity in its approach. The workshop adopted what it understood to be the ethos or language of machine, and the personalising marks of the hand tool were abandoned in favour of compositions of smooth, geometric solids. Apprentices such as Gyula Pap became convinced that only large, simple, geometric forms showed the qualities of the material to best advantage. In a highly questionable process, flat sheets of metal were hammered by hand into smooth, three-dimensional forms to look as if they had been machine-pressed.

The types of objects produced still remained well within the repertoire of the Kunstgewerbeschule. Heated debates about form and function raged over silver tea and coffee sets, of which an inordinate number were produced, along with elaborate set-piece samovars, tea caddies, tea infusion spoons and tea infusion spoon stands. Marianne Brandt, one of the workshop's most

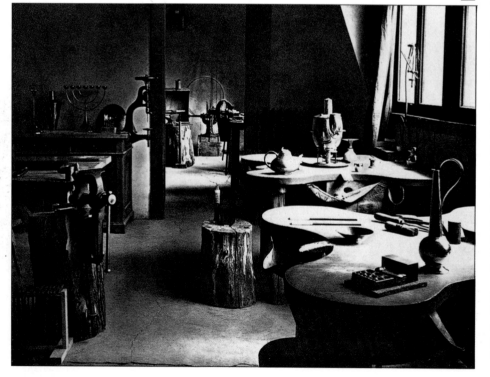

talented apprentices, later admitted that while they were very concerned about function (that vessels should pour properly and be easy to clean and so on), geometric, elemental forms were in themselves something of an obsession. She interpreted this as a reaction to the over-ornate kitsch they had all grown up with before the war. Even at the Bauhaus, supposedly the high temple of the functionalist faith, its basic tenets were continually re-examined and criticised; the in-house magazine Bauhaus frequently carried articles questioning the validity of functionalism.

Moholy-Nagy encouraged interest in an area that was ultimately to be of great importance: lighting. In particular, he encouraged experiments in the use of metal in conjunction with glass. One of the most famous results of these experiments is the Wagenfeld/Jucker table lamp of 1924. The reception accorded this lamp at the Leipzig Trade Fair in 1924 reveals very clearly the ambiguity of the metal workshop's approach. While the lamp aroused considerable interest, the price held potential customers back. They could not understand how something they took to be mass-produced could possibly be so overpriced. They were not to know that each lamp was laboriously made by hand, and that the components were acquired in small quantities from the suppliers. The lamp's look of modernity was largely derived from the design of the glass shade, which was borrowed from industrial lighting, and the gleam of nickled silver, an aesthetic borrowed from industry and placed in a household context. The lack of industrial capacity in this period

The group photograph of the workshop members (2) was taken about 1924. László Moholy-Nagy is seated in the middle, with Christian Dell directly behind him. Marianne Brandt is standing beside Dell, and Wilhelm Wagenfeld is seated on the ground, to the right of Moholy-Nagy. One of the Bauhaus's greatest industrial successes was its collaboration with the lighting manufacturer Körting und Matthiessen (Kandem) that began in 1928. In 1932 a competition was held within the school to design a logo for Kandem; Herbert Schürmann's entry (3) is barred with rays of light (poster paint on paper).

forced the metal workshop to become its own factory, and just like the furniture and pottery workshops, apprentices were set to work to reproduce the workshop models.

The move to Dessau gave the workshop the opportunity to tackle lighting on a large scale. The job of co-ordinating design and installation fell to the student Max Krajewski, who can claim credit for the dramatic patterns of fluorescent tubes mounted on the ceiling of the auditorium and canteen. However, progress with industry was slow. Success finally came in 1928, when two industrial contracts were signed: one with Schwintzer und Gräff in Berlin for the production and marketing of 53 light fixtures, and the other with Körting und Matthiessen (Kandem) in Leipzig, also for lighting. The arrangement with Schwintzer und Gräff does not appear to have been entirely successful, as the contract lapsed by the end of 1930. The nature of the contract with Kandem was rather different: the Bauhaus metal workshop undertook to act as design advisor to the firm. Rather than presenting it with finished models, as it had done with Schwintzer und Gräff, the metal workshop was drawn into the production process and Kandem began by giving a demonstration of its production methods. Not only did the Bauhaus workshop develop entirely new models for Kandem, but it also reworked models and components already in production. Sales were high – about 50,000 fixtures were sold by mid-1931 – and the metal workshop became one of the highest earners for the school.

The workshop's eventual success can be attributed not only to

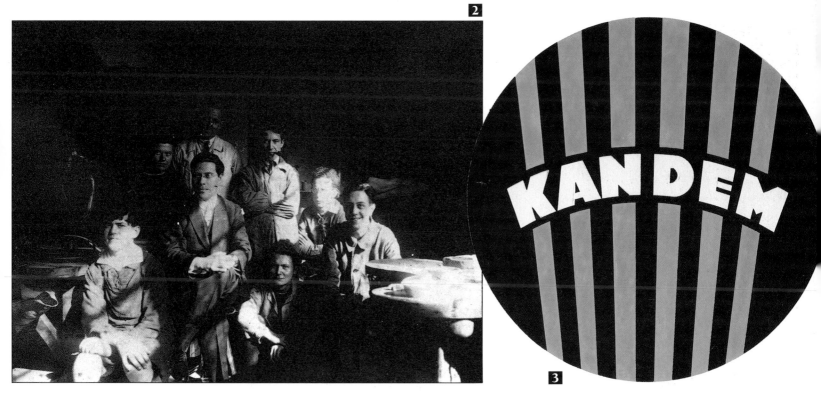

2

3

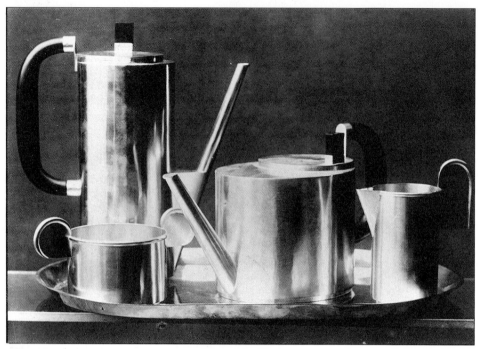

1

WILHELM WAGENFELD

Wilhelm Wagenfeld (b.1900) was one of the most notable German designers committed to mass-production. He was born in Bremen, where he trained in the Koch & Bergfeld silverware factory, and studied at the School of Arts and Crafts. After further study in drawing and metalwork in Hanau, he joined the Bauhaus in 1923, quickly qualifying as a journeyman in the metal workshop.

He chose not to move with the Bauhaus to Dessau, becoming instead an assistant at the Weimar College of Building where, in 1929, he became head of the metal workshop. He had already begun to work with glass in his lighting designs, and in 1930 he went to work at the Jena glassworks, Schott & Genossen.

From 1931 to 1935 he taught at the State College of Art in Berlin, before becoming Artistic Director of the Vereinigte Lausitzer Glassworks. His fine glass won international acclaim, but most of his work was in the design of everyday household and commercial ware in pressed glass. One of his classic designs is Kubus, a modular set of glass containers, all based on the cube. He also worked with the porcelain industry – for Rosenthal & Fürstenberg, for example – to which he brought the same clean lines.

After military service during World War II, he taught industrial design at the College of Fine Arts, Berlin, and became industrial design consultant for the State of Württemberg. He also began to work for the Geislingen metalware factory. In 1954 he established his own workshop, concentrating on consultancy work for industrial production. As a designer, he came to reject the Bauhaus ideals, repudiating function as a determinant of form and preferring to see it as a precondition of good design.

the talents of gifted students such as Marianne Brandt, but also in great measure to Moholy-Nagy's personal influence and, in particular, the working methods he instilled. The first stage of each project was a group discussion of the basic principles (often an attempt to re-evaluate the object and its function), which was aided by visits to trade shows and manufacturers, for instance, the Osram laboratories in Berlin and Kandem in Leipzig. The next stage was individual design work by the student, which included a consideration of manufacturing requirements. The third stage was the production of the object by hand. Finally, it was collectively examined and assessed. These methods avoided the dilettantism that Gropius disliked so strongly in the Kunstgewerbeschulen and encouraged a collective approach.

The Bauhaus set the standards for a number of different types of light fixture. Its range of hanging and ceiling lights were especially successful. In 1926 Marianne Brandt and Hans Przyrembel collaborated on the design of a counter-weighted hanging light that was used extensively in the Bauhaus workshops and was mass-produced by Schwintzer und Gräff from 1928 onward. The hanging lights designed at a later date generally incorporate opaque ("milk") glass, which reduces glare. These and the Bauhaus ceiling light were produced by Kandem and many consisted of opaque glass globes suspended on metal rods or caught in metal claws. Experiments were also made with shallow glass dishes or flat glass disks.

Task lighting was another successful area. Marianne Brandt, this time working in conjunction with Hin Bredendieck, created

Tea and coffee services, such as Wilhelm Wagenfeld's of about 1924(1), are the exemplary products of the later Weimar Bauhaus, with their attempts to find a family of forms that will "go together". The materials used were relatively costly: German silver and brass, and ebony for the handles. The most successful examples were designed by Wilhelm Wagenfeld and Marianne Brandt. One of the characteristics of Bauhaus tea and coffee sets that occasioned comment was the way in which lids on pots were placed eccentrically, near the handles. Wagenfeld, who always stressed the absolute functional justification for every design feature, maintained that the lids were thus placed to prevent any overflow on pouring. Placing the knob opposite the hinge also made the lid easier to open, he maintained.

the definitive form for small adjustable bedside and desk lights, with bell-shaped shades (intended to give an even distribution of light), gently curved necks and wedge-shaped feet. Brandt's "Wandarm" (wall-arm) of 1927 was a typical piece of Bauhaus ingenuity. Designed with hospital use in mind, it is an adjustable reading light with a push-button switch mounted on the wall-plate, where, it was hoped, it would be easy for the drowsy patient to locate it. Its design carefully minimised the amount of soldering needed. All the elements could be cast, pressed and riveted, in order to reduce labour costs and speed up manufacture. This incorporation of production requirements from the outset demonstrates the value of Moholy-Nagy's policy of industrial visits and direct contact with manufacturers.

Unfortunately, the very success of the metal workshop's lighting fixtures made finding manufacturers for its tableware difficult; it tended to be pigeon-holed as a lighting department. Interest in the paraphernalia of tea and coffee making was still strong at Dessau, but the forms became smoother and simpler and the lines more gently rounded. In terms of the types of objects designed and the materials used, it is hard to reconcile

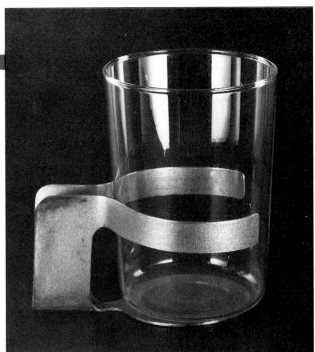

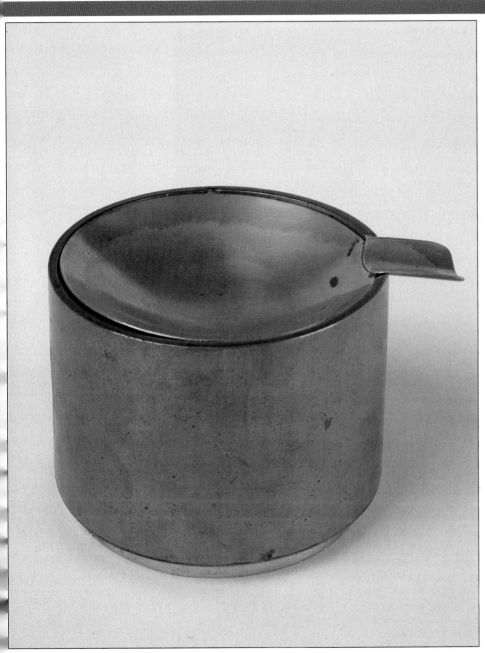

this type of work with the objectives of the Bauhaus at this time. The luxury of solid silver cake knives and nickled German silver fish steamers sits uneasily in the late Dessau period, when the workshops had been explicitly asked to consider the needs of the working man.

Moholy-Nagy resigned in 1928, after clashes with Hannes Meyer, just when his achievements as workshop leader were finally coming to fruition. In recognition of her contribution to the workshop's success, Marianne Brandt was persuaded to run it for a year. As part of Meyer's general reorganisation, the metal workshop was amalgamated into the interior design workshop along with furniture and wall-painting. Although innovative work in metal ceased on Brandt's departure, the lighting contracts continued to make money for the school. While the Bauhaus was by no means alone in the field (innovative work was being done by the P-H Lampengesellschaft, Ferdinand Kramer and the Rasch Brothers, among others), its models were extremely influential in setting the standards for useful, unassuming household light fixtures.

Brandt's ashtray of 1924(**2**) is a perfect mixture of functional considerations and what she admitted was the workshop's obsession with geometry. It is a bronze cylinder, with a tip-up German silver lid: the cigarette rest acts as a lever, with which one can either tip away the ash or remove the lid to tip the ash into the body of the ashtray.

As the metal workshop developed, it increasingly tried to incorporate ease of manufacture into its designs. Hin Briedendieck's tea-glass holder (**3**)(1930) was designed to be stamped out of sheet metal in one piece and then bent into shape.

INFLUENCES

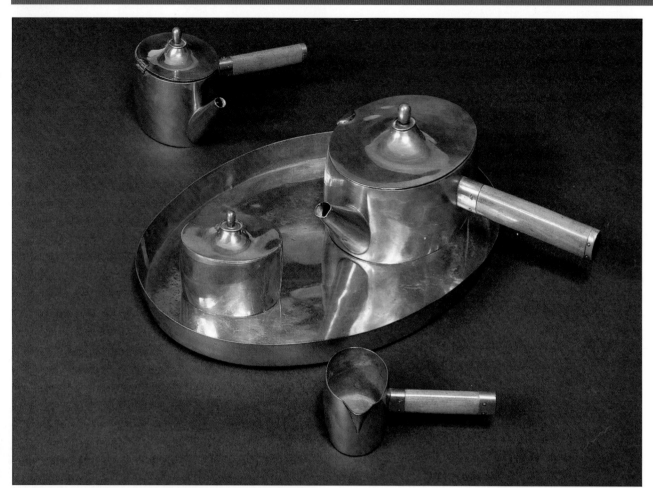

1

2

The Bauhaus Craft Master, Christian Dell, also became associated with the Neue Frankfurt group. His Type Klamp (3) was produced in wall-mounted and free-standing versions by Zimmerman in Frankfurt.

Bauhaus metalwork could not help but be influenced by the work of the Wiener Werkstätten (Viennese Workshops), which were founded in 1903 by Josef Hoffmann, Koloman Moser and Fritz Wärndorfer, in the hope of uniting art and craft. The Wiener Werkstätten coffee set (1) shares the Bauhaus desire to simplify.

Hoffmann's silver fruit basket of 1904 (3) shows a delight in the geometric that was to typify much of the Bauhaus's metalwork production. This contrasts with the flowing lines of the Jugendstil, of which this mirror (2) in silvered copper (1904) is an example.

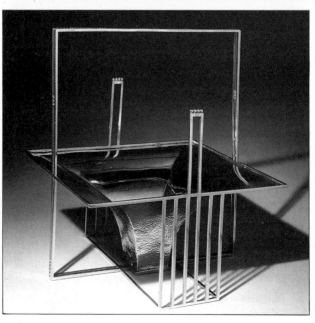

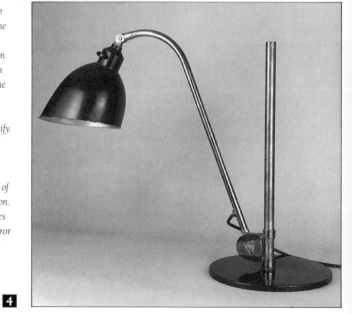

3

4

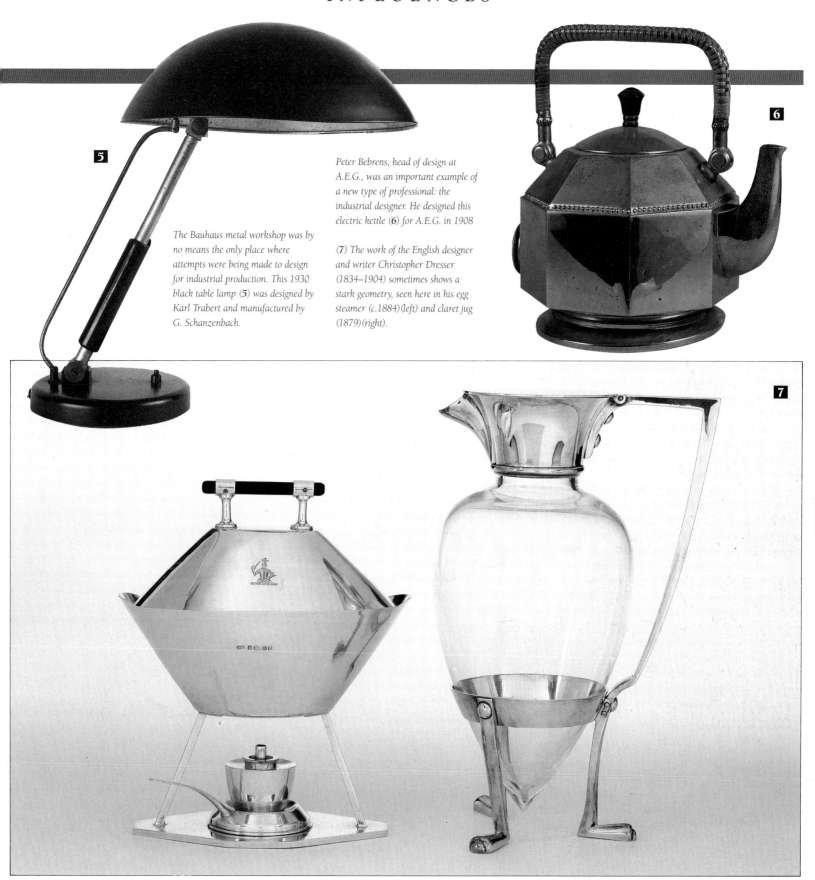

The Bauhaus metal workshop was by no means the only place where attempts were being made to design for industrial production. This 1930 black table lamp (**5**) was designed by Karl Trabert and manufactured by G. Schanzenbach.

Peter Bebrens, head of design at A.E.G., was an important example of a new type of professional: the industrial designer. He designed this electric kettle (**6**) for A.E.G. in 1908

(**7**) The work of the English designer and writer Christopher Dresser (1834–1904) sometimes shows a stark geometry, seen here in his egg steamer (c.1884)(left) and claret jug (1879)(right).

DECORATIVE OBJECTS

1

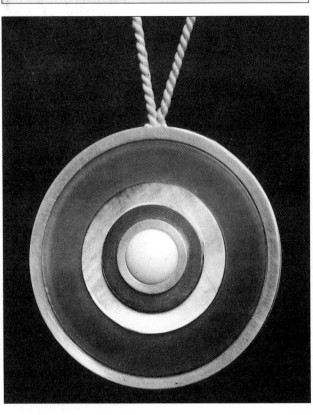

2

Gyula Pap's candelabra of 1923 (**1**), although a pleasing enough piece, could easily be the product of one of the Kunstgewerbeschulen, from which the Bauhaus wished to distance itself completely. It is a nicely finished piece of Arts and Crafts work, which predates Pap's decision to concentrate on using geometric forms to bring out the qualities of the material (although there are hints of this in the semi-circular pairs of arms). It belongs to the period of Johannes Itten's influence in the workshop, when many of the objects produced had a more or less explicitly liturgical character.
The pendant (**2**) was made by Naum Slutzky, a young Viennese jeweller, whom Gropius appointed as the first

Craft Master in the metal workshop. Slutzky established his own jewellery workshop at the Bauhaus, alongside the main one. The boundary between the two was indistinct for the first two or three years, and although the Bauhaus metal workshop eventually enjoyed considerable industrial success, its origins lay firmly in jewellery and decorative work in precious metals.

Naum Slutzky's copper jewel box (**3**) of 1920 is an interesting object. Its spherical shape can be seen either as a precursor of the Bauhaus obsession with geometric solids or as part of the mystical atmosphere created by the first Form Master, Johannes Itten. The circular theme is strong: the box is divided at a point approximating to the golden mean, and it is decorated with hand-tooled arcs that may be linked to Itten's preliminary course exercises in texture.

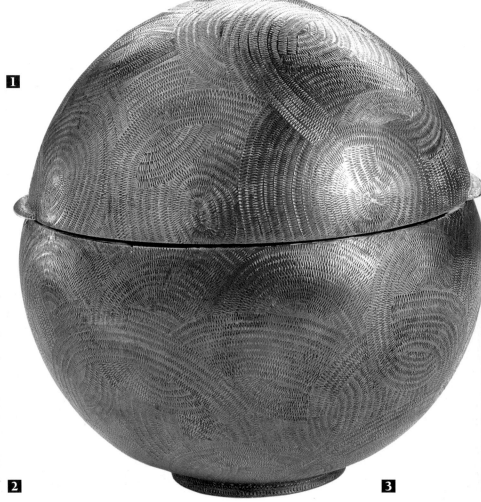

3

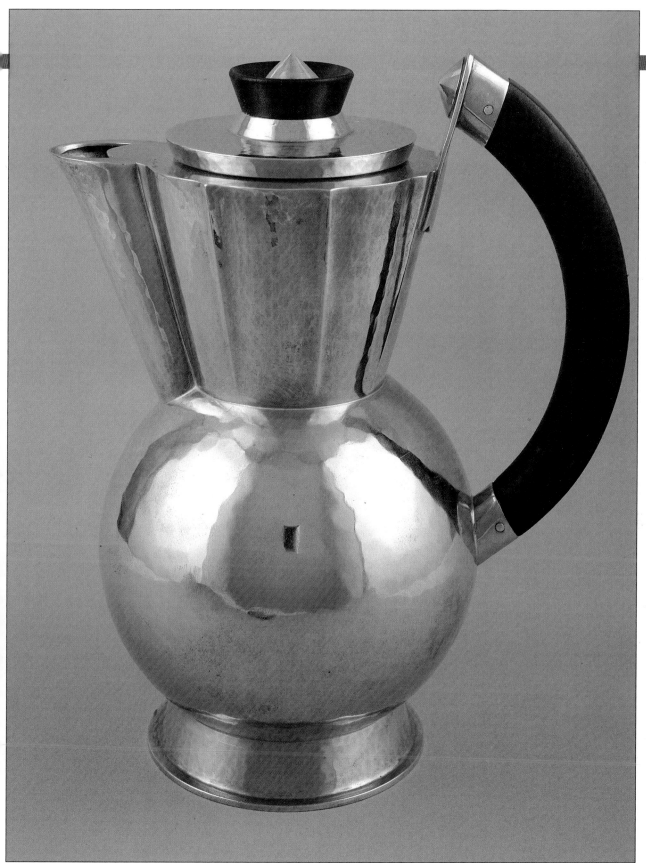

This wine pitcher was made c.1924 by Christian Dell, an excellent craftsman of the older generation who was appointed Form Master in 1922. It is made of German silver, with an ebony handle and finial. Although in some ways a conservative piece, its clear geometry and relative simplicity show that Dell, too, was influenced by the change in direction that took place in the workshop when Moholy-Nagy became Form Master in 1923.

5

Christian Dell's trophy is one of the many strange objects to emerge from the metal workshop in the early years. It is something of an extravaganza, its handles made of the tusks of a wild boar and its surface laboriously beaten into a series of ridges and troughs. It could hardly be further from what is normally considered to be typical Bauhaus style.

4

TABLEWARE

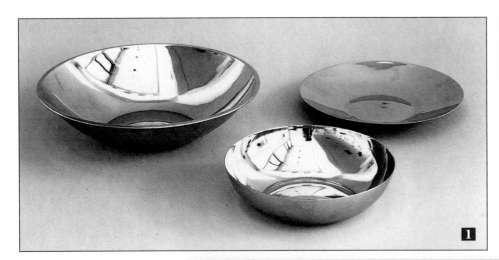

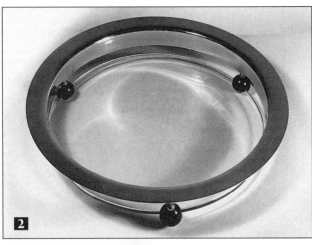

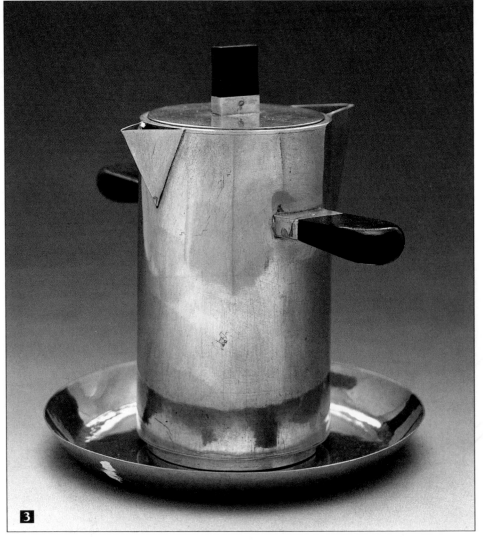

These simple dishes (**1**), formed from thin sheets of chromed brass by Marianne Brandt in 1929, bring out the smooth beauty of the material and offer intriguing reflections of the world. These dishes are all band formed, as the Bauhaus never managed to find an industrial manufacturer for its tableware.

Josef Albers designed and made this austere fruit dish (**2**) in 1924, with a perfectly circular glass base, a German silver rim and three wooden balls acting as feet as well as pinning the bowl together.

Wilhelm Wagenfeld's German silver gravy boat of 1924 (**3**) with ebony handles has a separate spout for fat and skim. It is a good example of his restrained, rather perpendicular style.

In 1932, the American Bauhaus student, Lawrence Haase, made the silver bowl (**8**), bringing out the fine contrast between the mat outside and the polished, reflective inside.

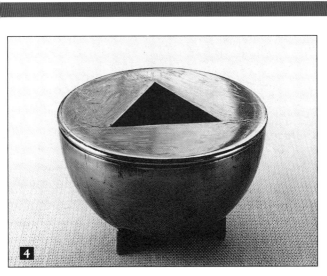

Of the two ashtrays by Marianne Brandt shown here, ashtray (4) of 1924 is the most dogmatically geometric, Brandt and her colleagues using the primary forms: the circle, the square and the equilateral triangle. Although this piece speaks loudly in the language of the machine, it was laboriously hand made.

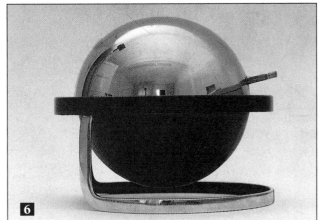

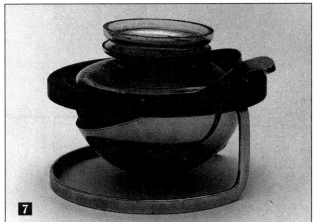

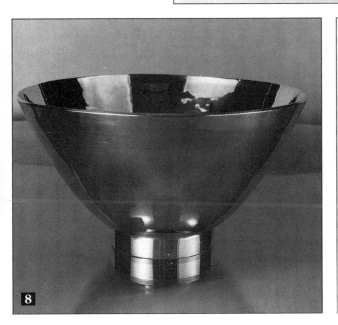

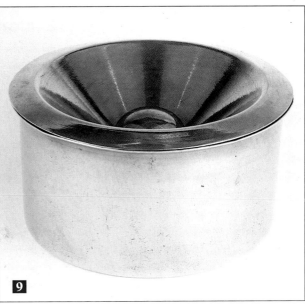

Brandt's inkwell and pen rest (5) (c.1924), made for her own use in copper and nickeled brass, reads like a spatial/construction exercise from Moholy-Nagy's preliminary course. Her inkwell (6 and 7) of 1931, made shortly after her departure from the Bauhausin in 1929, draws on her favourite themes of geometry and reflections. It is made of lacquered and chromed steel and was manufactured by the Ruppelwerken in Gotha.

In the Brandt ashtray of 1926(9), cigarettes can be stubbed out on the tip of the cone that protrudes through the circular hole in the lid; when the lid is raised, the ash falls automatically into the base.

TEA AND COFFEE

The metal workshop turned with great enthusiasm to the paraphernalia of tea and coffee. The workshop's output included tea infusers (**2** and **3**), versions of which were designed by Otto Rittweger, Wilhelm Wagenfeld and Wolfgang Tümpel, and Wagenfeld's cylindrical tea caddy (**1**) of 1924. Wagenfeld's tea caddy is a radical rethink of the object, which is redesigned not only to provide airtight storage but also to allow small quantities of tea to be poured over the lip. The tea infusers came with their own stand (**2**) or an individual rest (**3**). Precious materials – silver, bronze and brass – are used for these objects, and although they have the air of mass produced objects, they have been laboriously fashioned by hand.

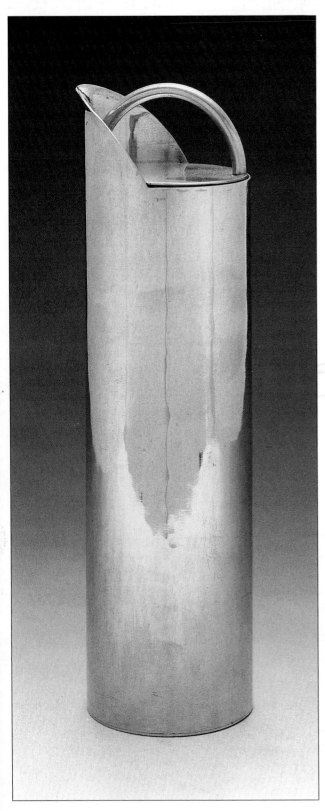

1

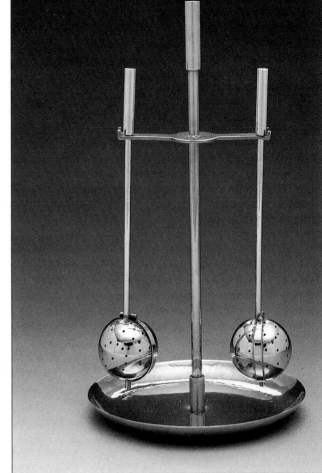

2

3

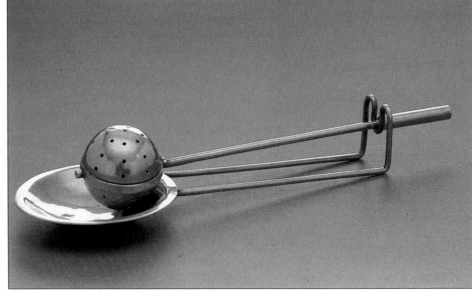

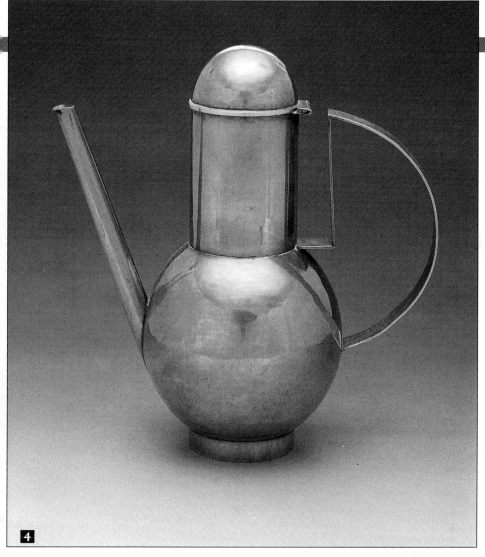

Making tea and coffee sets provided opportunities to experiment. Apprentices turned again and again to the basic geometric forms, using, for example, spheres for the body of a vessel and arcs for the handles. Rissger's jug (**4**) and Rittweger's tea set (**8**) date from 1924. Karl Raichle's less strictly geometric tea set (**7**) dates from 1928.

These two samovars, made by the apprentices K.J. Jucker (**5**) and Josef Knau (**6**) in 1924, are a contradictory pair. Jucker's samovar, which looks like something from Aladdin's cave, has an electric heating element; Knau's samovar, although it has adopted the geometric language of the machine, is heated by an old-fashioned alcohol lamp.

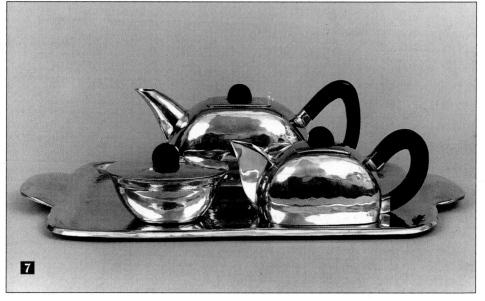

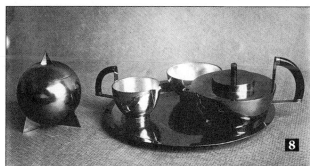

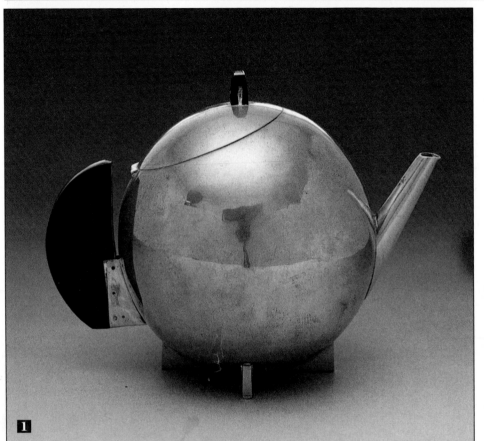

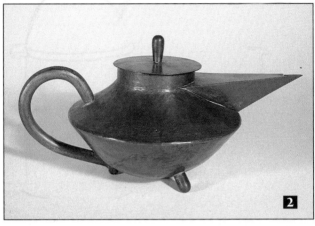

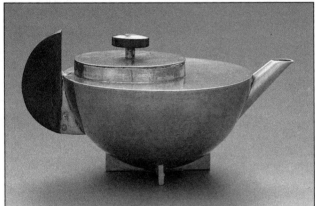

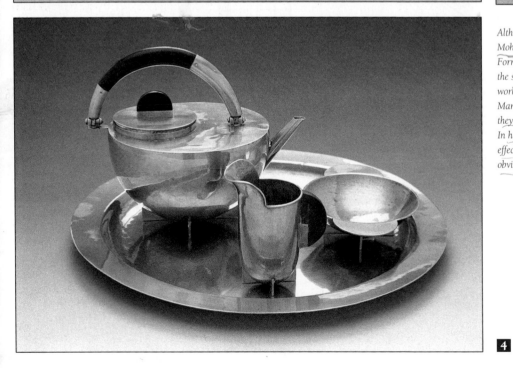

Although from 1923 onwards, when Moholy-Nagy took over from Itten as Form Master, function was invoked as the source of form, one of the workshop's most talented apprentices, Marianne/Brandt, later admitted that they were all obsessed with geometry. In her early/spherical teapot (1), the effect of the geometric obsession is as obviously formalistic as Leo Grewenig's expressionistic copper teapot (2). In her tea services of about 1924 (3 and 4), the effect is more measured. The basic form of the pot is very similar to the modular teapot developed by Theodor Bogler in the ceramic workshop. The semi-circular ebony handles are characteristic of the Bauhaus metal workshop.

MARIANNE BRANDT

Marianne Brandt (1893–1983) was born in Chemnitz, Germany, and studied painting and sculpture at the Grand-ducal College of Fine Arts in Weimar. After spending some time in Norway and Paris, she returned to Weimar in 1924 to enrol at the Bauhaus, where she entered the metal workshop. Although her all-male colleagues initially gave her a hard time, her talent was soon recognised, and in 1928 she became temporary head of the workshop. During her time at the Bauhaus she also began making imaginative photocollages, inspired by Moholy-Nagy. Her interests have the typical diversity of the successful Bauhaus student.
In 1929 she left the Bauhaus to work in Gropius's architectural office in Berlin for a short time before being appointed as a designer for the Ruppelberg metalware manufacturer in Gotha. In 1932 she returned to Chemnitz and worked independently, returning also to painting. In 1949 she became a lecturer at Dresden College of Free and Applied Arts. Although she did some freelance design work for industry, she turned in her later years to painting and small sculptures.

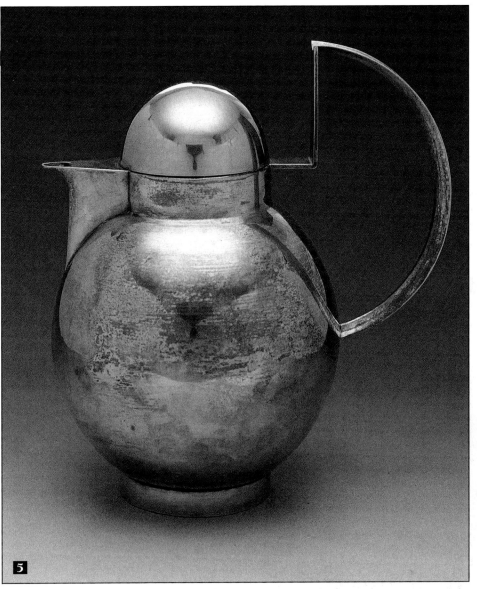

5

This mocha jug (5), sometimes attributed to Wagenfeld, bears a strong resemblance to Rïssger's jug pictured on page 31.

The Dessau metal workshop continued to make silver tea and coffee sets even after Hannes Meyer had declared that the purpose of the Bauhaus was not to design luxury objects, but models for mass production. Helmut Schulze's silver cream and sugar set (6) (c.1928), is considerably smoother and to modern/eyes, more conventional, than Weimar objects. The sugar tongs are highly simplified.

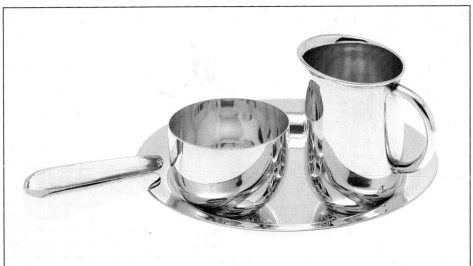

6

TABLE LIGHTS

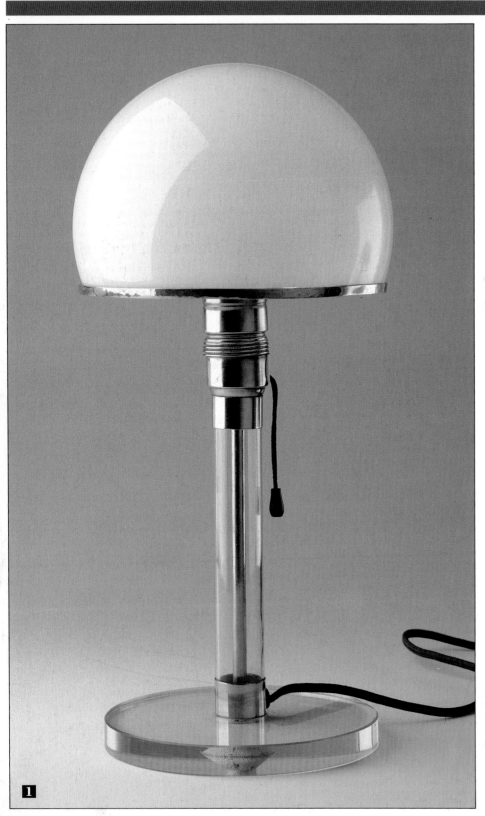

1

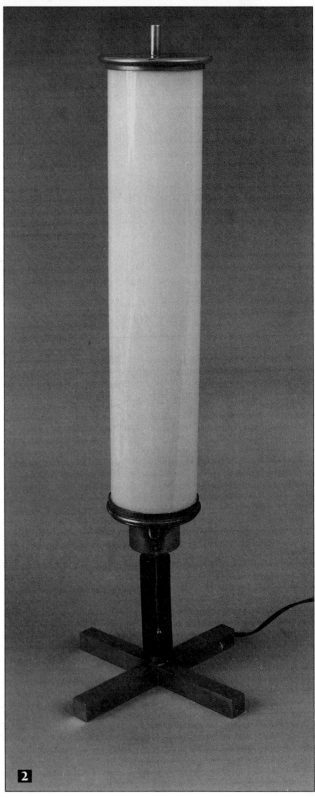

2

The Wagenfeld/Jucker light (1924) (**1**) is one of the best-known Bauhaus products. Its effect of modernity derives from the fact that it is an assemblage of industrial components: the milk glass shade, the hollow glass stem, which holds the cord, and the solid glass plate for the foot.

This unusual table lamp (**2**) in nickel-plated brass, with a milk glass shade, was designed by Wolfgang Tümpel c. 1927. It is one of a number of experiments in using industrial strip lighting in the domestic context, which were originally inspired by Gerrit Rietveld's assemblages of fluorescent tubes for ceiling lights. The cruciform foot is unusual; most Bauhaus table lamps had circular bases.

The metal workshop was continually striving towards adjustability in its lighting. Usually basing their experiments on the Wagenfeld/Jucker light (**1**), several workshop members tried to incorporate rotation into the shade. The table lamp (**5**) of about 1928 uses a pivoting aluminium hemisphere; Karl Jucker's experimental lamps (**3** and **4**) use fabric stretched across a wire frame.

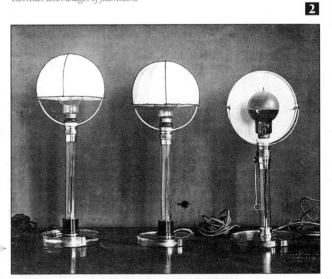

2

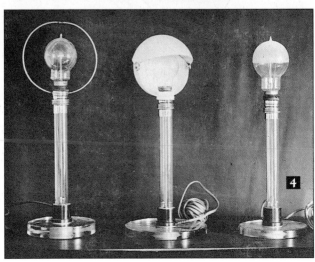

4

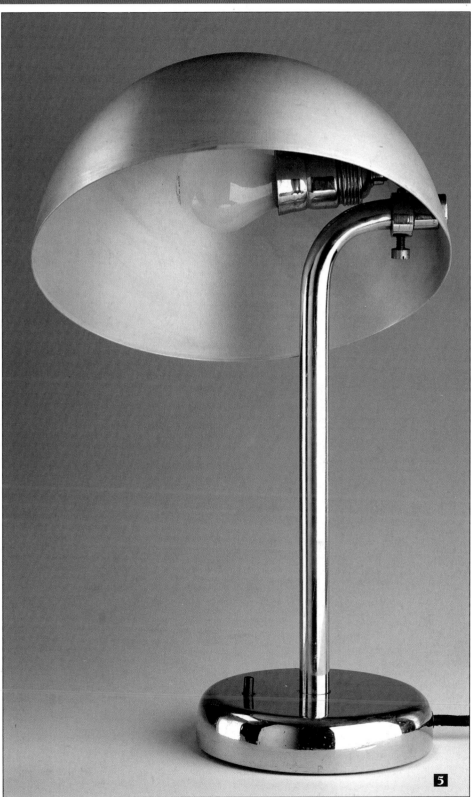

5

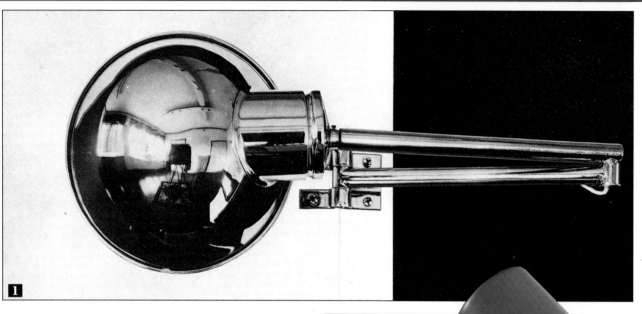

1

In this elegant uplight (**3**), designed by Gyula Pap for the Haus am Horn in 1923, the cord is conducted from the circular reflector down to the glass foot through the stem itself. Switching is by an on-off pull mounted at the base of the bulb. Details like these are shared with the Wagenfeld/Jucker table light (page 34), and together with Pap's own recollections of his experiments with glass components, they point to a much closer collaboration between Wagenfeld and Gyula Pap than has been previously supposed.

Marianne Brandt's "Wandarm" (wall-arm) (**1**) of 1927, intended primarily for hospital use, is an ingenious piece of design. The white reflective board (black was also available for a softer effect) allows indirect lighting, and the switch is mounted on the board for easy location. It was designed for ease of manufacture, and was indeed mass-produced by a Stuttgart firm.

Work in the Bauhaus workshops was often genuinely collaborative. At Dessau, Marianne Brandt and Hein Briedendieck developed what was for many years the definitive shape for a reading or bedside light. The bedside light (**2**) (1928) is an unusual example in that it is lacquered green (most examples are pure white), but it has the characteristic, adjustable bell-shaped shade, which gives a directional focused and even light, and the wedge-shaped foot, which is stable and suitable for a drowsy, groping hand to slide up and find the push-button switch. The cord disappears neatly out of the back of the foot. Such lights were manufactured by Kandem (Körting und Matthiessen) from 1928 onward.

2

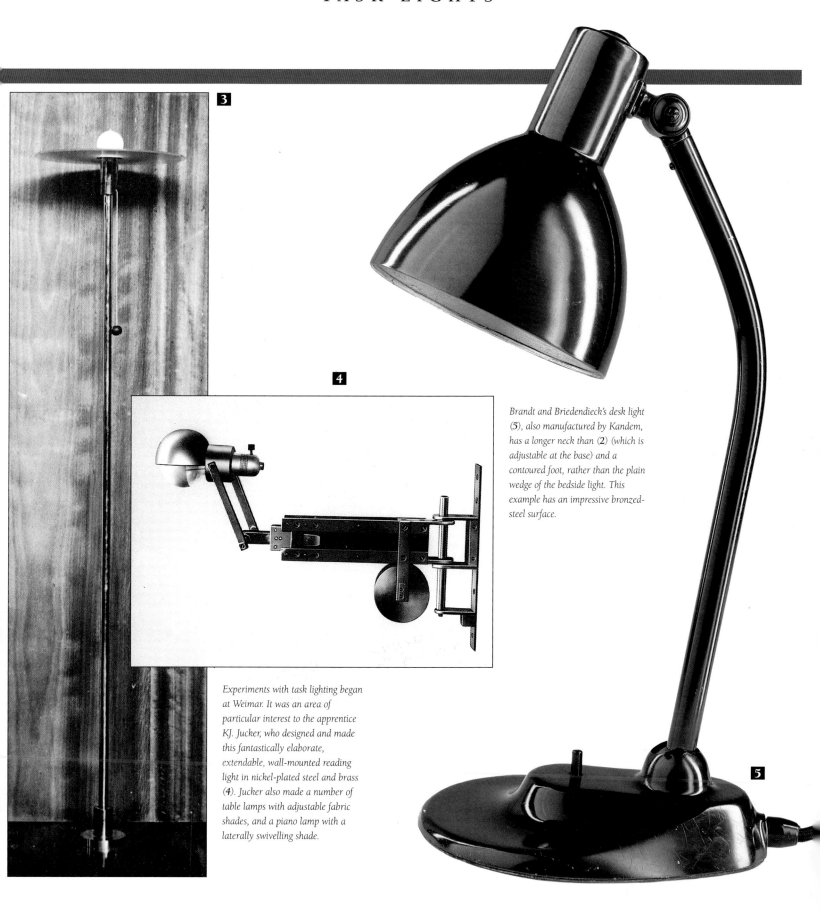

3

4

Brandt and Briedendieck's desk light (5), also manufactured by Kandem, has a longer neck than (2) (which is adjustable at the base) and a contoured foot, rather than the plain wedge of the bedside light. This example has an impressive bronzed-steel surface.

Experiments with task lighting began at Weimar. It was an area of particular interest to the apprentice KJ. Jucker, who designed and made this fantastically elaborate, extendable, wall-mounted reading light in nickel-plated steel and brass (4). Jucker also made a number of table lamps with adjustable fabric shades, and a piano lamp with a laterally swivelling shade.

5

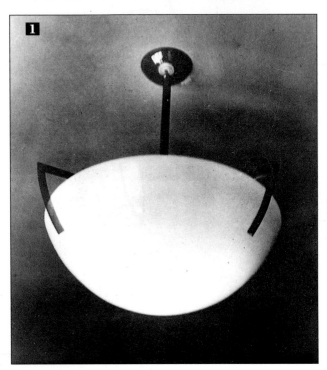

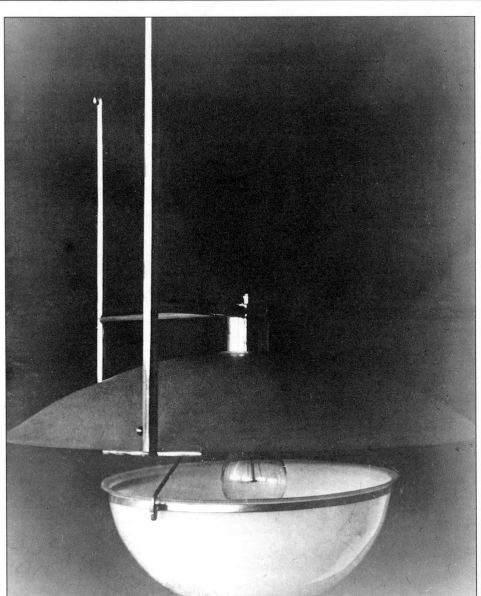

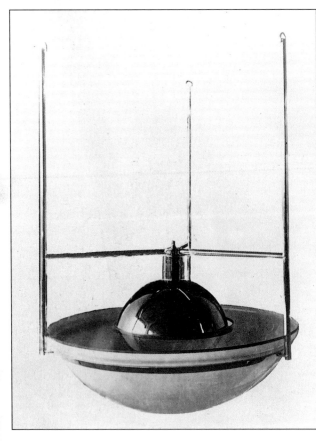

These ceiling lights (**1**, **2** and **3**) were designed and made by Max Krajewski, who worked closely with Gropius on the lighting for the new school building in Dessau (1925–6). In each case, a plain milk glass dish is used: (**1**) simply clasped by three claws and (**2** and **3**) suspended in a more complicated arrangement with a reflective dish positioned above the light source to direct all the light downwards. (**2**) This style was used in the school canteen.

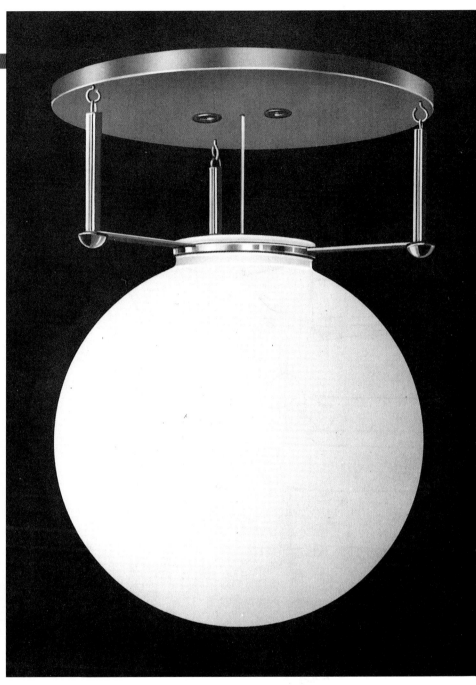

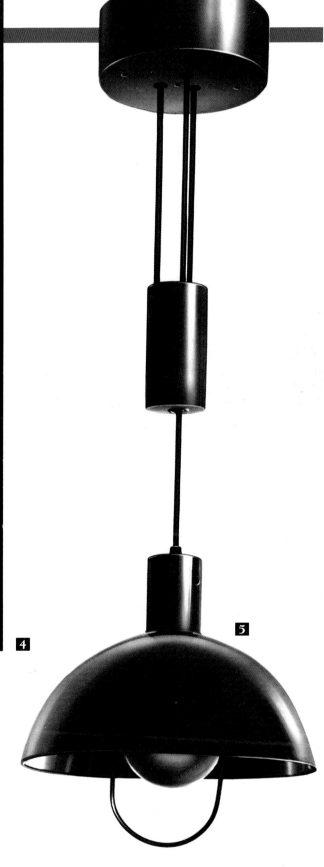

4

5

Marianne Brandt's ceiling light (4) of 1926 is, like many of the early experiments in ceiling lighting at Dessau, based around a simple, spherical milk glass shade, a component borrowed directly from industrial lighting and transposed into the domestic context. In order to change the bulb, the shade can be removed from the aluminium fixture by unhooking it. It was produced for a short while (1928–30) by Schwintzer und Gräff in Berlin. Brandt also designed ceiling lights using concentric rings of milk glass, which did not throw strong shadows or collect dust. (5) This counterweighted, adjustable ceiling light was the result of collaboration between Marianne Brandt and Hans Przyrembel in 1926. It was also manufactured by Schwintzer und Gräff and was used extensively in the Bauhaus workshops, for which purpose it was ideal, although it was also suitable for use in dining rooms and studies. In some models, a small shade was placed beneath the light source to prevent dazzle. As many people objected to naked aluminium, the shades were often spray-painted in a colour.

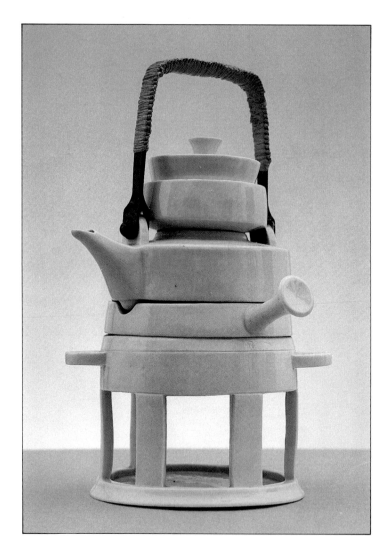

*Theodor Bogler's six-part porcelain mocha
machine, 1922.*

CHAPTER • TWO
CERAMICS

CERAMICS

Of all the workshops at Weimar, the pottery workshop was one of the few that successfully developed models for industrial manufacture. Paradoxically, it developed industrial prototypes though basing its work on a wholehearted return to vernacular and traditional forms.

One of the reasons for the ceramic workshop's success lay in its location. It was based at Dornburg, 15 miles from Weimar, and was therefore isolated from the heady debates that frequently disturbed work at the main school. As the Bauhaus had inherited no facilities for pottery and could not afford to establish and equip its own workshop, it had to seek collaboration with an outside pottery. Gropius was aware that the villages around Weimar had once been the site of a thriving pottery tradition, which was then suffering badly through the establishment of pottery factories. The new factories monopolised supplies of raw materials, which were very scarce directly after the war, and had little use for the hundreds of skilled potters in the region. Motivated, at least in part, by a desire to revive the local pottery tradition, Gropius struck an agreement with a potter called Max Krehan in Dornburg an der Saale, which had once been at the centre of the traditional potteries.

Krehan owned the last remaining workshop for hand-turned pottery, situated in the stables of Dornburg's rococo palace, and continued to work in the traditional manner producing everyday ware for the local community. The Bauhaus pottery workshop was officially opened on October 1, 1920. Krehan, whose workshop had been effectively taken over by the Bauhaus, was the Craft

1

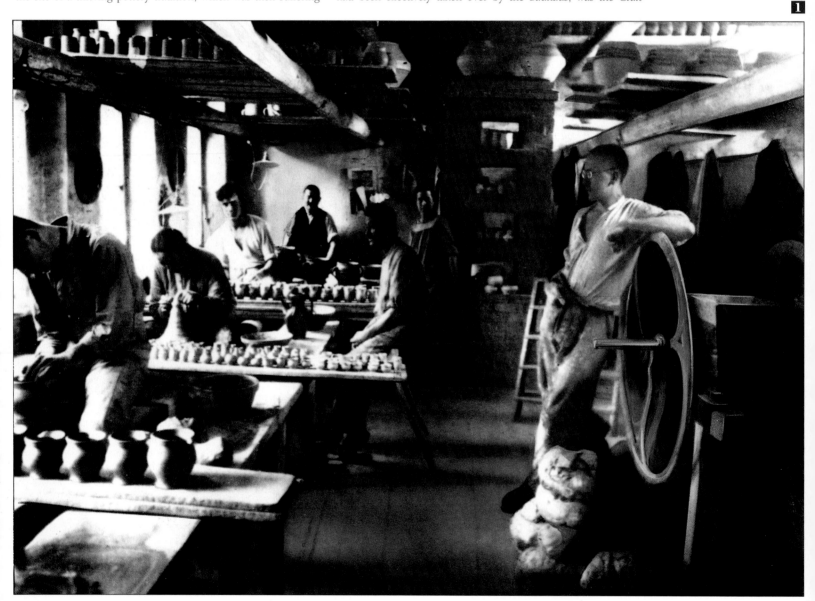

Master, and the sculptor and printmaker Gerhard Marcks (1889–1981) was the Form Master.

Conditions at Dornburg were extremely primitive and life was physically hard. The workshop grew its own food and dug its own clay, and there was a constant struggle to gather and chop enough dry wood to stoke the kiln. But its isolation from Weimar proved advantageous, as its members formed a close working community, far away from the time-consuming theoretical debates that frequently disturbed work in the main school. There were several talented apprentices, including Otto Lindig and Theodor Bogler. The apprentices worked eight hours a day, continuously under Krehan's supervision, and for the first six months did nothing but throw pots, again and again. Only when they had a solid craft foundation were they allowed to experiment.

In general, the partnership between Krehan and Marcks was a successful one. Krehan provided the practical wisdom of an experienced potter and long familiarity with the strong, characterful, folk forms of the local pottery tradition, while Marcks brought artistic stimulation and a sculptor's sense of form.

As far as Marcks was concerned, it was a question of resurrecting the true forms of the local pottery tradition which Krehan represented. Form was considered much more important than decoration, and glazes were kept simple. As Marcks remarked in his reminiscences in 1978: "The form was the main thing. It had hardly changed for centuries, that is, it had become weaker and weaker, and Krehan was only a distant descendant, even though he had a fiery temper. He was a solid character, intelligent too. The form had to be rediscovered first." Marcks' sense of form was keen. According to one former Bauhaus student, Howard Dearstyne, he was "a kind of primitive with archaic leanings." His own ceramic work and the work done under his influence is strongly anthropomorphic and has such "personality" that affinities with Maya and Inca figures have been pointed out. Lothar Schreyer, briefly Form Master of the stage workshop, recalled the effect of Marcks' work on the rest of the school: "We Weimar people recognised, always with astonishment, how Marcks, in his plastic works, succeeded in shaping earthen vessels for the hidden postures of the human soul. Under the eyes of such a master, even the plates, pots, and pitchers of the pottery became, as it were, living beings to which we had, so to speak, a personal relationship."

The workshop produced a number of different kinds of ceramics. The first type is clearly related to Marcks's concerns. These are the hand-thrown pots, best exemplified by the large (indeed, often enormous) jugs, jars and pitchers of the early days. They are strongly rustic in feeling, with spouts, handles and rims used to create characterful protrusions, acting as limbs to the body. Where the forms are plainer, surfaces are often decorated with rural themes, such as plowmen and cattle. These vessels represent an attempt to return to the primitive and forceful forms of the vernacular and to reinterpret them.

Secondly, there are the simpler forms that were produced in quantity, that is, serially, in the workshop, often in several different

Dornburg was a rural community and conditions were primitive. Apprentices' duties included chopping wood for the kiln (2). Max Krehan, the Craft Master, is standing at the far right with his brother, Karl, second from the left.

The porcelain tea service (3) was designed by Marianne Brandt in about 1947.

2

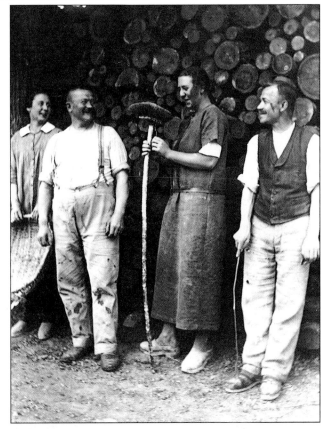

3

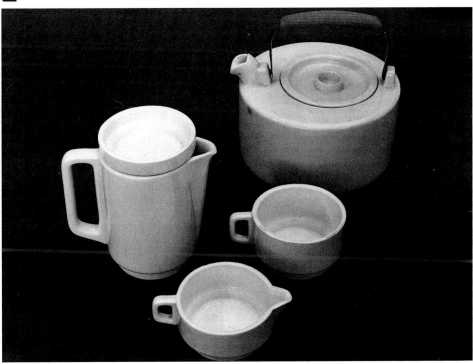

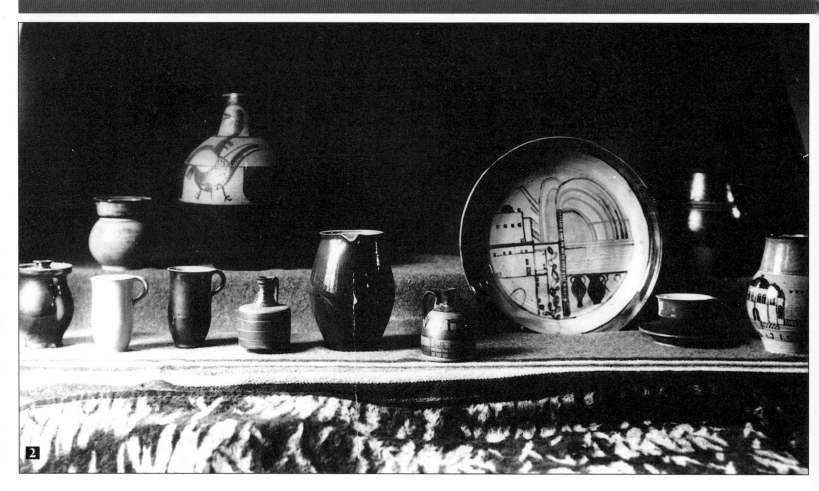

sizes. This type of work relates to experiments in the development of industrial prototypes, which Gropius was keen to encourage. It entailed a shift from earthenware clay to stoneware (which, being fired at a higher temperature, produces a surface that is impervious to water and does not necessarily need glazing), less emphasis on decorative effects and greater concentration on the simplification of form. Otto Lindig made the greatest contribution to this kind of work, the simplicity of his style being well suited to it. Bogler's kitchen storage jars were also successful results of this approach.

The third type of work, which also arose directly from a desire to achieve industrial production, was experimentation with an elemental or modular approach. In common with all the other workshops of the Weimar Bauhaus, the pottery workshop was attracted to the basic geometric forms, using them in particular to articulate and differentiate the separate parts of an object. The enthusiasm for the geometric was justified by the belief that it would be advantageous for mass-production if simplified elements could be developed. These could then be used in different combinations to produce a variety of articles using the same moulds. There seems to have been no conflict with the interest in vernacular, folk forms as they too were largely simple, strong forms.

The clearest example of this approach is Bogler's teapot of 1923, in which the various elements – bowl, spout, handle and lid – are treated as separate elements to be combined and recombined in a number of variations. There was even a version that used the hemispherical body of the vessel upside down, to form a flat-bottomed teapot. It was thought to be an added advantage of this approach that the objects it produced, being composed of the same family of forms, would automatically "go" together, without the need to resort to decoration to achieve harmony.

Ceramics were among the most popular products of the Bauhaus. Initially, fellow members of the Bauhaus placed orders, which were often for specific, "one-off" items. The Form Master Johannes Itten, for instance, ordered an elaborate (and expensive) coffee set. The student Else Mögelin placed an order for a ceramic bathroom set, which included soap case and toothbrush holder. There were, however, larger commissions: one of its largest orders was for the Bauhaus dining hall. By 1922 the workshop was supplying 500 mugs at one mark each for a hotel in Weimar and child-size beakers for the Montessori school in Jena. (This was one of the Weimar workshops' many links with local progressive schools.)

The output of the ceramic workshop in about 1923 (1) included such deliberately simplified forms as the two beakers on the left, which stand side by side with rustic flagons and decorated jugs and plates. The applied decoration is a mixture of the primitive and the sophisticated.

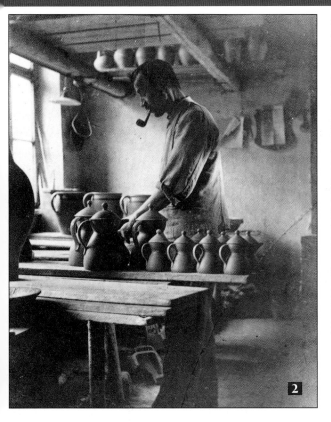

white porcelain coffee pots. These industrial successes demonstrated the feasibility of the Bauhaus ideal of bridging the gap between craft and industry.

However, on the dissolution of the Weimar Bauhaus in 1924, the pottery workshop did not move to Dessau with the rest of the school. For reasons that are not entirely clear, it was left behind to become part of the school that succeeded the Bauhaus in Weimar, Otto Bartning's Bauhochschule. Former students, such as Marguerite Wildenhain, went on to work successfully in the ceramics industry and in education, and they remained grateful for the thorough (and arduous) training they had received at the Bauhaus. Marcks took charge of the pottery workshop at the Burg Giebichenstein school, while Bogler went to work at Velten-Vordamm, the stoneware factory that had manufactured his storage jars. In 1927, however, he abandoned pottery to become a monk. Lindig remained as a teacher at the Dornburg workshop and eventually took over its direction. In a lifetime of teaching at Dornburg and elsewhere, he had enormous influence on his pupils and transmitted the Dornburg values of the beauty of form rather than of decoration.

Until the workshop made contact with appropriate manufacturers, it was obliged to mass produce its models serially within the workshop, and it became, in effect, a cottage industry. Here, Max Krehan is seen working at his wheel (2), producing quantities of large and small coffee jugs. Marguerite Friedländer (3) was already a pottery journeyman when she joined the workshop. She later recalled the students' frustration at having to throw literally hundreds of pots before they were allowed to fire the first one.

In December 1922 Gropius and the Bauhaus business manager, Emil Lange, suggested that workshop production be divided into two types: on the one hand, the so-called "commercial brand," and on the other, the superior "Bauhaus ceramics." The "commercial brand," which consisted of brightly coloured cups, bowls and pots, caused a certain amount of anxiety in the workshop, but it was imagined that these items would sell particularly well at the Bauhaus Exhibition and provide much-needed revenue for the school. In the event, the more elaborate Bauhaus ceramics were in greater demand. Their very success put the workshop under considerable pressure, for in the absence of industrial manufacturers, the workshop was forced to reproduce these models itself. Lange initiated a fierce production drive that produced a conflict in the workshop between its needs as a place of learning and as a place of manufacture. The relationship between the two Masters was also put under strain. Marcks was unhappy that the workshop was being turned into a factory and that Gropius had changed his attitude at this time. Like a number of other Masters, he found Gropius's more utilitarian conception of the value of craft particularly worrying.

Despite difficulties and divergences of view, the workshop did develop prototypes that found industrial manufacturers. In 1923 Bogler's kitchen storage jars were the first Bauhaus products to be produced industrially. They were followed by his complicated six-part porcelain mocha set and by Lindig's elegant designs for plain

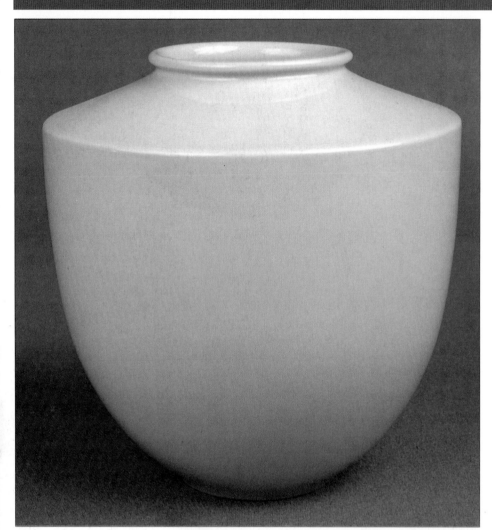

The fresh boldness of the blue and white glaze on Theodor Bogler's large, double-handled punch bowl (2) (c.1925), is reminiscent both of peasant pottery (particularly Mediterranean) and of the blues of Persian ware.

Normally loath to apply decoration, in this storage jar (3) (c.1931), Otto Lindig was, however, obliged to inscribe the word Zucker (sugar), albeit discreetly.

During their successful careers in Holland and the US, Marguerite and Frans Wildenhain, both former members of the Bauhaus ceramics workshop, continued to refine their simple but sophisticated vessel forms, of which Marguerite's celadon vase (c.1930)(1) is an excellent example.

Otto Lindig's refined style was well suited to manufacture by the ceramics industry. This tea set was made by Majolika-Manufactur, Karlsrube, c.1930.

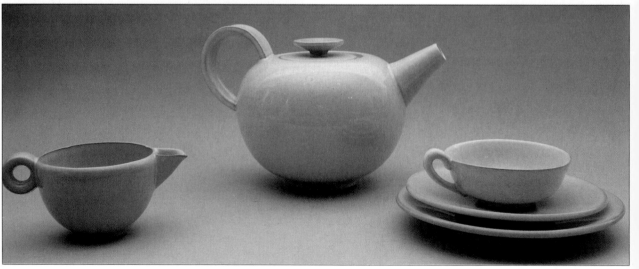

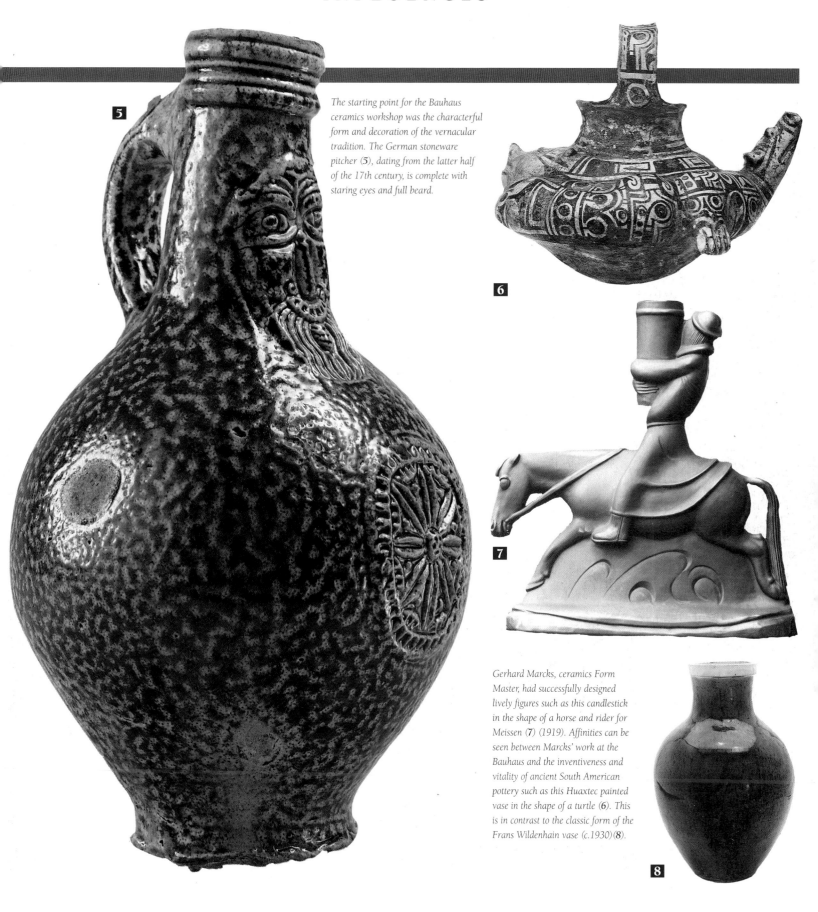

The starting point for the Bauhaus ceramics workshop was the characterful form and decoration of the vernacular tradition. The German stoneware pitcher (5), dating from the latter half of the 17th century, is complete with staring eyes and full beard.

Gerhard Marcks, ceramics Form Master, had successfully designed lively figures such as this candlestick in the shape of a horse and rider for Meissen (7) (1919). Affinities can be seen between Marcks' work at the Bauhaus and the inventiveness and vitality of ancient South American pottery such as this Huaxtec painted vase in the shape of a turtle (6). This is in contrast to the classic form of the Frans Wildenhain vase (c.1930)(8).

RUSTIC

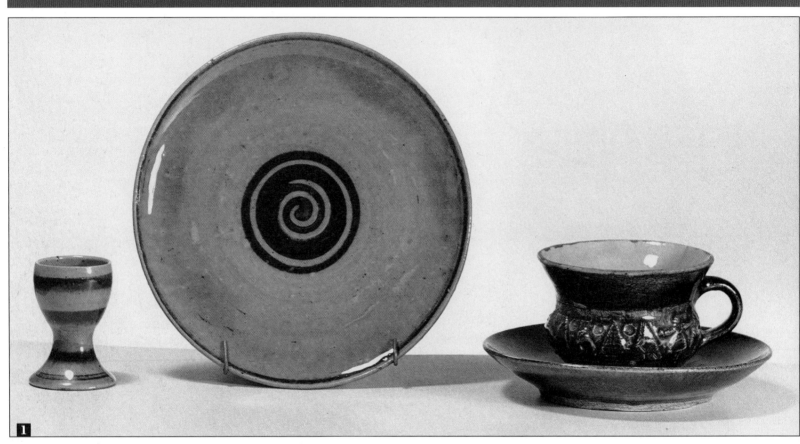

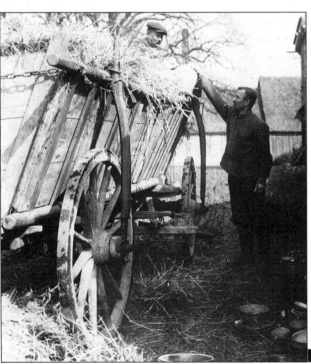

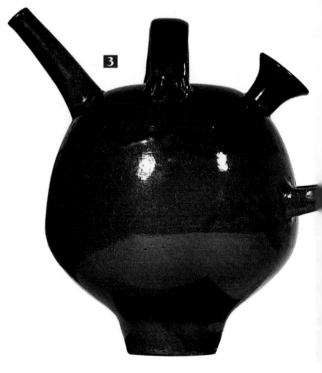

Vernacular pottery traditions were the single most important influence on Bauhaus ceramics. Johannes Driesch's honey-coloured plate and egg cup of 1922 (**1**) are simple in both form and decoration. The cup and saucer may well have been for a child. The dark brown cup is decorated with a relief showing characters from a nursery rhyme or fairy tale about a huntsman a forest. The Spanish "poron" (water or wine jug) inspired both Max Krehan's jug (**4**) and that of Johannes Driesch (**3**) (both c.1923). (**2**) shows Krehan and his brother loading pottery into a haycart.

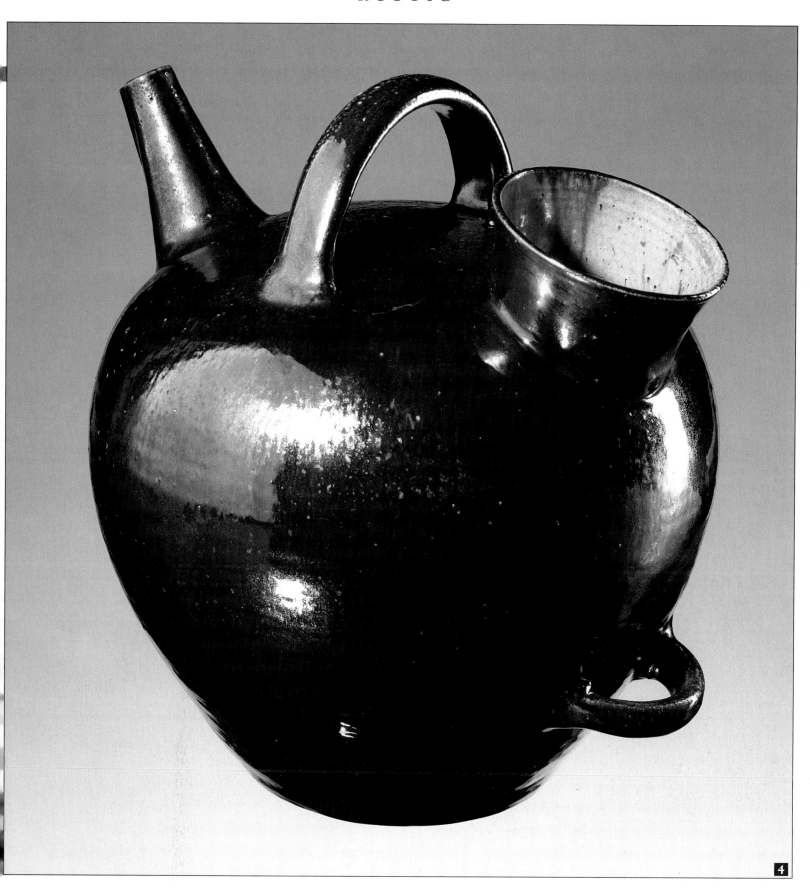

DECORATED

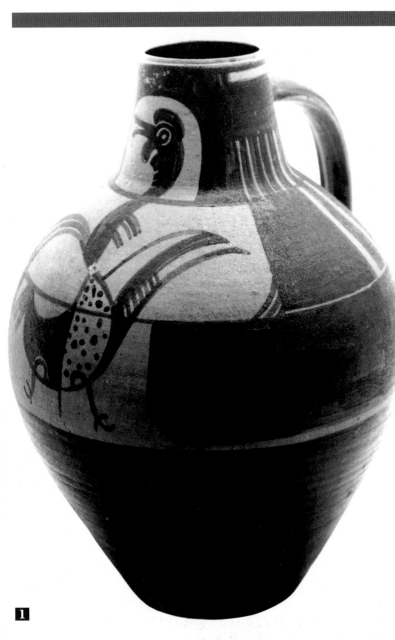

This decorated pitcher (1924) (**1**) was the result of collaboration between the ceramic workshop's Craft Master, Max Krehan, and the Form Master, Gerhard Marcks. Krehan provided the simple, strong form, and Marcks the decoration, which is an interesting blend of the primitive and the sophisticated.

In this bottle-shaped, salt-glazed pitcher (c.1922), (**2**), Krehan was responsible for the stoneware vessel and Marcks for the decoration. In this case, the effect of Marck's plowman and oxen and of the deliberately roughly executed decorative bands beneath is almost of a pastiche rusticity. The outlines of the decoration are incised and filled with dark blue glaze.

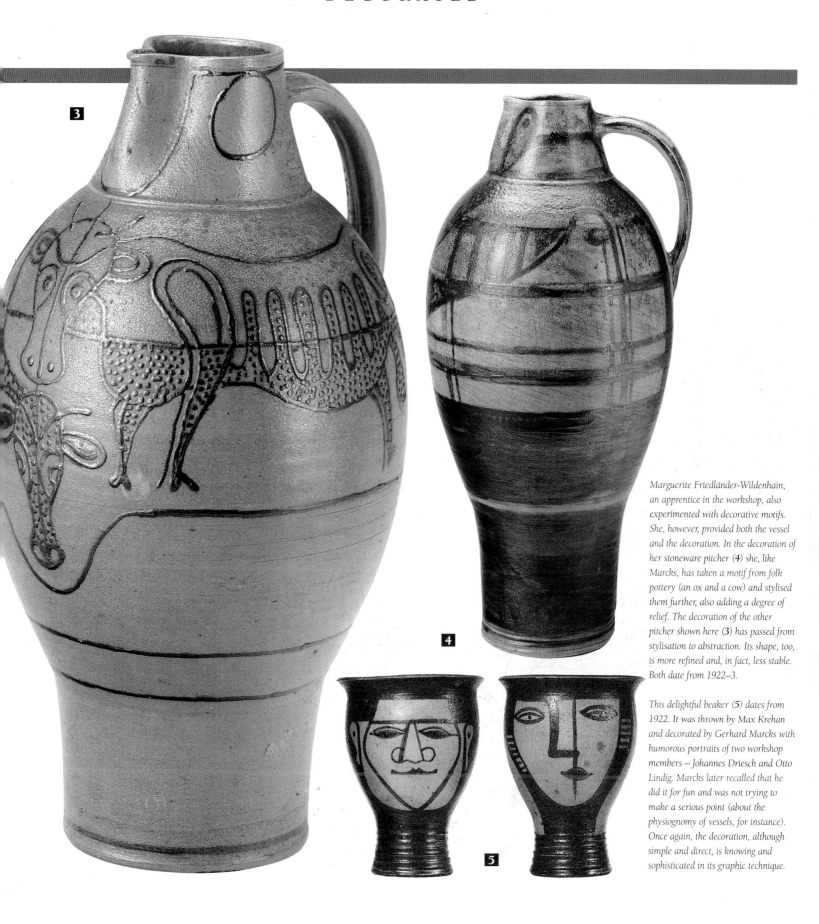

3

4

5

Marguerite Friedländer-Wildenhain, an apprentice in the workshop, also experimented with decorative motifs. She, however, provided both the vessel and the decoration. In the decoration of her stoneware pitcher (**4**) she, like Marcks, has taken a motif from folk pottery (an ox and a cow) and stylised them further, also adding a degree of relief. The decoration of the other pitcher shown here (**3**) has passed from stylisation to abstraction. Its shape, too, is more refined and, in fact, less stable. Both date from 1922–3.

This delightful beaker (**5**) dates from 1922. It was thrown by Max Krehan and decorated by Gerhard Marcks with humorous portraits of two workshop members – Johannes Driesch and Otto Lindig. Marcks later recalled that he did it for fun and was not trying to make a serious point (about the physiognomy of vessels, for instance). Once again, the decoration, although simple and direct, is knowing and sophisticated in its graphic technique.

SIMPLIFIED

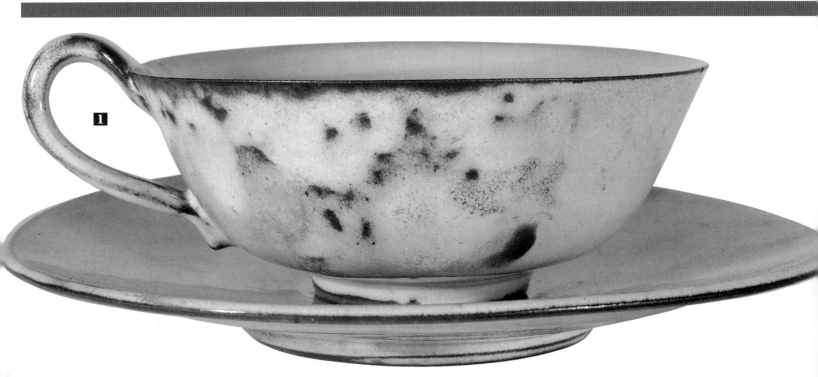

Otto Lindig led the workshop in the search for simplified vessel forms that would be suitable for serial production. Both his cup and saucer (1) (1923) and his vase (3) (1923) have discarded the characterful outlines of the rustic-inspired pots for simple, graceful outlines, and replaced decoration with the beauty of well-chosen glazes. Other workshop members were quick to appreciate Lindig's approach, as we see in Leo Grewenig's black-glazed vase (c.1924) (2). The tiny handles on this piece are just large enough to add interest to the form.

Models developed by Lindig, such as his cocoa pot (**6**) and his milk pitcher (**4**) (1922–3), were produced in quantity by other workshop members, and they were at available in a number of different sizes (**4**). Bauhaus ceramics were among its most popular products, and the workshop could barely meet demand after the publicity it received from the 1923 Exhibition. The vase (**5**), produced in the ceramics workshop under the influence of Lindig (c.1924), is an example of the use of light, semi-opaque glazes to produce a decorative mottled effect.

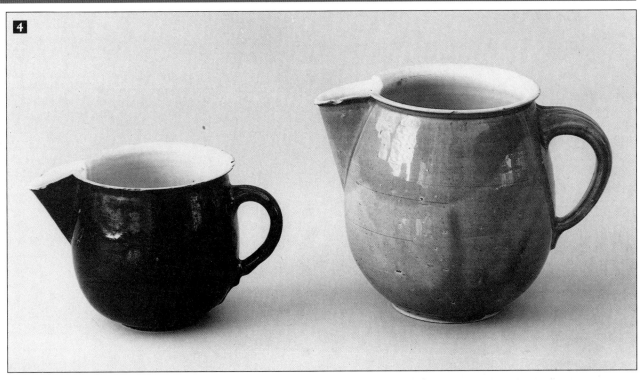

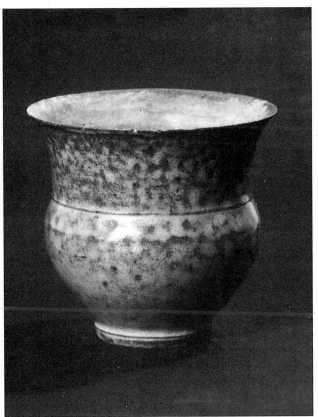

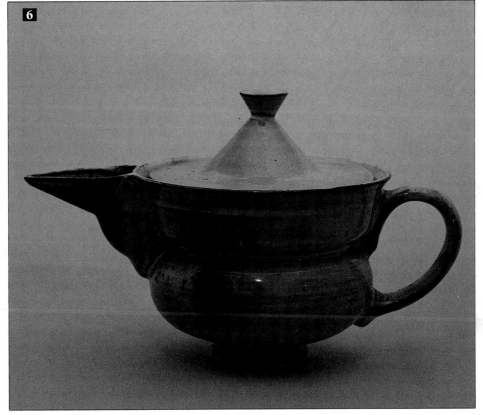

MODULAR

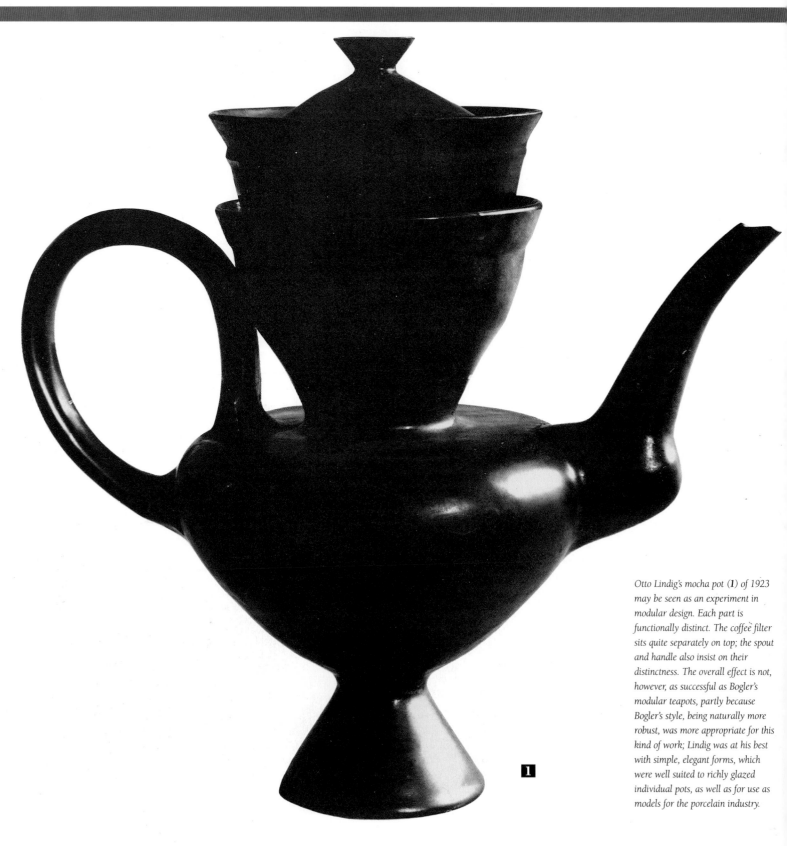

Otto Lindig's mocha pot (**1**) of 1923 may be seen as an experiment in modular design. Each part is functionally distinct. The coffee filter sits quite separately on top; the spout and handle also insist on their distinctness. The overall effect is not, however, as successful as Bogler's modular teapots, partly because Bogler's style, being naturally more robust, was more appropriate for this kind of work; Lindig was at his best with simple, elegant forms, which were well suited to richly glazed individual pots, as well as for use as models for the porcelain industry.

1

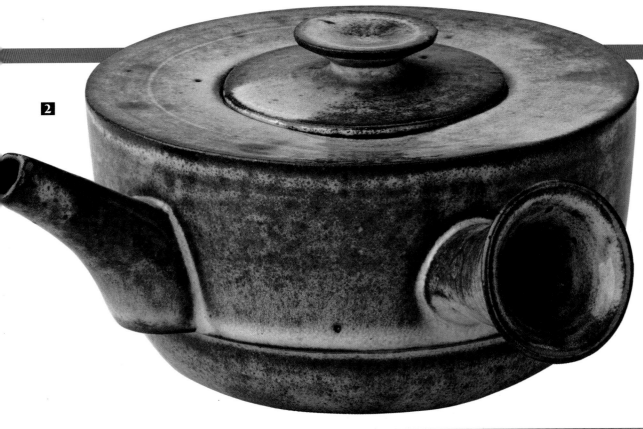

2

While teapot (3) swings freely from a metal handle, teapot (2) has a hollow, funnel-shaped ceramic handle placed at the side. Among the many other variations, there was a teapot that used the main body of the vessel upside down. This kind of work reached its apogee in 1923.

3

In common with many Bauhaus products, the individual elements of the teapots have a strong geometric character. This used both to articulate the functional separateness of individual parts of the object, and to make the objects designed in this way "go together" without having to resort to superficial decoration. Theodor Bogler's teapot (3) is composed of moulded elements, which could be used in a modular fashion to create a number of different variations. The individual elements (body, spout, lid, etc.) could be made in quantity, using the same moulds, thus approaching a kind of mass-production.

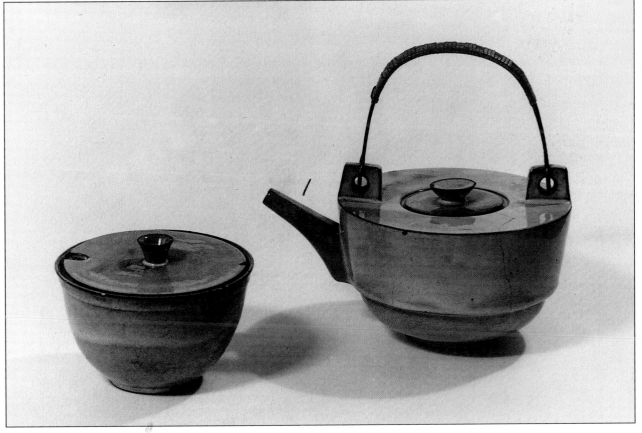

INDUSTRIAL

The ceramic workshop was the first Bahaus workshop to achieve industrial production of its models and to demonstrate the feasibility of its goal of bridging the gaps between art, craft and industry. The workshop's experimentation with simplified form paid off in 1923, when the Velten-Vordamm ceramics factory agreed to mass-produce Theodor Bogler's kitchen storage jars (1). They were widely illustrated, and their simple, but refined, design earned them the approval of Erna Meyer (see page 111).

Theodor Bogler's set of kitchen storage containers was completed by plain jars and tall bottles (2) for liquids such as oil and vinegar.

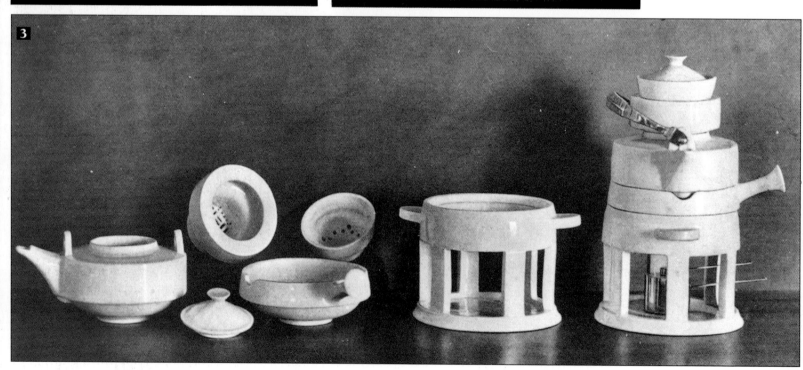

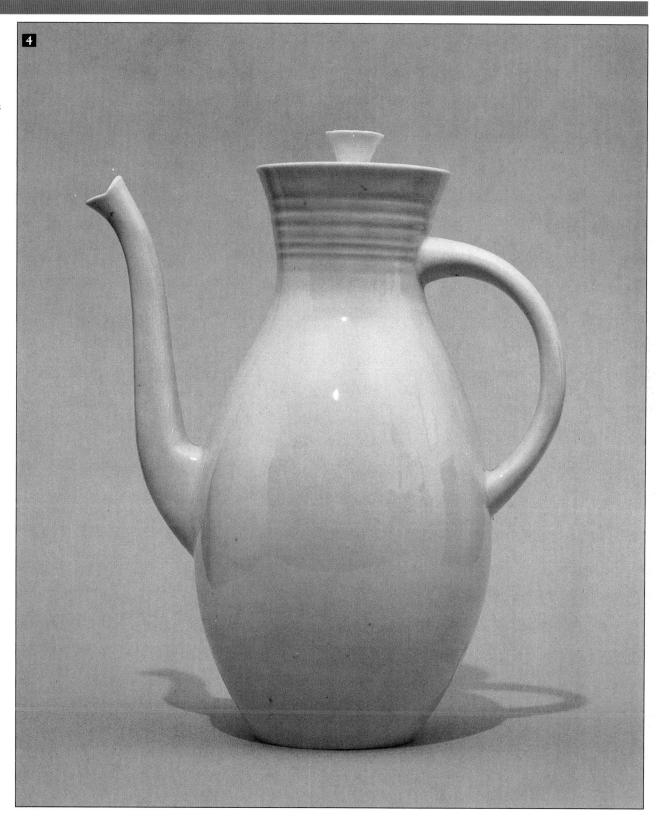

4

Otto Lindig's plaster model for a tall coffee pot (**4**), dating from 1923–4, was reproduced in significant quantities, not (as far as we know) by an outside ceramic factory, but by the workshop itself. After the success of its ceramics at the Bauhaus exhibition in 1923, the workshop was put under considerable pressure to become a factory so that it could keep up with the demand for such models.

The tour de force of Theodor Bogler's modular design approach was his six-part porcelain mocha machine (**3**), which was manufactured by the Staatliche Porzellanmanufaktur in 1923. There is provision for a small burner to keep the chocolate in the main pot warm while the coffee is filtered in through the top.

Cradle by Peter Keler, painted wood, 1922.

CHAPTER • THREE
FURNITURE

FURNITURE

Bauhaus furniture design was based on the premise that it was necessary to develop new and radically different forms for the pieces of furniture that were to be accepted as the basis of the modern home. It was therefore considered essential to reject all existing preconceptions about furniture design to create a tabula rasa. In particular, traditional furniture types – the heavy armchair, the mahogany armoire and so on – and the bourgeois love of ornamentation were rejected. According to the young Hungarian apprentice Marcel Breuer, who soon became a powerful influence on the workshop, there was no justification for ornament: the way to make various items of furniture "go" well together was to design each one so that it adequately fulfilled its function and was economic to produce – a "good" chair would automatically "go" with a "good" table.

The functionalist approach was enthusiastically embraced by the carpentry workshop, as was Gropius's belief that people's needs were largely identical. It was therefore the workshop's task to develop the forms that would provide for those needs in the most definitive and economic way. Given the shortage of housing space and the mid-1920s fashion for health and hygiene, the goal was to create lightweight, adaptable, multi-purpose furniture in clean, hard materials (soft upholstery was thought to harbour dust and mites).

Although furniture design was of central importance to the Bauhaus, the carpentry workshop was one of the last to open. Work did not start until the beginning of 1921, when the large sculpture studio in the former School of Applied Art was converted for its use. The Form Master was Gropius himself, who had some experience of furniture design from his Deutsche Werkbund days. However, as he was always busy elsewhere, he was supplemented by the ubiquitous Johannes Itten. The workshop was not well equipped, and there was a high turnover of Craft Masters (one of whom, Zachmann, was dismissed for intrigue against the Bauhaus). Raw materials were extremely scarce, and on at least one occasion, the Craft Master was reduced to raiding oaks from the park in Weimar.

The apprentices were given a solid grounding in the basic techniques of carpentry, although some of the staples of the conventional carpentry training of the time, such as the design and application of ornament and making working drawings in historical and modern styles, were not included. Students who had already been trained elsewhere often had difficulty in adjusting to the regime.

Despite the fact that the workshop's philosophy theoretically

The carpentry workshop at Weimar was housed in one of the light studios at the top of the workshop building (2), designed by the Belgian architect and designer Henri van de Velde between 1904 and 1911.
Walter Gropius designed this walnut shelving unit(1) in 1923, for the display and storage of newspapers and magazines. Two such units were placed in his office. Its form is unconventional and asymmetrical, but very disciplined.

1

2

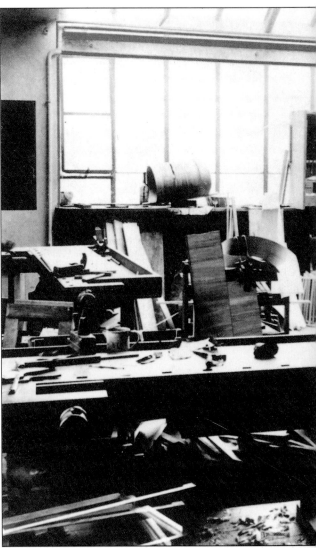

entailed the rejection of all "styles," it is, of course, possible to trace the development of a Bauhaus style at Weimar. At first, the desire to find new forms produced idiosyncratic results. As with ceramics, inspiration was initially derived from primitive forms. Breuer's African chair is the best known of these experiments; it could just as easily be a throne for an ancient Magyar warrior as for a Zulu chief. Just four years later, Breuer was welding lengths of tubular steel.

Next came a period of constructivist enthusiasm, largely inspired by the De Stijl movement. The hallmarks of the De Stijl manner, as interpreted by the carpentry workshop, were asymmetry, a clear distinction between the separate parts of an object and architectural quality, often expressed in the orthogonal meeting of planes and in cantilevered forms. There was no architecture workshop at Weimar, but architecture was

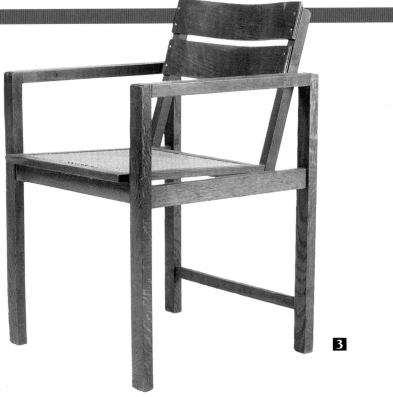

3

everywhere. Theo van Doesburg (1883–1931), De Stijl's chief proselytiser, was in Weimar in 1921–2, cheerfully seeking to undermine Gropius's authority and setting up alternative seminars to lure the students away to his vision of the role of the artist in the modern world. The work of the De Stijl group was illustrated and discussed in the periodical of that name, and the Bauhaus carpentry workshop was thus given access to a powerful influence: the furniture of Gerrit Rietveld (b.1888).

The results of the De Stijl influence were initially somewhat mannered, but by 1923–4, a more mature aesthetic had evolved. Asymmetry for its own sake had been succeeded by the search for balanced, symmetrical compositions, and the distinction between the separate elements had become subtler. The tectonic quality was still pronounced, but less aggressive. Erich Dieckmann's work contains many good examples of this stage of the workshop's development.

In terms of production, the workshop at first concentrated on making individual pieces of furniture. The pattern changed dramatically in the spring of 1923, when the whole workshop was put to work on the furniture for the Haus am Horn, the model house designed and built for display at the Bauhaus Exhibition. The workshop was asked to design sets of furniture:

Erich Dieckmann's armchair in cherrywood and cane (3) (1925) was also available as an occasional chair. Its structure achieves the lightness and clarity that other workshop members were also seeking. Dieckmann's work continued to be well thought of in progressive design circles, and it was featured in guidebooks to the new way of living written by Wilhelm Lotz and Werner Gräff.

FURNITURE

Dieckmann, for instance, worked on the dining room, Breuer on the lady's bedroom and Wigand on the nursery.

The next step was a real advance: the development of "combination furniture," or what we would now call unit furniture. The aim was to create efficient, multi-purpose, space-saving furniture. Josef Albers (who later became an important teacher on the preliminary course) was particularly successful in this area. He combined, for example, one of the characteristic Weimar products, the glass-fronted display case, with cupboards and open shelves. Nowadays, we have no difficulty in recognising such composite furniture as living-room units, but at the time the idea was quite novel. The unit approach also extended into the Haus am Horn's kitchen, which can claim to be the first built-in kitchen.

Although the Weimar carpentry workshop failed to make contact with industry, it fulfilled a number of external commissions and was busy from an early date. It collaborated in a number of interior design commissions, largely for private houses, and took part in external competitions, including a slightly macabre contest to design coffins for the Carpentry Masters' Union. By 1923 it was doing a large volume of serial production work. Breuer's talents as a designer soon came to the fore, and it was not long before apprentices were put to work producing Breuer chairs. Demand was strong for the children's furniture designed by Breuer and Alma Buscher; it was hard to keep up with in the case of the Bauhaus toys, which included Buscher's Ship sets and Ludwig Hirschfeld-Mack's optical colour mixers. With their cheerful colours and educational content, they were much sought after in the contemporary climate of educational reform. However, as in the pottery workshop, the drive for production was not always compatible with the workshop's educational role.

On the dissolution of the Weimar Bauhaus in 1924, Erich Dieckmann remained as a teacher at Bartning's Bauhochschule. Marcel Breuer became leader of the new workshop in Dessau, with the technical support of the Master Carpenter, Heinrich Bokenheide. Furniture design immediately took a dramatic turn as Breuer became captivated by the properties of a new material: tubular steel. Legend has it that he was cycling around Dessau when he was struck by the strength and lightness of his bicycle frame and realised the potential of this industrial material for the creation of lightweight, elegant, industrially-produced furniture. True or not, in 1925 he created one of the exemplary Bauhaus products: the Wassily chair, named after one of its admirers, Wassily Kandinsky. This led to experiments in one of the key furniture forms of the late 1920s, the cantilevered chair. The cantilevered chair is now so familiar that it is hard to imagine the initial shock of a chair without back legs, formed from an apparently continuous loop of gleaming chrome-plated steel. As with Bauhaus lighting design, an industrial material was placed in a household context. Tubular steel was widely used in the furnishings for the new school building, which was the major task of the workshop under Breuer's direction.

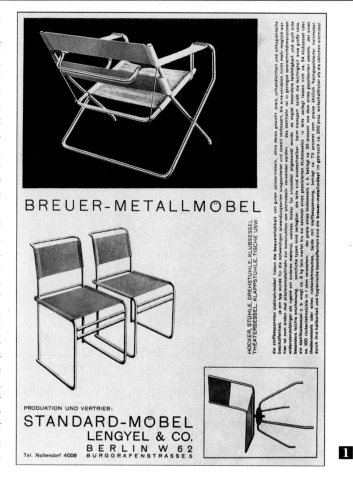

Following his private negotiations, Marcel Breuer's tubular steel furniture was manufactured and marketed by Standard-Möbel. The Standard-Möbel catalogue (1) (c.1927) vaunts the advantages of Breuer's furniture: it has all the comfort of traditional upholstered furniture, without its high price, weight, unwieldiness and "unsanitary quality." The chair at the top (the B4) is the folding version of the Wassily chair; the two occasional chairs are B5s, which were one of the company's best-selling models.

Breuer's tubular steel furniture was one of the great industrial successes of the Bauhaus, being manufactured by Standard-Möbel, which was bought up by Thonet in 1929. However, it occupies an anomalous position in Bauhaus production, as Breuer insisted that his designs for tubular steel furniture were his own private work. He negotiated separate patents to protect them, which greatly angered Gropius. Breuer left the Bauhaus on the arrival of Hannes Meyer, whose approach he found strongly antipathetic. This was not surprising, as Meyer was a collectivist, who played down the role of the individual to the extent of identifying Bauhaus products with catalogue numbers rather than with the names of the designers.

Breuer was replaced first by Josef Albers (1888–1976), and then by Alfred Arndt. As part of Meyer's reorganisation of the school, furniture design was assigned to the amalgamated interiors workshop, which made more sense, now that metal and glass as well as wood were being used in furniture design. Meyer took a keen interest in the interiors workshop. Like Gropius, he encouraged the development of standard forms, but he wanted the workshop to be clear about who these standard forms were

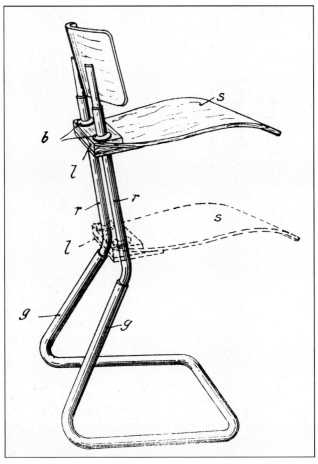

In 1931 the Bauhaus was granted a patent on its work-chair with adjustable seat (2), which was designed in 1930. The patentable feature was the direct joining of the seat to the tubular steel frame in such a way that it locked securely in position when weight was applied (ie when it was sat upon).

2

3

for. A new theme was introduced – Volksbedarf statt Luxusbedarf, which meant turning to the needs of the mass market ("the people") and abandoning those whom Meyer called wealthy middle-class culture snobs, whom he considered to have been the Bauhaus workshops' chief customers to date.

Under Arndt's direction, the emphasis was on providing lightweight, low-cost, adaptable furniture for workers' housing in which space was at a premium. This entailed making detailed studies of, for instance, the number of shirts and socks the average worker needed to have room for in his closet. It also meant taking a renewed interest in wood. However, instead of using the more precious, intrinsically attractive woods used at Weimar, experiments were made with plywood, which was low cost and, being a laminate, pliable. Many seating designs used metal in conjunction with wood to provide flexibility and "give." A special leg construction was developed to achieve greater lightness in wooden furniture. This leg construction was widely used in the furniture shown in the Bauhaus People's Dwelling, which was displayed in Leipzig in 1929. Interest in unit furniture did not flag; in 1931, cupboard and desk units were entered for

a Deutsche Werkbund competition for standard household furniture. A fold-down record player cabinet was also entered.

Under Arndt, the workshop created some interesting prototypes, particularly for adjustable and folding work-chairs using tubular steel frames and plywood surfaces, but ironically it was Breuer's "élitist" tubular steel furniture that was ultimately more successful in reaching a mass market. His cantilevered occasional chair with wicker seat of 1928 is now widely available (it has been greatly plagiarised); the Wassily chair can now be found in waiting rooms all over the Western world. It is extraordinary to think that to own either chair now, 60 years later, is still to make a statement of one's commitment to modernity.

Placing less emphasis on compactness than Breuer, Mies van der Robe designed some very elegant, curvaceous tubular steel chairs. When his cantilevered MR535 side-chair (3) was first shown at the Weissenhofsiedlung Exhibition in 1927 it caused great excitement. It has subsequently been manufactured by Joseph Müller, Bamberg Metallwerkstatten, Thonet and Knoll International. Two MR535s are seen here with a table Mies also designed in 1927.

INFLUENCES

In the 1920s many designers turned to the primitive and the exotic in their search for the new: The bronze chair (1) by Armand-Albert Rateau (1882–1936) is a typically exotic concoction.

A key idea at the turn of the century was that of the "Total Work of Art", the integration of architecture, interior design and art. The Scottish architect and designer Charles Rennie. Mackintosh (1868–1928) designed a highly influential House for an Art Lover in 1901. The music room (2) incorporates panels designed by Margaret Macdonald.

The light, elegant, bentwood furniture of the Thonet Brothers in Vienna in the 19th century (3) has long been recognised as the precursor of the classic tubular steel chairs of the 20th century.

Gerritt Rietveld's Red-Blue chair (4) was the single most influential chair for the Bauhaus. Rietveld was a cabinet-maker, who was adopted by the De Stijl group. Apparently an intuitive constructivist, he designed the chair in 1917–18, and it was published, uncoloured, in the De Stijl periodical in 1919. It was not published in its coloured form until 1923, but for Marcel Breuer, it was the form that was paramount: its transparency, its radical statement of function (sitting surface, backrest, armrest and so on) and the starkly severed ends of each structural member.

The constructivist influence was very strong at the Bauhaus. The combined drawing, writing and dining table (5) was designed by the Russian constructivist Alexander Rodchenko in 1924. It clearly relates to the Bauhaus's attempts to design adaptable, multi-purpose, "combination" furniture. Rodchenko taught at a school in Moscow, the Vkhutemas, founded in 1920, which had many affinities with the Bauhaus.

In terms of the founding ideas of the Bauhaus, the British Arts and Crafts movement, represented here by an armchair by William Morris (6), was of fundamental importance. In particular, the Bauhaus inherited Morris's convictions about the moral value of craft and the importance of honesty of materials and structure. (It also inherited some of the confusions of Morris's ideas.) This chair, produced from 1865 onward, is upholstered in one of Morris's ever-popular textile designs based on stylised natural forms, a woollen tapestry called "Bird", which was designed in 1878. The chair, which is based on a Sussex carpenter's design, has an adjustable back.

EARLY CHAIRS

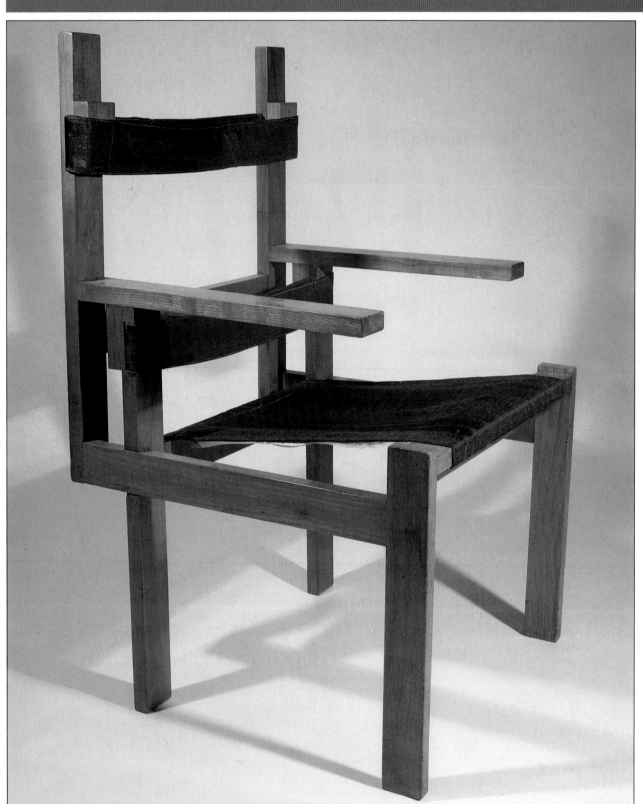

Breuer's Lattenstuhl (slat chair) (**1**) (1922). Shown here in pearwood, but often made in cherry, it was undoubtedly influenced by the work of the De Stijl furniture designer Gerrit Rietveld. It is one of a series of experiments inspired, in particular, by Rietveld's Red-Blue (see page 65) and Highback chairs. The Lattenstuhl created considerable interest at the Bauhaus exhibition in 1923, but Breuer could claim a functional justification for every feature.

In his attempt to return to first principles, Breuer turned to the primitive, producing a tribal throne called the African chair (**2**) in 1921.

Despite the success of Marcel Breuer's tubular steel chairs, experiments continued in the use of wood. Peer Bücking used it for his lightweight, collapsible armchair (a,b) in 1928, as well as for his upholstered sidechair, "ti 200b" (c) (1928), which has a curved plywood backrest. Martin Decker used plywood to create a more comfortable wooden seat in his chair, "ti 201", also of 1928 (d).

Erich Dieckmann's work was less dogmatic than that of Breuer at this stage. His cherrywood chair with a cane seat (3) (1925) is much simpler and more elegant in conception. He, too, was keen to distinguish the different functional elements, but his chair is visually a very light structure, somewhat akin to Breuer's later achievements in tubular steel.

Marcel Breuer designed this aggressively bulky armchair (4) in cherrywood and black leather in 1921 for the hall of the Sommerfeld house (see page 105). In this case, the idea seems to have been radically to refashion a traditional furniture form, the club armchair, by carving it up and rearranging the pieces. Breuer also designed a massive, five-legged table for the Sommerfeld house, with each leg projecting above the table-top in a similar castellated manner.

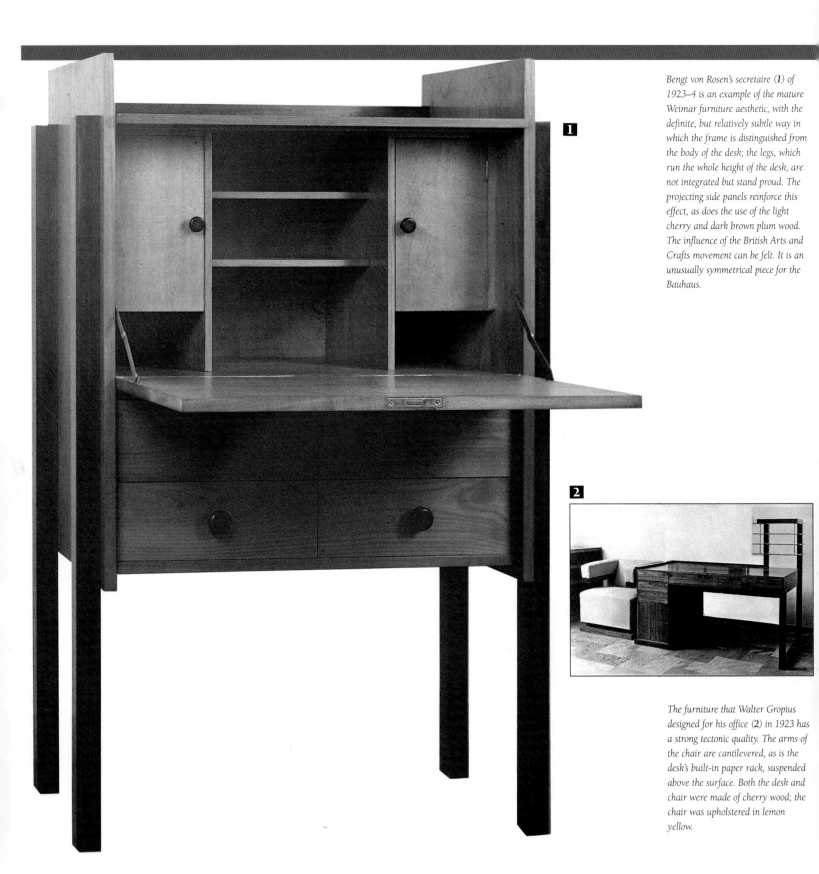

1

Bengt von Rosen's secretaire (**1**) of 1923–4 is an example of the mature Weimar furniture aesthetic, with the definite, but relatively subtle way in which the frame is distinguished from the body of the desk; the legs, which run the whole height of the desk, are not integrated but stand proud. The projecting side panels reinforce this effect, as does the use of the light cherry and dark brown plum wood. The influence of the British Arts and Crafts movement can be felt. It is an unusually symmetrical piece for the Bauhaus.

2

The furniture that Walter Gropius designed for his office (**2**) in 1923 has a strong tectonic quality. The arms of the chair are cantilevered, as is the desk's built-in paper rack, suspended above the surface. Both the desk and chair were made of cherry wood; the chair was upholstered in lemon yellow.

3 **4**

Erich Brendel's tea table (**3,4**) (1924) is made of walnut veneer, with strips of gray linoleum at the base. It is a marvellous mixture of function and pure constructivist form. Closed (**4**) it is a cube; opened, the surface forms a cross, providing more space for setting out tea things, and revealing two surfaces for storage within. It thus manages to fulfil another criterion of Bauhaus furniture design; it is space-saving and flexible.

This unusual set of bedroom furniture (**5**) was designed by Marcel Breuer in 1926 for Kandinsky's house in Dessau. Kandinsky also commissioned Breuer to design a set of dining room furniture "with as many circular elements as possible"; this bedroom set continues the circular theme. The circular legs and surfaces of the tables are offset by straight elements, which are painted black to make them distinct. Plywood has been used in the head and footboard of the bed to achieve rounded forms. Breuer returned to these curved forms when he worked with plywood for the English furniture firm, Isokon, in the late 1930s.

5

UNITS

1

2

The development of unit or "combination" furniture provided opportunities for "furniture as architecture", producing strongly architectonic compositions. Josef Albers' storage unit (**1**) combines a cupboard with a glass-fronted display case. Note the absence of a solid corner piece (allowing an undisturbed view of the objects) and the irregular shelving arrangement. Lilly Reich's wardrobe storage unit (**2**), which date from her period as head of the interior design department (1930–33), are impressive, symmetrical pieces, their plainness offset by the beauty of the walnut. The use of this relatively precious wood harks back to the Weimar period. Reich's closets would be equally at home with the Wiener Werkstätte or the Deutsche Werkbund, with which she was previously associated.

3

Breuer's display/storage cabinet (**3**), designed for the living room of the Haus am Horn in 1923 (see page 107), is a monumental constructivist composition.

By the late Weimar period, the workshop had developed truly modular, interchangeable units, such as these dining room cabinets (**4**), illustrated in a 1924 catalogue designed by Herbert Bayer.

4

66a | 66b | 66c

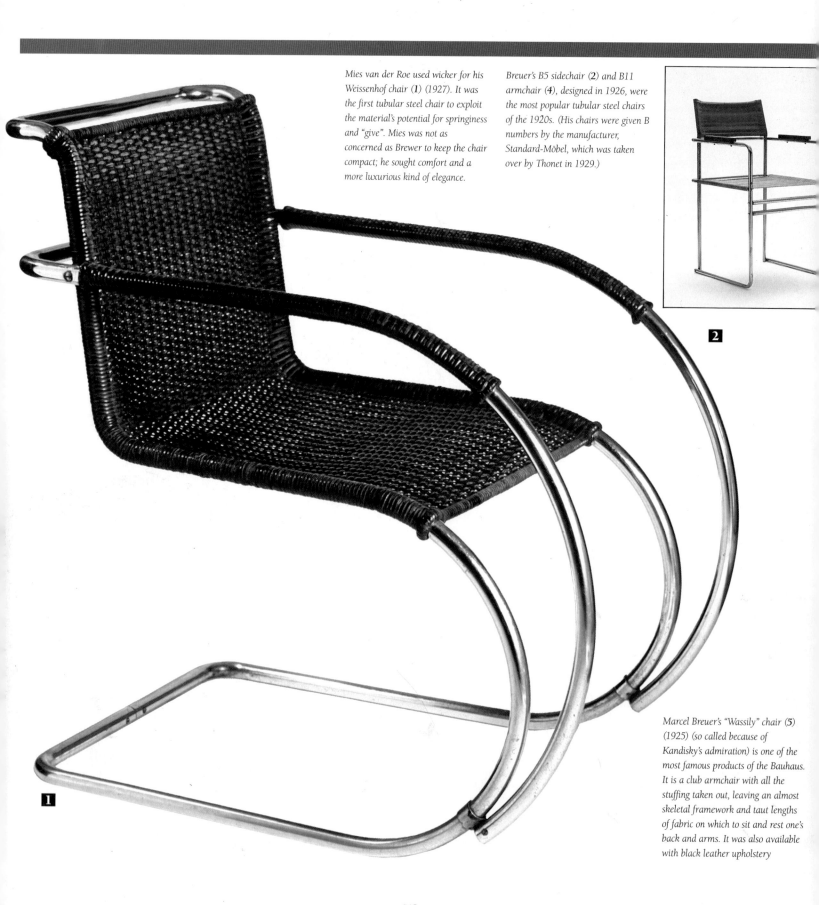

Mies van der Roe used wicker for his Weissenhof chair (**1**) (1927). It was the first tubular steel chair to exploit the material's potential for springiness and "give". Mies was not as concerned as Brewer to keep the chair compact; he sought comfort and a more luxurious kind of elegance.

Breuer's B5 sidechair (**2**) and B11 armchair (**4**), designed in 1926, were the most popular tubular steel chairs of the 1920s. (His chairs were given B numbers by the manufacturer, Standard-Möbel, which was taken over by Thonet in 1929.)

2

1

Marcel Breuer's "Wassily" chair (**5**) (1925) (so called because of Kandisky's admiration) is one of the most famous products of the Bauhaus. It is a club armchair with all the stuffing taken out, leaving an almost skeletal framework and taut lengths of fabric on which to sit and rest one's back and arms. It was also available with black leather upholstery

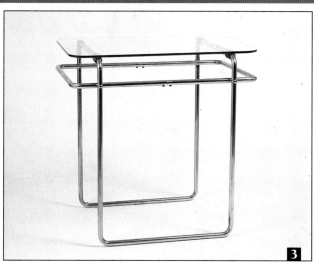

3

Breuer designed a number of tubular steel and glass tables, such as the B19 (**3**), for which he adapted rubber connectors used in plumbing as a means of joining steel and glass without using bolts or screws.

4

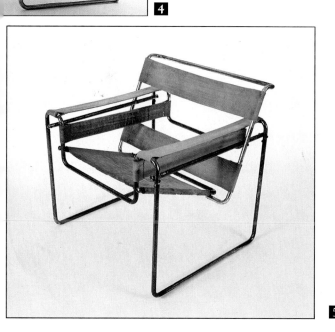

5

Breuer's B33 occasional chair (**6**) of 1927–8 is another well-known Bauhaus product. Breuer was not the inventor of the cantilevered tubular steel chair (the credit must be taken by the Dutch designer, Mart Stam); he is, however, responsible for developing and refining the possibilities. The B33 is widely, and cheaply, available today in various plagiarised versions, most of which retain the spare elegance of the original. Breuer's tubular steel chairs were generally upholstered in a tough material developed by the Bauhaus textile workshop. It was a modification of "Eisengarn," which was normally used for military belts and straps. The B33 was also available with a cane seat.

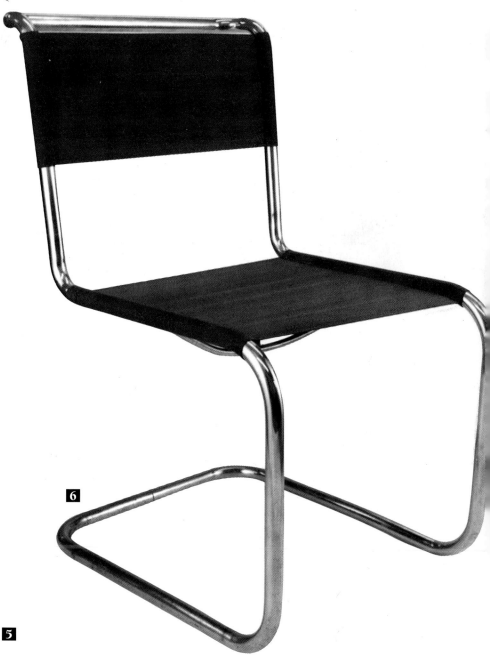

6

When Hannes Meyer became director in 1928, and Breuer was succeeded as leader of the furniture workshop first by Josef Albers and then by Alfred Arndt, the workshop's priorities were realigned. The aim was now to create low-cost, multi-purpose, standard furniture. A number of ingenious folding or adjustable work-chairs were designed, often using tubular steel and plywood in conjunction. Alfred Arndt's chair (1) (1929–30), which is sometimes attributed to Breuer, folds completely flat so that it can be stored against the wall.

Meyer and Arndt reasoned that, as times were hard, workers had to be mobile; furniture therefore needed to be light and adaptable. The workshop's lightweight wooden furniture was exhibited in a Volkswohnung (people's apartment) in 1929 (2). Note the folding bed and the table's special leg construction (called the Hannes Meyer leg), which used vertical braces to increase strength without sacrificing lightness.

In 1930 the workshop collectively developed a work-chair with a movable seat (3 and 4), which automatically locked in place when weight was applied. The construction was patented in 1931 (see page 63).

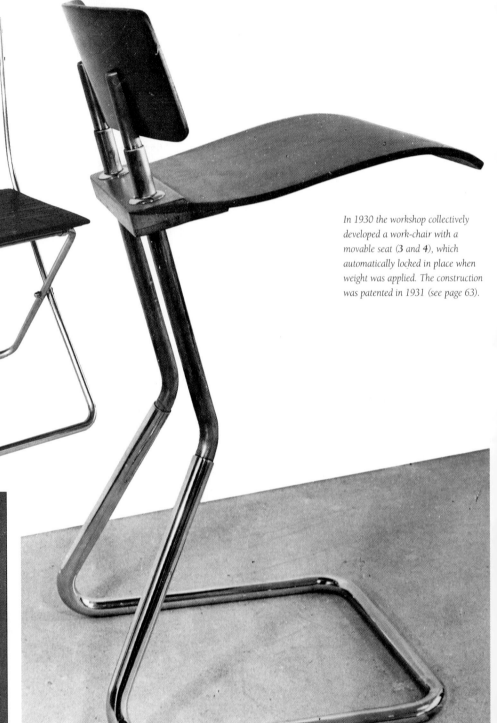

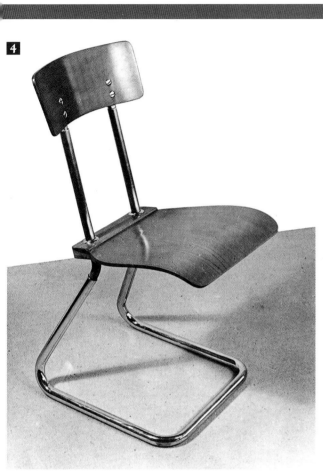

The Bauhaus exhibited six lightweight wooden chairs at the exhibition The Chair in Stuttgart in 1928, of which two are shown here (*5* and *7*).

Individual furniture designs are rarely attributable under Meyer's directorship as he stressed collectivity; however Martin Decker probably designed (*5*) and Peer Bucking (*7*). Decker has created what looks like a more comfortable seat by using plywood's capacity to be formed both in the backrest and seat.

A compact closet (*6*) was designed for the Minimal Dwelling. Note the hanging space slotted in at 90 degrees behind the shelving, the special shoe compartment and the castors for mobility. The students were asked to research – not guess – the number of pairs of shoes, socks and so on, that people of a certain income actually possessed.

1

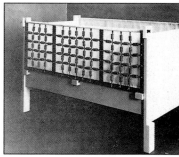

3

Alma Buscher designed a number of pieces of nursery furniture, which were well received by the public. She tried to incorporate the latest ideas in child development, choosing, for instance, bright primary colours, which were thought to encourage the child's sensory development. Buscher's crib (**3**) (1924) has elastic sides made of a web of corks. Her rather complex nursery dresser/changing table (**4**) (1924), which is made of lacquered wood, was designed to accommodate a variety of activities and storage areas and to separate clean from dirty linen. Note the simple, round knobs, which were also used by Marcel Breuer in his kitchen units.

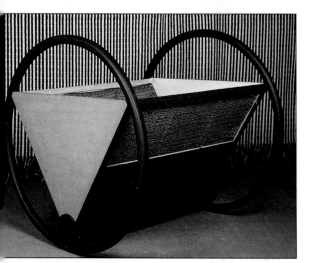

2

These two cribs, both dating from about 1922, are very different in inspiration but, in their own ways, are equally fanciful. Johannes Itten's (**1**) is a mixture of folk-inspired and mystical motifs; Peter Keler's (**2** and **6**) is one of the many tributes to Kandisky's ideas on the correspondence of primary colours and forms, although it does perhaps sacrifice stability to artistic theory. Together they represent the complexities of the transitional period at Weimar.

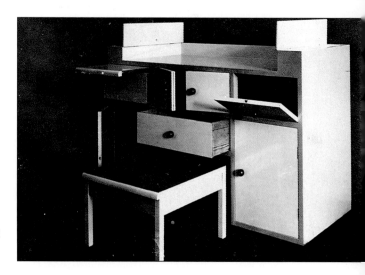

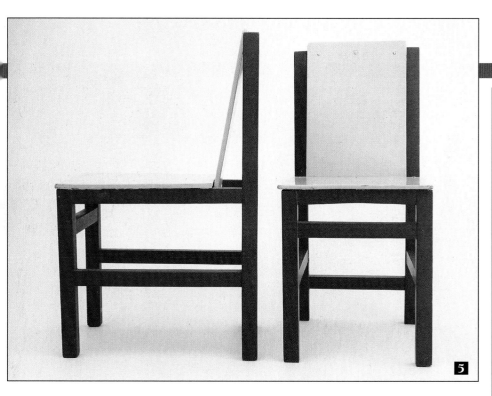

Breuer also designed some very popular children's chairs (**5**) (1923), again using bright colours. These came in a variety of sizes, including one for adults; they were light, as the seat and back were made of plywood. A simple square nursery table with a leg at each corner was also available. These items were made serially in the carpentry workshop.

The carpentry workshop received several commissions to furnish kindergartens and children's homes, and the nursery in the Haus am Horn (see page 107) was well received by the professionals.

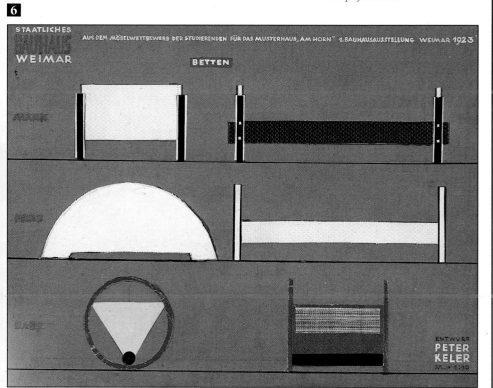

MARCEL BREUER

One of the most important furniture designers associated with the Bauhaus, Marcel Breuer (1902–81) was born in southern Hungary. In 1920 he took up a scholarship at the Art Academy in Vienna but left almost immediately to enrol at the Weimar Bauhaus. He soon emerged as an outstanding student in the carpentry workshop, which he led in its endeavours to find radically new forms for furniture befitting the modern age.

For a short time in 1924 he worked as an architect in Paris, rejoining the Bauhaus in Dessau as leader of the carpentry workshop in 1925. He started his now-legendary experiments with tubular steel, which began with the Wassily chair and culminated in the cantilevered side chair, with which he is closely identified, even though the concept was first developed by the Dutchman Mart Stam.

From 1928 to 1931 Breuer worked for Gropius's office in Berlin. Using his own range of modular furniture (cabinets, desktops, shelving), he designed some outstandingly sophisticated interiors, but he also became increasingly involved in architectural projects. These were initially informed by an enthusiastic "Amerikanismus" – his multi-level traffic scheme for the Potsdamer Platz of 1928, for instance, was based on the flow diagrams of an American assembly line – but he later turned to constructivism, for example, the Kharkov Theatre project. Finally, he arrived at a Corbusian purism, exemplified in the Harnismacher house, Wiesbaden.

After travelling in the Mediterranean and north Africa in 1932–5, Breuer joined Gropius in Britain, sharing a practice with the architect and writer F.R.S. Yorke. Breuer and Yorke summarised their favourite projects in the ambitious Civic Centre of the Future, which they designed for the British Cement Industries in 1936. Breuer also met Jack Pritchard, for whose company, Isokon, he designed the elegant Long chair.

In 1937 Breuer joined Gropius as a professor at Harvard, where he helped educate a new generation of Modernists. In their domestic architecture he and Gropius (who were partners in 1937–41) were influenced by the New England vernacular architecture. In 1946 Breuer formed his own partnership in New York. Although he experimented with wooden prefabricated housing, his main work was on ambitious projects for substantial industrial concerns and institutions in North and South America. In Europe his best known building is the Y-shaped Unesco Headquarters in Paris (1953–8).

Like a number of Modernists, after the war his work lost its sense of direction. His private houses, and in particular his interiors, are generally more successful than his grander projects.

Josef Hartwig's chess set (**1**) (1924) exemplifies the Bauhaus desire to rationalise and simplify. The shape of each piece is determined by its move: the pawn, for example, which moves parallel to the edges of the board, is a simple cube; the bishop, which moves diagonally, is a cross, and the mobile queen is a sphere. The chess set was very popular, and every set was carved by hand in the carpentry workshop. This example has pearwood pieces, in natural and black finishes.

Alma Buscher designed children's toys in brightly coloured lacquered wood (**2** and **3**). The little and large ship sets (**3**) were particularly well received both in Germany and elsewhere. The packaging proposed that the blocks he used to create not only a ship but a landscape, a gateway and a prehistoric animal.

Lyonel Feininger carved these characterful toys (**4**) out of beechwood and painted them for the children of friends in the mid-1920s.

2

3

4

Tapestry in wool by Hedwig Jungnick, c.1921.

CHAPTER • FOUR
TEXTILES

TEXTILES

Even those who admire the austerity of the Bauhaus design approach may occasionally find themselves longing for contrast and relief. The vivid abstract patterns, rich colours and textures of Bauhaus textiles, particularly those produced in the early years, provide exactly this counterpoint. Hung on a white wall, washed with the natural light that is one of the hallmarks of a Bauhaus interior, they blaze with colour and movement, and with formal complexities that found little outlet in other workshops.

A number of factors combined to give Bauhaus textiles their special character. One of the most important influences was the textile workshop's origins in the preliminary course. When the Bauhaus opened, the majority of students were women, and there was much debate as to their proper occupation. It was widely felt that the "heavy" crafts such as metalwork, carpentry and wall-painting were unsuitable, and that the women would be better off in their own department learning weaving, sewing and dyeing, the crafts with which they were traditionally associated. The arrangements for the preliminary course were still fluid at this time; until 1921, both Johannes Itten and Georg Muche taught sections of it, and male and female students were separated. The female branch of Itten's course, which became known as the Frauenabteilung (Women's Department), trained the students in observation, in sensitivity to materials and in thinking in terms of pairs of contrasting qualities. All of this had a great effect on their subsequent work.

The second factor was the desperate shortage of raw materials, which meant that formal instruction in weaving was initially out of the question. Under Itten's tutelage, the Women's Department did a variety of imaginative work with scraps of material collected from the townspeople of Weimar. A great deal of appliqué work was done at this time, including a large decorative hanging for the

The textile workshop in Dessau, seen here in about 1927(1), was well-equipped. It had four different types of loom, and its own dyeing shop. Gunta Stölzl was able to develop a full curriculum.

1

Sommerfeld house. The students also made improvised toys (which they dubbed "primeval creatures") from scraps of coloured rags, wood, wire, fur, beads, buttons and straw, and they were sold for a penny each at the "Dada stall" at the Weimar Christmas Fair in 1920. In 1921, the shortage of materials became less acute, and the Women's Department appears to have merged with the official textile workshop. Helene Börner, a talented weaver who had previously taught at van de Velde's School of Applied Art, was appointed Craft Master, and she generously allowed the Bauhaus use of her own hand-looms.

The third factor was the influence and inspiration of contemporary developments in painting. Chief among these was abstraction, which was understood by the textile workshop to mean the freedom to use the elements of form directly, neat and undiluted. The approach to textile design in Weimar was, accordingly, strongly pictorial. Each piece of work was conceived as an independent formal composition.

Writing in the Bauhaus magazine in 1931, Gunta Stölzl spoke in rapturous terms about what they had been trying to do at Weimar, once the playful attitude that Itten had encouraged had become more serious: "With the elements we had just conquered we attempted to make pictorial compositions, surfaces which would bring a wall to life...Each different material had to be ordered according to its value: structure, colour, three-dimensional quality, light-dark, key concepts such as soft-hard, rough-smooth. They had to be released from the unconscious, in order to become useful elements of new design." She continues: "For this creation, this transformation of experience, there was no pattern book from the past, no technical or intellectual recipe. With the new generation of Bauhaus painters, we were searching in the whirling chaos of artistic values..."

Textile design compositions fell into two main types. The first was the expressive, organic, dream landscape, vibrant with contrasting tone, pattern and colour. The second was the checkerboard design, in which a more constructive approach was taken and certain elements were systematically varied. Both types, which were also used in combination, were related to preliminary course exercises in their use of pairs of contrasting qualities.

Both Paul Klee (1879–1940) and Georg Muche (b.1895) acted as Form Master for textiles at different stages. Klee's influence as a guide through "the whirling chaos of artistic values" is difficult to assess. According to former students, he greatly appreciated weaving and compared it with music making, his other great love aside from painting. His lectures on the elements of pictorial composition were scheduled for textile students, and striking formal comparisons can certainly be drawn between his work during the Weimar years and textiles produced in the workshop.

Georg Muche was not a great success as Form Master. He later made the strange boast that he had made and kept a vow never to weave a thread or tie a knot. As one might expect, his influence on the workshop was minimal. In general, the students were allowed to do what they pleased, Muche insisting only that they began with a sketch, and he helped them to select the most

suitable one for development. Benite Otte and Gunta Stölzl, two of the workshop's most talented students, were sent on external textile training courses in 1922 and 1924, and when they returned, their knowledge far exceeded Muche's. They also found Helene Börner's attitude frustratingly old-fashioned, and occasionally conflict flared up. In the main, however, one gets the impression that, from their point of view, Muche's complaisance in allowing them free rein to their invention and fantasy compensated for his lack of technical competence.

The textile workshop produced an extraordinarily large output. (Paul Klee was amazed at how hard-working women could be!) Although the high prices deterred some people, the wall-hangings, sofa covers and table-cloths were very popular with individual customers, and the workshop frequently worked to their specifications. The workshop's earnings at Weimar were second only to those from ceramics.

Although formal experimentation at the textile workshop was to bring excellent results in time, the immediate results had little relevance to the school's overall aim, which, by the mid-Weimar period, was defined as designing models for industrial production. While Gropius and Lange were pleased that individual pieces were well received, they had difficulty in persuading the textile workshop to concentrate on more systematic work that could lead to industrial manufacture. Work

2

Grete Reichardt's tapestry wall-hanging (2) called Mussel Mosaic is an interesting mixture of geometric and organic forms, saturated and dilute colours, and warm and cool tones. Formally, it has much in common with Paul Klee's water-colour compositions.

was begun on "Meterware" (cloth to be sold by the meter), but with little real enthusiasm. Lange complained that at the Leipzig Trade Fairs in 1924 the expensive, individual wall-hangings were given pride of place, while the less assuming 'Meterware' was hidden from view.

The move to Dessau was a watershed in the development of the textile workshop. Although Muche remained Form Master, the workshop's effective leader was Gunta Stölzl. She was supported by an external weaving Master both in Dessau and Berlin. The new workshop was excellently equipped with four different kinds of loom and its own dyeing shop, and Stölzl developed a curriculum that could lead to a full journeyman's examination. (This was in contrast to Weimar, where the students' achievements were never officially recognised by the Chamber of Craft.) Once a student had the journeyman's qualification, she or he could try for the coveted Bauhaus Diploma. The workshop training was divided into two stages: initial training (one and a half years) and then experimental work with the aim of creating industrial models. Stölzl also developed a course on weaving techniques and materials. Problems still arose with Muche, who was increasingly preoccupied with his architectural projects. After a number of difficult episodes, he left the Bauhaus in 1927, giving a farewell lecture on architecture, and Stölzl assumed the official position of workshop leader.

At Dessau, individual pieces of handweaving were gradually marginalised, and work proceeded in a more orderly fashion, making sure that the full potential of any advances was explored before the next project was considered. The way they presented their work to the outside world changed: individual fabric samples were numbered and mounted on board to show the options within a given pattern, along with prices and availability. Within the workshop there was more collaboration and less individualism. Students from other workshops could no longer walk in and weave a rug. In some ways this was a shame, as the Weimar workshop had been a centre for independent experimentation.

The workshop's brief at Dessau was to develop upholstery fabrics, carpets and wall-coverings for the new interior. "System" and "structure" were the new catch-words. Experimental fabrics were developed using aluminium, metal alloys and glass, and recently developed synthetic materials such as cellophane. A fabric incorporating Eisengarn (a canvas-like patent product designed for use in military belts and bootlaces) was developed for the upholstery of Breuer's tubular steel seating. Hannes Meyer, who took a direct interest in the textile workshop, increased the trend towards systemisation of the design process. He had been intensely critical of the textile pieces he saw at the inauguration of the Dessau Bauhaus, and, seeking to replace the last vestiges of untrammelled self-expression with science, he encouraged the workshop to undertake extensive research into the physical characteristics of various materials (strength, elasticity, colour-fastness, transparency, reflectiveness and so on). For the auditorium of Meyer's Trade Union School in Bernau, Anni Albers

1

This fabric sample (1), by Margarete Leischner, relates to one of the many experimental upholstery and wallcovering fabrics developed at Weimar. It incorporates bands of yellow synthetic silk (rayon), which varies the texture and reflects light differently from the yarn.

designed a special wall-covering fabric incorporating cellophane that not only reflected light but also absorbed sound, thereby ridding the auditorium of an unwelcome echo. The workshop experimented with wall-covering fabrics that could be wiped clean, and in 1927 it received an important commission to fit out the large Café Altes Theatre in Dessau. Many fabrics were produced within the Bauhaus in great quantity; as in other workshops, the pressure often produced conflict between training and experimental needs and production. Despite Meyer's exhortations, however, the workshop continued to make and sell individual pieces for individual customers and for display in collections of applied art.

When Stölzl left the Bauhaus in 1931, she was succeeded first by Otti Berger and then by Lilly Reich, who was Mies van der Rohe's partner. Reich had no weaving skills, but considerable experience in interior design. When it was based at Weimar, the workshop had refused commissions to provide designs for printed fabrics, but after Stölzl's departure, its attitude relaxed and ranges of Bauhaus upholstery and furnishing fabrics, manufactured by C. E. Baumgartel and Van Delden, were sold in conjunction with Bauhaus wallpapers. Like the wallpapers, Bauhaus upholstery fabrics were reasonably priced, and they were widely specified by progressive architects, especially in their mass-housing projects. The printed fabrics were something of a compromise: a number of the patterns in the "bauhaus 33" collection, for instance, were directly transposed from the Bauhaus wallpapers. In 1930 manufacturing contracts were also

2

Although the Bauhaus's industrial successes were not achieved until the Dessau period (1925–32), the workshops had worked to commission from the earliest days at Weimar. The school was unusual in that workshop members received payment for any work that resulted in a sale, partly in order to relieve the students' poverty and partly in order to instil a responsible attitude toward materials and time.

The 1923 exhibition increased demand for Bauhaus goods, and the workshops began to make specific models in quantity. A network of trade representatives was established in Germany and abroad, and the Bauhaus also participated in international trade fairs.

The school's financial situation was always precarious, and in 1923 negotiations were begun to establish a business-like, independent form for its production – i.e. a separate company. The Bauhaus GmbH was finally set up at Dessau, and by the end of the decade "bauhaus" had become a valuable trade mark. The Bauhaus's first industrial contracts were signed in 1928; lighting, wallpapers and textiles all earned considerable sums for the school.

The profile of its clientele, the professional middle class, had hardly changed, however, and despite industrial successes, the Bauhaus can never be said to have achieved its goal of designing everyday goods for ordinary people.

finding industrial positions, and many have also been influential in education – Margarete Leischner, for example, was appointed Head of Weaving at London's Royal College of Art in 1956. Formal elements of Bauhaus textile design were absorbed into the decorative vocabulary of Art Deco; in Britain, for instance, they resurfaced in carpet designs by Edward McKnight Kauffer for the Wilton Royal Carpet Factory. More fundamentally, Bauhaus textiles offered a model for a systematic design process; the use of unorthodox materials to develop new fabrics with specific properties; and a new concept of the role of textiles in interiors. Above all, they demonstrated how to create interest through the structure of the fabric itself, rather than through superficial pattern.

signed with Polytex, but a satisfactory relationship was never established. Otti Berger suspected that Polytex was only interested in using the Bauhaus trade name (which had a certain cachet by that time) rather than in a true collaboration.

However, despite the difficulties in the final years, Bauhaus textile design has had far-reaching effects on the industry. Students from the textile workshop were particularly successful in

Margarete Willers's small rug (2) of 1927 demonstrates that although the emphasis shifted in Dessau from individual pieces to developing furnishing fabrics for the "new interior", workshop members still made formally complex rugs and wall hangings.

2

Some of the artists associated with the Dada movement, such as Kurt Schwitters, turned to scrap materials not only in order to create rich, abstract compositions, but to signal their disgust with conventional "salon" art. Kurt Schwitters' collage of torn paper, called "Aphorism" (1), dates from 1923.

The textiles workshop grew out of the preliminary course and its exercises had a significant influence on the directions Bauhaus textiles would take. Under Itten's guidance, students were encouraged to be bold in their investigations of formal elements. Max Peiffer-Watenphul's study of the formal characteristics of a square (2) of about 1920 (charcoal on paper) could almost be a design for a rug already. Willi Dieckmann's materials study (3) of about 1921 is, like the first products of the textiles workshop, entirely composed of scraps, which are juxtaposed so as to bring out their special qualities, especially their tactile characteristics.

1

3

4

5

Another possible source of inspiration lay in the freshness and boldness of Eastern European traditional dress (**4**).

Paul Klee, who was textiles Form Master, was another important influence. His water-colour, "Herzdame" (Queen of Hearts) (1922–3) (**5**) is a composition of rich, contrasting colours.

ORGANIC

Gunta Stölzl's gobelin of 1926–7 (**1**) is one of the most famous pieces of Bauhaus textile design. It is an opulent pictorial composition, with colours ranging from vivid, saturated primary and secondary colours to muted tertiaries. Geometric pattern is set against free-flowing curves. Stölzl herself described how there was no intellectual or technical recipe for such compositions; she and her fellow workshop members "were searching in the whirling chaos of artistic values." The warp is linen and the woof predominantly cotton.

This detail (**2**) of a wall hanging by Hilde Rantsch (c. 1923) shows the richness of texture and pattern achieved by using different colours and kinds of yarn. The inclusion of yarns of widely different sizes increases the curvaceous "landscape" effect.

3

4

Stölzl's gobelin of 1920 (**3**) seems to contain recognisable representational elements: a cow, a donkey, and a star shining above a mountainous landscape – perhaps suggesting a Nativity scene.

Stölzl made this detailed water-colour design (**4**) for a wall hanging in 1927.

This pillow (**5**) was made in about 1922 by a student in the "Women's Department," the female wing of Item's preliminary course. Its bold, abstract design has much in common with Itten's paintings.

5

GEOMETRIC

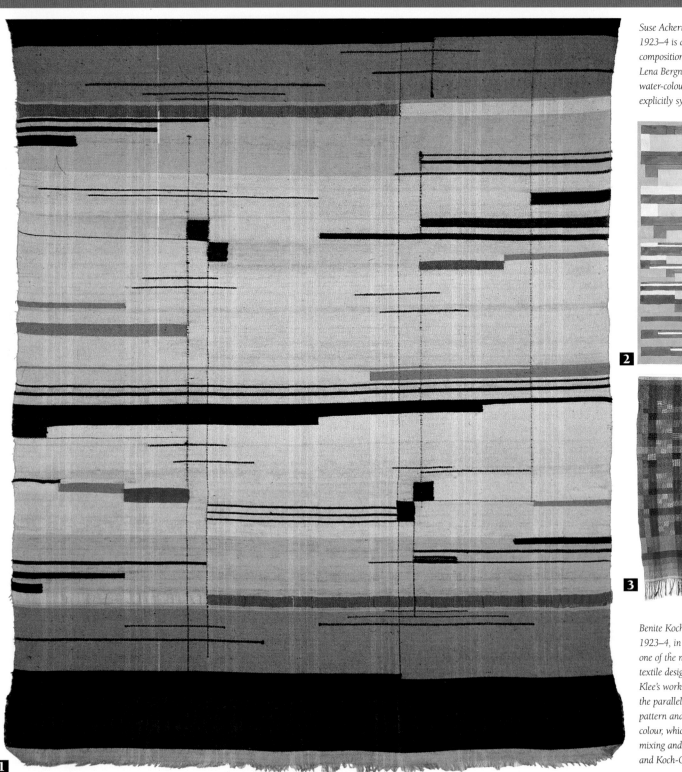

Suse Ackermann's blanket (**1**) of 1923–4 is a relatively systematic composition of stripes and squares. Lena Bergner's textile design (**2**) in water-colour and gouache is more explicitly systematic.

2

3

Benite Koch-Otte's wall hanging of 1923–4, in wool and cotton (**3**), is one of the many pieces of Bauhaus textile design in which parallels with Klee's work can be seen. In this case, the parallel lies in the checkerboard pattern and the subtle gradations of colour, which Klee achieved by careful mixing and diluting of water-colour, and Koch-Otte by weaving.

1

4 **5**

Lena Bergner used strong colours in her carpet design (c. 1928) (**4**). It is based on a sequence of small grids of thirty-six squares each.

Ruth Hollos-Consemuller's gobelin of about 1925 (**5**) is typical of many of the more systematic, geometrically-based compositions, with its muted range of colour and tone, enlivened by accents of black and red.

This detail (**6**) is of the woollen upholstery material that Gunta Stölzl designed and made for one of Breuer's black polished pearwood chairs in 1922–3.

6

EXPERIMENTAL

GUNTA STÖLZL

Preparatory samples of stretch fabric by Gunta Stölzl incorporating cellophane.

Gunta Stölzl 1897–1983), one of the century's most original weavers, was born in Munich. From 1914 to 1919 she studied at the Munich School of Arts and Crafts and served in the Red Cross, but she joined the Bauhaus as soon as it opened in 1919 and plainly thrived in its atmosphere. Having passed her journeyman's examination in weaving in 1924, she was asked by Johannes Itten to come to the Mazdaznan headquarters in Herrliberg to run a small weaving workshop.

In 1925 she returned to the Bauhaus to take over the technical direction of the textile workshop, while Georg Muche was the official workshop leader. After Muche's departure in 1926, she became head of the workshop, a position she held until 1931, when she left the Bauhaus to set up her own workshop in Zurich. She was one of the finest weavers of her generation, equally at home with hand-woven pieces and designing for mass production.

Margarete Leischner's rug (1) (detail) may be seen as an experiment in repeated forms. From about 1923 onward, the Bauhaus administration was keen to shift the emphasis of the workshop from the creation of "one-off," expensive designs to the production of more systematic work with the aim of developing industrial models.

1

Hilde Reindle's water-colour textile design (2) is one of a large number of experiments in using a strict grid to generate pattern. Reindle used six grids of six by six squares.

In Lena Bergner's preparatory sample of fabric for a blanket (3), shiny threads – possibly synthetic silk (rayon) – are used to create interest and a feeling of luxury. Although more systematic than her wall hangings, this fabric uses a similar variety of shades and sequence of contrasts.

Margarete Leischner's curtain material (4) uses the uneven texture of the woof to create partial transparency. This structural approach is typical of the upholstery fabrics created in the late Dessau and Berlin periods. Interest is created not through superficial pattern, but through structure.

2

3

4

INDUSTRIAL

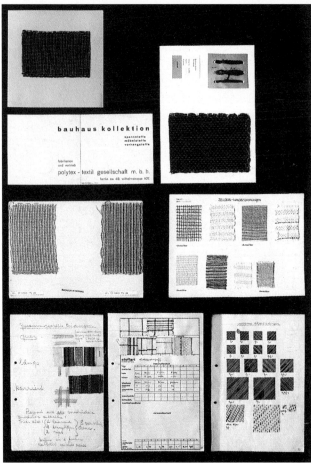

Grete Reichardt's black and red fabric sample (1928) (**1**) is attractive on both sides.

This collection of production patterns and teaching material (**2**) dates from about 1930. At the top we have production patterns for the "Bauhaus collection" manufactured by Polytex; in the middle, sample cards for upholstery materials which the Dessau workshop could itself supply in small quantities (the samples on the right, by Grete Reichardt, contain cellophane and four are labelled "wipeable"); below, teaching material and notes by Otti Berger, Gunta Stölzl and Bella Ullmann, which show how systematic the workshop's approach had become at Dessau. Visits to factories such as Poly-textil (Polytex) in Berlin and Pausa in Stuttgart were of vital importance to the development of the workshop, as these offered first-hand experience of commercial manufacturing processes.

Gunta Stölzl designed this fabric (3) for covering a recent addition to the living room: the radio. The fabric contains cotton and rayon, which gives it its sheen. Like most of the fabrics designed for commercial applications at Dessau, it comes in a number of different colours. There is no "pattern" as such, just colour and structure. The same is true of Stölzl's preparatory sample for a wool blanket (4).

5

This unobtrusive curtain material (5) was featured in the advertising pamphlet for Polytex's "Bauhaus collection" in 1930. Such materials were eagerly used by progressive architects and interior designers who appreciated their practicality and understatement.

Agnes Roghé's "Meterware" (6) (1923–24) is one of the earliest examples of a Bauhaus fabric designed to be sold by the yard. Roghé systematically developed the positive and negative pattern, and experimented with various colour combinations.

4

6

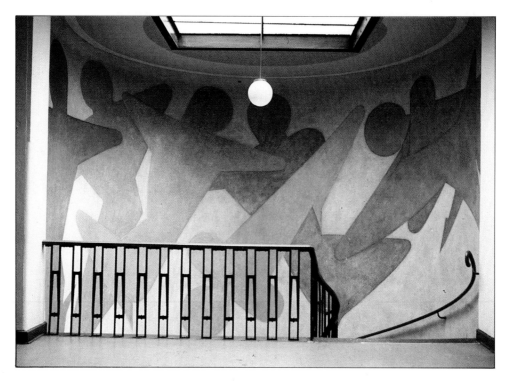

Oskar Schlemmer's mural at the top of the stairwell in the workshop building, Weimar, 1923.

CHAPTER • FIVE

ARCHITECTURE

ARCHITECTURE

It was clear from Gropius's manifesto that the ultimate aim of the Bauhaus was architecture; the very name Bauhaus suggests it most strongly. Each of the school's three directors, Gropius, Meyer and Mies van der Rohe, was above all an architect and, rightly or wrongly, the Bauhaus has become strongly identified with the architectural approach that has variously been called Modernism, the Modern Movement or the International Style. (At the time in Germany it was often called the New Architecture.) Although architecture was both the root and goal of all Bauhaus work, it was not until 1927 that any kind of formal architectural instruction was offered. However, with their enthusiasm for debating and redefining the forms for modern life, architecture was never far from the students' minds, and they eagerly embraced new movements in architectural thinking.

A great many architectural influences were at work at the time.

From across the Atlantic came Frank Lloyd Wright's dramatic private houses, along with an architectural language for high-rise office buildings, seen, for instance, in Dankmar Adler and Louis Sullivan's Guaranty Building in Buffalo, New York (1894–5). (It was Sullivan who coined the phrase "form follows function".) From England and France as long ago as the mid-19th century had come demonstrations of the enormous potential of two new construction materials – iron and glass. More recent European developments were also coming into play: the work and ideas of the Viennese architect Adolf Loos (1870–1933); the dynamic approach of the De Stijl architects; and, as the 1920s progressed, the exquisite villas of Le Corbusier.

The debate surrounding Modernism or the New Architecture was carried on in terms heavy with moral connotations: truth, purity, honesty. Democracy even entered into it with the attempt

The photograph of the draughting room in the newly established architecture department (3) was taken in about 1928. Note the counterweighted hanging lights, designed by Marianne Brandt and Hans Przyrembel in 1926, and the impression of orderliness, helped by details like the shutter-fronted plan cabinets and the gleaming linoleum floor (linoleum was one of a number of new materials that had recently been developed).

1

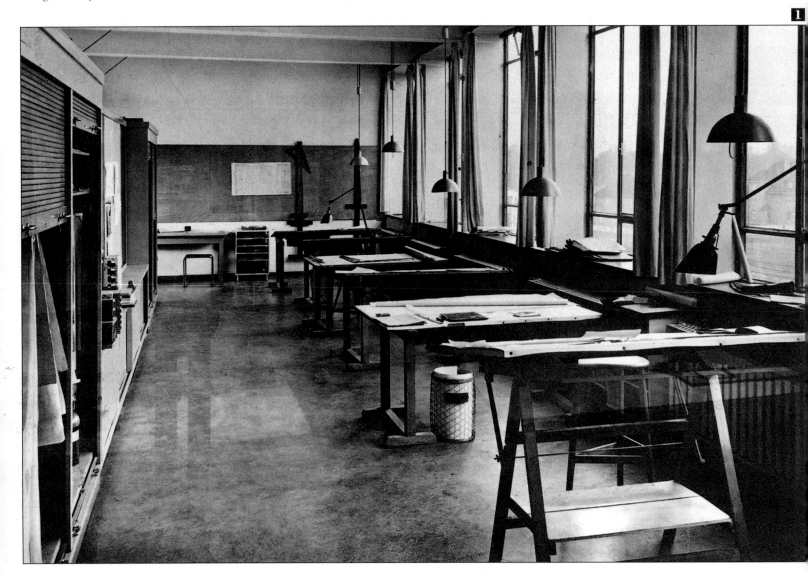

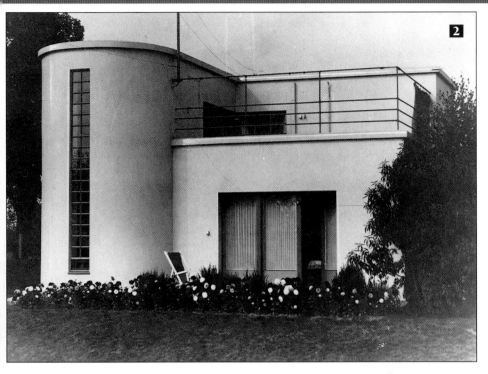

New Architecture. At the Bauhaus Exhibition in 1923, Gropius and Meyer mounted a small but important exhibition of designs, photographs and models on the theme of International Architecture, which tried to show that the new way of building was indeed an international issue. They also promoted a concept called *Baukasten in Grossen*, or full-scale building blocks. The idea was to use low-cost, prefabricated housing units (blocks) to give the greatest degree of variation within a standardised system, thereby creating not only low-cost housing but unity in the diversity of the modern city. The need for large-scale social housing was acute at the time, because Germany was facing a major housing crisis. Thousands of people were living in severely overcrowded conditions in 19th-century tenements, often without even minimal facilities.

Other factors were also having an effect on architectural ideas. One of these was the phenomenon of the disappearing servant. After the war it was extremely difficult for middle-class families to find household staff, and homes had to be maintained by one person. This seems to have been a decisive factor in the design of Georg Muche's model house for the Bauhaus Exhibition. This remarkable little Modernist villa, called the Haus am Horn, has no servants' quarters, corridors, staircases or pantries, but consists of seven small rooms arranged around a central living room, lit by clerestory windows.

Gropius is reported to have felt ambivalent about the whole idea of showing a model house, which might be seen as highlighting the lack of an architecture workshop at the Bauhaus. He later justified the omission by maintaining that he always saw architecture as the culmination of Bauhaus training, for which no student could be ready until he or she had completed the preliminary course and a full craft training. However, by the end of the Weimar period, there was strong pressure from the students to introduce an architecture course. Muche and Breuer, in particular, were experimenting with high-rise apartment buildings with balconies, their enthusiasm fired by pictures of American skyscrapers. In 1924 Muche, Breuer and Farkas Molnar were allowed to set up an unofficial architectural working party to study housing problems.

to suppress the predominance of one face of the building (the faáade) in favour of buildings that could be appreciated only by walking around and through them – or, like Gropius's Bauhaus building in Dessau, from the air. The structure of the building had to be expressed clearly by its outward appearance. In formal terms, the horizontal was emphasised rather than the imposing verticals of 19th-century public buildings; flat planes were interlocked at right angles and surfaces were rendered white to symbolise purity and clarity. One of the most controversial elements in the German context was the use of the flat roof; the pitched roof was seen in conservative circles as inalienably Germanic. The Weissenhof Estate, an international forum of Modernist architecture convened by Mies van der Rohe in 1927, was dubbed the "Arab village," and a doctored postcard, showing the estate full of Bedouins, palm trees and camels, was circulated.

Before World War I, Gropius had established a reputation for radicalism. Above all he was involved with architectural theory, taking an active part in the debates on standardisation in the Deutsche Werkbund. One of his key interests was in the industrialisation of the building process, in order to achieve good, low-cost housing. Having been politicised (in a very general way) by the experience of war, he became a member of the radical Novembergruppe and Chairman of the Arbeitsrat für Kunst (Working Soviet for Art) in 1919.

Even after he became Director of the Bauhaus, Gropius continued his private practice with his partner Adolf Meyer. Their work, in particular their projects such as the international philosophy academy in Erlangen, bears all the hallmarks of the

Bauhaus student Carl Fieger designed this family house in Dessau in 1927. The balcony has a rail for a curtain to provide privacy for sunbathing.

Gropius and Meyer produced a model (3) of their project for an international philosophy academy at Erlangen in 1924. With its emphasis on the horizontal, it is a clear precursor of Gropius's Bauhaus building in Dessau.

ARCHITECTURE

Although there was no architecture workshop, there was a fully-operational wall-painting workshop, whose objective was the integration of colour into the architectural environment. Finding a suitable Craft Master proved difficult. Mendel, a master from Weimar, resigned shortly after his appointment in 1921, and was replaced by Oskar Schlemmer's brother, Carl. Carl Schlemmer was dismissed for intrigue against the school and replaced in 1923 by the competent Heinrich Beberniss. In terms of artistic direction, Oskar Schlemmer and Johannes Itten alternated responsibility, until Wassily Kandinsky's appointment as Form Master in 1922.

The training was both practical and theoretical. Using the walls of the workshop itself, apprentices experimented with interior and exterior painting techniques, including fresco and sgraffito, and took part in theoretical discussion of colour systems and colour psychology. Kandinsky's theories about the correspondence of form and colour were extremely influential, and they were the subject of heated discussion throughout the Bauhaus, culminating in a famous questionnaire in which the respondents were asked to assign to each of the basic shapes (square, circle, triangle) one of the primary colours.

The wall-painting workshop's early projects included the interior of the Sommerfeld house and Dr Otte's house in Berlin, and a room (to Kandinsky's design) at the Juryfreien Exhibition in 1922, also in Berlin. The Bauhaus Exhibition brought the chance of working not only on the interiors of the Haus am Horn, but also on the entrance and stairways of van de Velde's workshop building.

When Gropius designed the new school building in Dessau in 1925–6, he was making a powerful public statement about the Bauhaus's intentions. With its interlocking wings, it is a dynamic

The wall-painting workshop at Weimar (c.1928) (1)

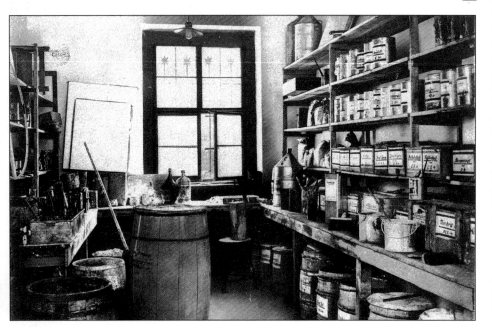

composition which needs to be walked around and through to be appreciated. Behind the great curtain walls of the workshop wing, the activity of the school was clearly visible. It is superbly photogenic architecture, and Gropius used it to the full to publicise the school. Its uncompromising modernity won it many friends and, many enemies.

The four masters' houses (three double houses and a single for Gropius) represent Gropius's ideals for domestic architecture. His own house was the show house of the little colony. A constant stream of visitors came from all over the world to marvel at the smooth running of domestic life, time-saving appliances (which helped to compensate for the lack of household staff), large windows and extensive balconies, some of which had curtains to provide privacy for sun and air baths.

Hinnerk Scheper (1897–1957) became the wall-painting workshop leader and, apart from a period of sabbatical leave in the Soviet Union in 1929–31, he remained in charge until the Bauhaus was finally closed in 1933. The training given under his supervision was extraordinarily thorough, encompassing everything from gypsum and colour harmony to stencils and scaffolding. Although Gropius was not over-enthusiastic about the use of colour in architecture, the wall-painting workshop developed schemes for the interior of the new school building, the masters' houses, and the Folkwang Museum in Essen. As we shall see, although the Bauhaus has become identified with the primary colours, the colour schemes they developed are subtle. Ornamental wall-painting, whether abstract or figurative, had no place at Dessau, where the concern was to articulate architectural space.

By 1926, Gropius's concern to industrialise the building process to reduce construction costs and to make it independent of the normal vagaries of building (such as the weather, fluctuations in the price of labour and materials) had become a national one. Central organisations such as the State Efficiency Board had been established to address Germany's pressing housing and manufacturing problems. Gropius was offered the opportunity to put his ideal to the test when he was granted state funds to build a workers' residential development in the Törten area of Dessau. He chose to build two-story row houses with central heating, double glazing and built-in closets. He drew up a strict schedule, which he compared to a train timetable, for every stage of construction. Concrete components were manufactured on site in a kind of assembly line. The schedule worked: 60 houses were built in 1926, 100 in 1927 and 156 in 1928. However, technical problems soon arose, which lent ammunition to the critics of the Bauhaus who had already decided that the houses looked like chicken coops.

A Bauhaus architecture department was finally established in 1927, and Hannes Meyer was appointed as its head. A wide range of teaching was available through the other faculty members such as Ludwig Hilberseimer (1885–1967), Hans Wittwer (Meyer's partner), Anton Brenner, Edvard Heiberg and Carl Fieger. Mart Stam was a guest lecturer.

Meyer's teaching remains controversial. His approach was strongly collectivist and materialist, and it was his firm belief that architecture was not an aesthetic process, but a technical one. His design methodology was an extreme kind of functionalism in which everything was reduced to the formula "function times economy." It was as if one could feed the different requirements of a building in at one end of the process, and the total design would appear at the other, complete with plan and elevation.

Students were asked to make extremely detailed studies. When working on a housing complex, for instance, they were asked to research and incorporate factors ranging from hours of sunlight, units of carbon dioxide per cubic yard, and the social, political and sexual relationships of the proposed inhabitants. Sometimes, of course, the truth can hurt – an analysis undertaken of the city of Dessau in terms of social class and amenities revealed that all the workers' housing was concentrated in areas of high pollution. The Dessau authorities felt obliged to suppress the findings.

Under Meyer's direction, the Törten estate was completed, and another major project was undertaken: a large trade union school complex at Bernau, with the various buildings grouped on the shores of a lake. Under Scheper's direction, the wall-painting workshop developed a range of lightly textured wallpapers manufactured by Rasch. They were well-suited to the small-scale modern home interior and were a tremendous commercial success for the school.

On his appointment as Director of the Bauhaus, Mies van der Rohe assumed leadership of the architecture department, and he was worshipped by those students who didn't leave in disgust on Meyer's dismissal. Mies made the students concentrate almost exclusively on designs for single houses, maintaining that if they could solve the design problems of a small house, they would be in a good position to tackle larger projects. His pupils worked very much in the shadow of the great man and a "school of Mies" grew up, sharing even the style of draftsmanship. They produced sheaves of drawings of elongated rectangular houses, enclosed on three sides by brick walls and, on the fourth side that faced the garden, by floor-to-ceiling plate glass. Under Mies van der Rohe the ideal of workers' housing receded dramatically. Not many projects under Gropius, let alone Meyer, had featured grand pianos and slabs of marble, nor had the proportions of their living rooms been determined by the dimensions of the Barcelona chair.

Although Gropius's Bauhaus building in Dessau, now restored, is still magnificent, Bauhaus architecture can be said to lack the variety and formal interest of the work of Frank Lloyd Wright or Le Corbusier, and it has suffered through being identified with the "little boxes" approach to housing. But in addressing the challenge of prefabrication and the industrialisation of the building process, the Bauhaus was, as always, confronting questions that are still being debated. The use of such techniques by the "High Tech" architects of our own time, such as Richard Rogers, is still controversial and often offensive to the conservative majority.

Rash Brothers, who manufactured one of the Bauhaus's most successful products, its wallpapers, have continued to produce wallpapers influenced by the Bauhaus's understated, textural designs (2 and 3).

The interior of Frank Lloyd Wright's highly unconventional Unity Church (**1**) in Oak Park, Chicago (1906), with its strongly geometric, rectilinear character, is at one with the structure.

This poster (**3**) by the Viennese architect Josef-Maria Olbrich (1867–1908) is for the 1901 exhibition of work by the Darmstadt artists' colony, a group that was deeply committed to the idea of the total work of art and the symbolic content of architecture.

Le Corbusier's Pavillon de l'Esprit Nouveau (**4**) caused a sensation at the 1925 Exposition des Arts Décoratifs in Paris, constructed as it was around a tree, which pierces its roof.

The Frankfurt Kitchen (2), seven square meters in floor area, was designed by the architect G. Schütte-Libotzky for Ernst May's extensive building program in Frankfurt in 1925.

Ernst May's first housing project (5) for Frankfurt, the Bruchfeldstrasse estate of 1925, designed with C.H. Rudolff, consisted of a large courtyard of housing units arranged in zigzag fashion, enclosing a landscaped garden with a pond.

The architecture and interiors of the De Stijl movement were a powerful influence on the Bauhaus. Rietveld's Schröder house (6) in Utrecht (1923–4) shows De Stijl characteristics in three dimensions: monumentality (even in this tiny end-of-the-row house); the use of colour and of overlapping and orthogonal planes to desolidify walls, and the lack of a dominating faáade. A steel frame freed the interior and exterior walls from load, to create a flexible living space.

Peter Behrens, whose monumental turbine hall for A.E.G. in Berlin (1909) is illustrated (7), was a tremendous influence on a whole generation of architects, including Gropius, Le Corbusier and Mies van der Robe.

Van Doesburg's stained-glass panel (8) of 1920 shows the De Stijl movement's main characteristics in two dimensions: rectilinearity and the restriction to the three primary colours and black and white.

EARLY PROJECTS

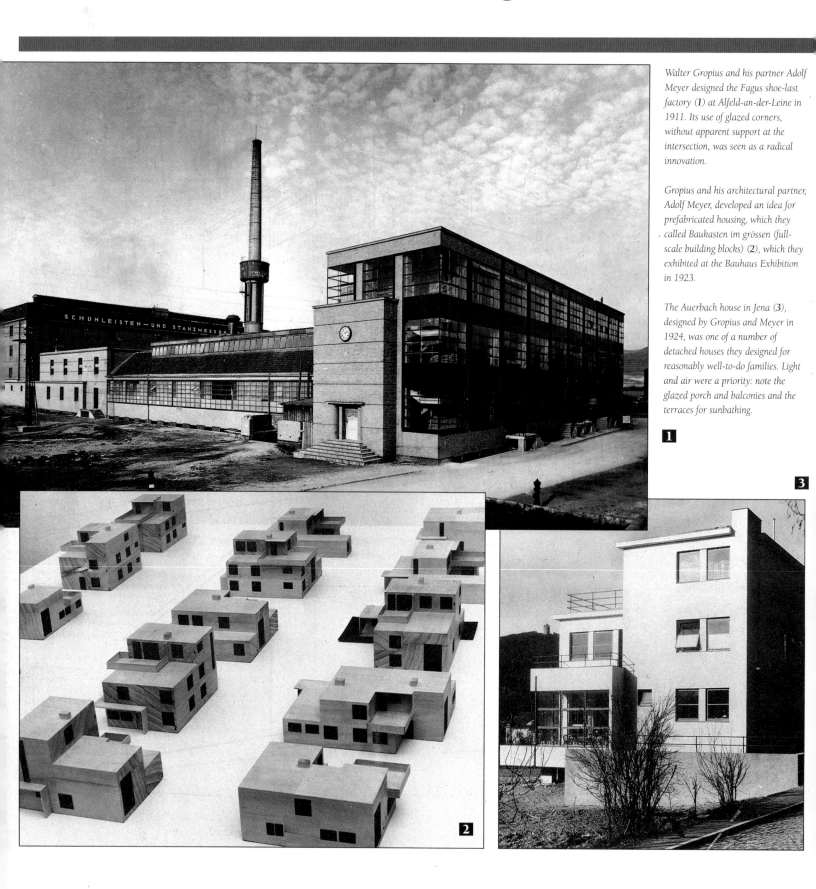

Walter Gropius and his partner Adolf Meyer designed the Fagus shoe-last factory (1) at Alfeld-an-der-Leine in 1911. Its use of glazed corners, without apparent support at the intersection, was seen as a radical innovation.

Gropius and his architectural partner, Adolf Meyer, developed an idea for prefabricated housing, which they called Baukasten im grössen (full-scale building blocks) (2), which they exhibited at the Bauhaus Exhibition in 1923.

The Auerbach house in Jena (3), designed by Gropius and Meyer in 1924, was one of a number of detached houses they designed for reasonably well-to-do families. Light and air were a priority: note the glazed porch and balconies and the terraces for sunbathing.

The Sommerfeld house (**4**) was built for the Bauhaus's patron Adolf Sommerfeld in Berlin in 1921–2. Gropius and Meyer's use of timber has sometimes been seen as folksy regression, but using timber was a piece of pragmatism: building materials were scarce and Sommerfeld was a timber magnate. It remains, however, a curious building, half log-cabin, half temple. Joost Schmidt, from the wood-carving workshop, was responsible for the carvings in the Expressionistic-looking teak-clad interior. (**6**) The frieze in the stairwell represents aspects of the timber industry.

(**5**) shows Alfred Arndt's colour scheme for the ground floor of the Auerbach house (dining room, music room and gentleman's room). Bauhaus interiors were largely in muted colours, with occasional stronger accents. Their purpose was to enhance the existing architectural spaces, not to make independent statements.

EARLY PROJECTS

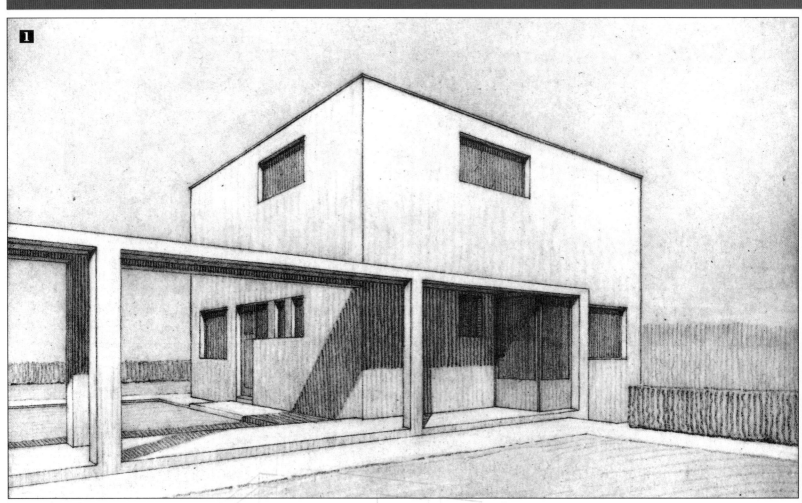

Fred Forbat's detached house (1) (1922) was intended for the projected estate of experimental houses on the am Horn site in Weimar, of which only Muche's was built (the Haus am Horn). Forbat's house is an uncompromising white cube, relieved only by the adjoining pergola or walkway.

Farkas Molnar's detached house (2) is a composition of cubes and cuboids of different heights. The use of exterior colour is unusual. Unfortunately, the floor plans for these houses have not survived, for they would show if the houses were conceived as anything more than pictorial compositions.

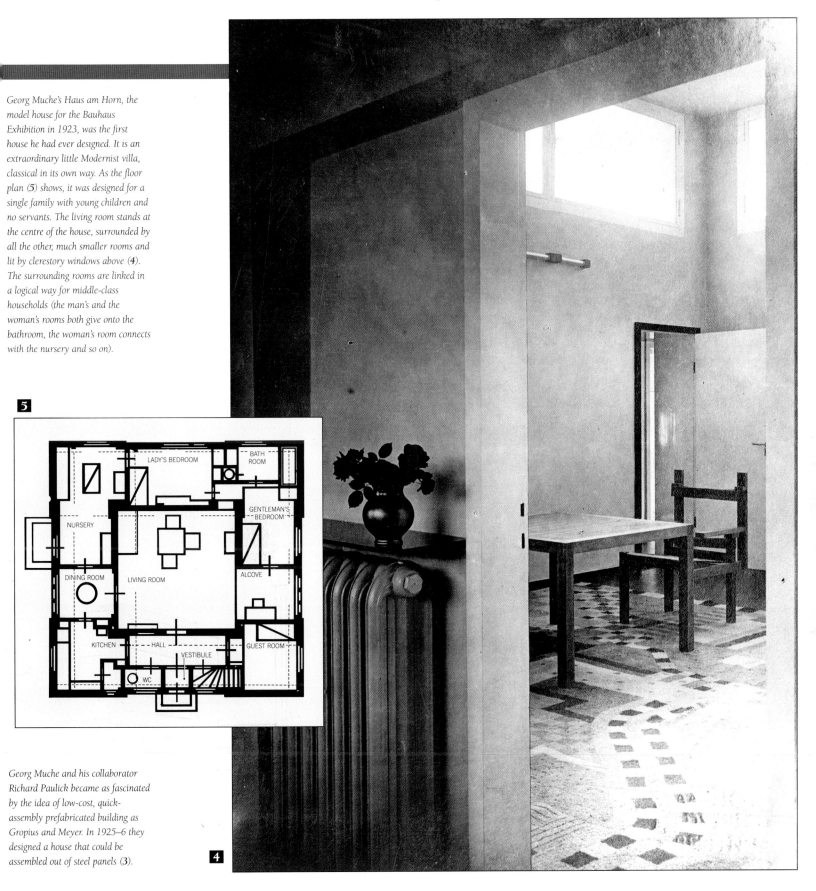

Georg Muche's Haus am Horn, the model house for the Bauhaus Exhibition in 1923, was the first house he had ever designed. It is an extraordinary little Modernist villa, classical in its own way. As the floor plan (5) shows, it was designed for a single family with young children and no servants. The living room stands at the centre of the house, surrounded by all the other, much smaller rooms and lit by clerestory windows above (4). The surrounding rooms are linked in a logical way for middle-class households (the man's and the woman's rooms both give onto the bathroom, the woman's room connects with the nursery and so on).

5

LADY'S BEDROOM

BATH ROOM

NURSERY

GENTLEMAN'S BEDROOM

DINING ROOM

LIVING ROOM

ALCOVE

KITCHEN

HALL

GUEST ROOM

VESTIBULE

WC

Georg Muche and his collaborator Richard Paulick became as fascinated by the idea of low-cost, quick-assembly prefabricated building as Gropius and Meyer. In 1925–6 they designed a house that could be assembled out of steel panels (3).

4

BAUHAUS DESSAU

The new building that Gropius designed for Bauhaus when it moved to Dessau is one of his finest buildings. Its dynamic plan is shown well in the modern model (1). Moving clockwise, the wing bearing the name "Bauhaus" contained the workshops; the bridge across the road housed the central administration; the wing opposite was for a separate technical college; and the taller block with the projecting balconies provided student workshops.

No one side of the building dominates – true to the principles of the New Architecture, there is no façade. The building is best seen from the air; indeed, Gropius commissioned aerial photography especially for publicity purposes.

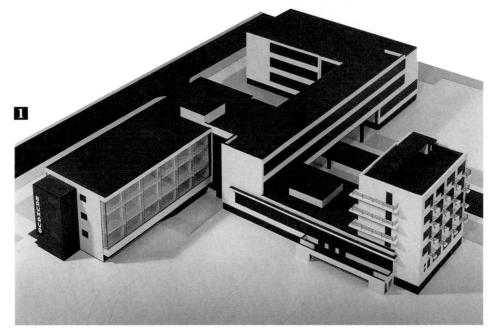

Originally set among plowed fields (2), the building was gradually engulfed by the suburbs of Dessau. The construction methods used were a pragmatic mixture of experimental and traditional. The flat roof leaked, much to the satisfaction of the Bauhaus' enemies. One of the National Socialists' first acts when they gained control of Dessau in 1932 was to brick up the famous curtain wall of the workshop wing, and the building remained in a sorry state for many years. It was, however, restored in 1976.

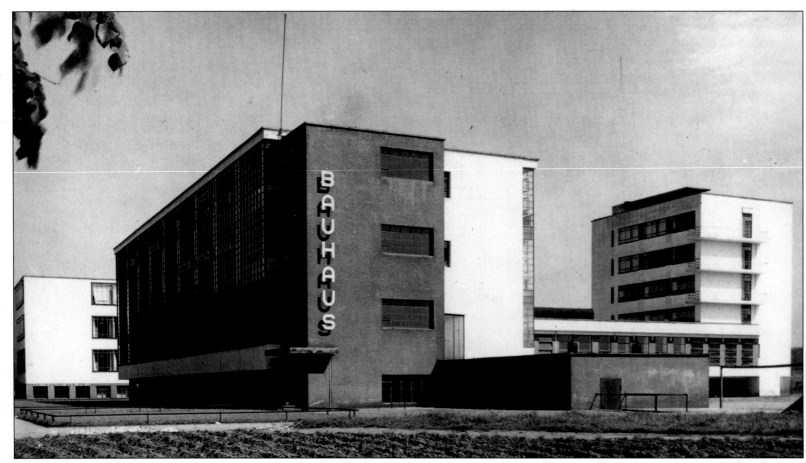

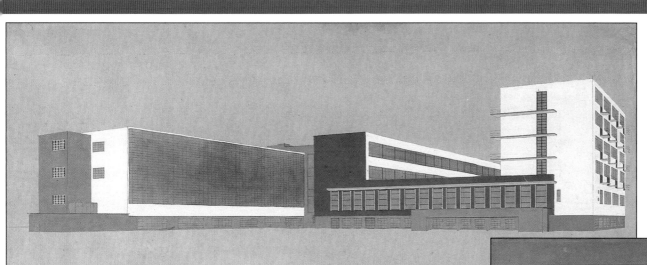

Hinnerk Scheper, who was responsible for planning the colour schemes for the interior of the building, also made detailed plans for the exterior (**3** and **4**), using four shades, including red to pick out doors and window frames. In the event these were not used; the exterior colours were restricted to white and gray, with black paint for the steel window frames.

3

4

This contemporary photograph (**5**) shows the north-west corner of the workshop wing, highlighting its extraordinary transparency, which earned it the nickname "the aquarium". As in Gropius' Fagus factory of 1909, there is no structural member at the corner, just a curtain of glass, wrapped around 90 degrees.

6

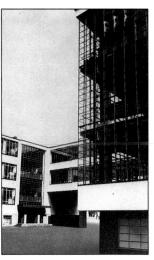

5

The lettering used for the name Bauhaus, emblazoned over the main entrance to the school (**6**), was also used vertically on the side of the workshop wing (**2**), but it was rarely, if ever, used elsewhere. When the new buildings were officially opened in December 1926, Herbert Bayer was still developing his Universal Type.

The balconies of the student workshops (**7**) are extremely photogenic. A number of Bauhaus photographs feature student highjinks and balancing acts on the railings.

7

As leader of the wall-painting workshop, Hinnerk Scheper was responsible for the detailed planning of the interior colour scheme of the new Bauhaus building, including colour plans for the ceilings on the second floor (1). The ceilings were basically white, with colour used to highlight the corners and structural elements, along with corridors and stairways. Scheper's orientation plan for the whole building (2) demonstrates how colour was used to distinguish the functions of different areas and to guide the users through the building to their desired destination. Colour and different textures of plaster and paint were also used to distinguish load-bearing from non-load-bearing architectural elements. The colours were applied in subdued, subtle shades.

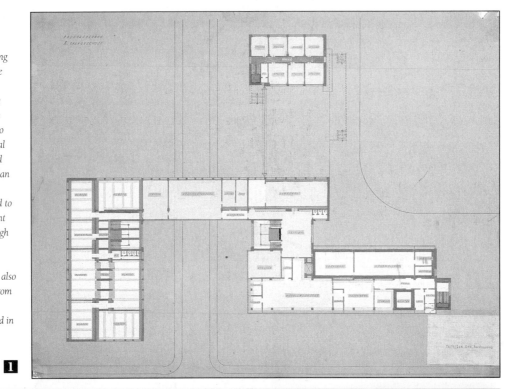

1

2

3

The auditorium (3) had tubular steel and canvas seating especially designed by Marcel Breuer. The seating is fixed in rows, with light-weight, tip-up seats. The armrests are plain lengths of tubular steel. This photograph is taken looking from the stage toward the three pairs of doors which lead out into the hallway. The reflective disks on the doors are pairs of semi-circular metal finger-plates.

5

The cafeteria (**5**), which was the centre of Bauhaus life at Dessau, as it had been at Weimar, was simply furnished with plain, long tables and the small tubular steel and plywood stools/tables that Breuer designed for use throughout the building. The room could also open out onto the stage for large events. Note the ceiling lights, which were designed by Max Krajewski.

A Bauhaus student is seen (**6**) having temporarily abandoned the work on her desk to relax on the balcony of her studio room and read a copy of bauhaus, the school magazine. Her aluminium desk light was designed in-house (see page 35). The other spartan, but adequate furnishings (**4**), include a bed alcove, a closet and a low table, with (as always) a double function, as it is low enough to sit on. Each room also had a washbasin and running water.

6

ERNA MEYER AND THE NEW HOUSEHOLD

In 1926 the home economist Dr Erna Meyer published Der neue Haushalt (The New Household), a book that rapidly became a best-seller, as it addressed a very pertinent question for the middle-class woman: how to run a servantless house efficiently and hygienically. Meyer was keen to illustrate the kitchen cupboards and storage jars that the Bauhaus had designed and produced in Weimar, and she and Gropius entered into a lively correspondence, planning to install a model kitchen in the back of a truck so that it could be taken all over Germany.

She was enthusiastic about the kitchen in Gropius's new house in Dessau, particularly the hatch through to the dining room from the kitchen, which seemed an attractive solution to the lack of servants waiting on tables. News of the innovation had travelled fast in the architect/designer circle.

Meyer was not, however, uncritical of Bauhaus production. She demanded practical explanations, for instance, for the eccentric placing of lids and knobs on their tea and coffee pots and questioned the use of expensive materials. The cost of equipping "the new household" had to be kept low, she argued, or women (for it was they who ran households) could use the traditional argument against change – that it was too expensive.

4

MASTERS' HOUSES

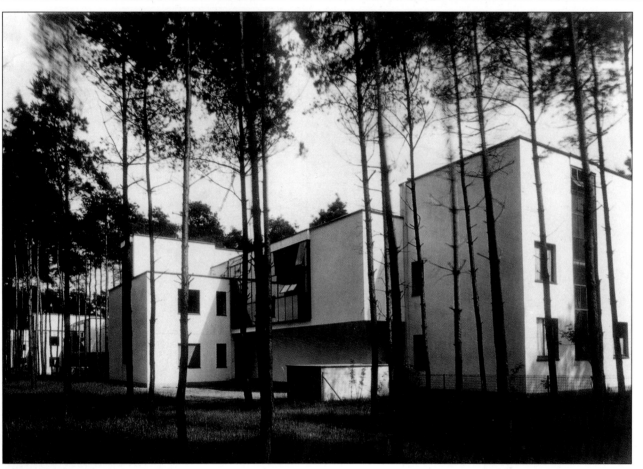

Gropius included housing for the senior masters in his plans for the new school building in Dessau. In a shady avenue, about ten minutes' walk away from the main school, four houses were built (1): a single house for Gropius, and three semi-detached houses for pairs of masters (Klee and Kandinsky, Muche and Schlemmer, Moholy-Nagy and Feininger). They were constructed from cement-based blocks, and although each had a studio, no two houses were identical. Formal and dignified, but asymmetrical, no one side predominates, and spaces are formed by interlocking volumes at right-angles. Sun and air were a priority, and balconies, some with curtains, provided privacy for sun- and air baths.

Gropius's house (2 and 3) was the show house for the little colony, and a constant stream of visitors came from all over the world to marvel at the smooth running of domestic life that could be achieved by careful planning and modern domestic appliances.

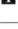

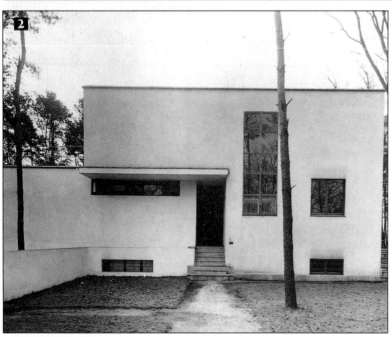

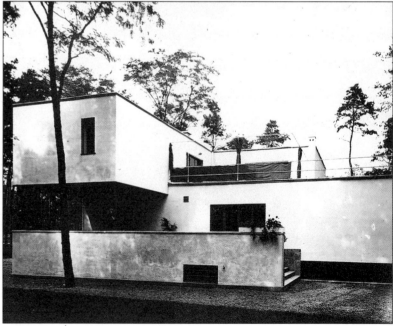

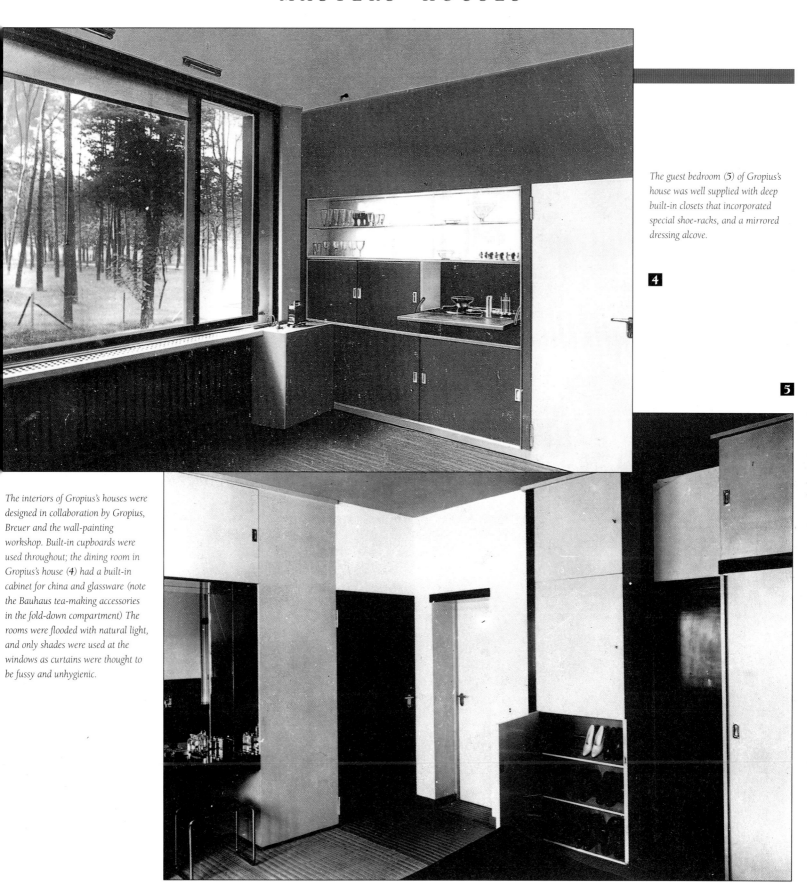

The guest bedroom (5) of Gropius's house was well supplied with deep built-in closets that incorporated special shoe-racks, and a mirrored dressing alcove.

4

5

The interiors of Gropius's houses were designed in collaboration by Gropius, Breuer and the wall-painting workshop. Built-in cupboards were used throughout; the dining room in Gropius's house (4) had a built-in cabinet for china and glassware (note the Bauhaus tea-making accessories in the fold-down compartment) The rooms were flooded with natural light, and only shades were used at the windows as curtains were thought to be fussy and unhygienic.

TÖRTEN ESTATE

At Dessau, Gropius was offered the opportunity to put into practice his ideas on rationalising the building process in order to provide much-needed low-cost workers' housing. State funds were made available for him to begin a planned program of construction in a working-class suburb of Dessau called Dessau-Törten. Gropius chose to build terraces of two-storey houses, which although small, had central heating, double-glazing and built-in cupboards. One can see from the plans (**1** and **3**) that the plots were fairly generous (about 530 square metros); this was because tenants needed to be able to grow their own food.

The concrete building components were manufactured on site, in a kind of assembly line, and construction progressed according to a strict timetable, with over 300 houses being built between 1926 and 1928. Work at Törten was continued by the architecture department under Hannes Meyer, and five apartment blocks of 28 flats were constructed in 1930 (**2**), their living quarters facing the sun, while stairways and services faced the shady north.

The Törten estate was dogged by technical and political problems. A number of different house types were built, but very few have remained in their original state (**4**). The high windows aroused particular antagonism, and most were quickly altered.

1

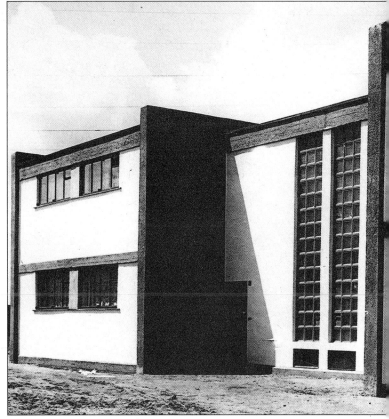

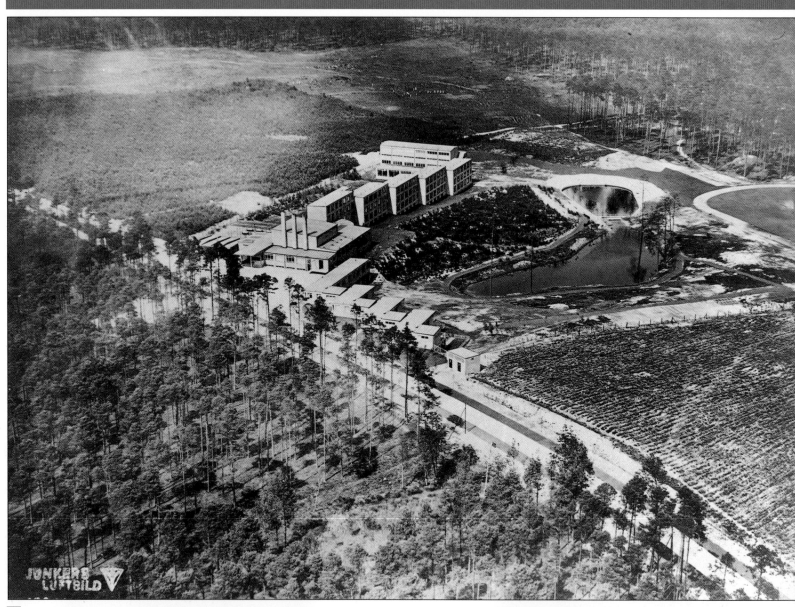

1

2

From 1928–30 Hannes Meyer
involved the architecture and interior
design departments in his prestigious
commission to build a large trade
union training school in Bernau near
Berlin. The buildings were grouped
around a lake (**1**), and the rooms and
circulation areas were filled with
natural light (**2** and **3**)

3

The design methodology taught by Meyer was an extreme functionalism. The heading of the student exercise (1930) (4) reads: "the ground plan is calculated from the following factors." Exact measurements of sun and air are used to determine the disposition of rooms in an apartment. The other study (5) (1930) examines the psychological and physical aspects of the yard.

The interior design department had a variety of commissions, including the interior of a Suchard chocolate shop in Leipzig (6) 1930.

Hannes Meyer and Hans Wittwer's project for the League of Nations Building in Geneva (7) (1926–7) brought them international attention.

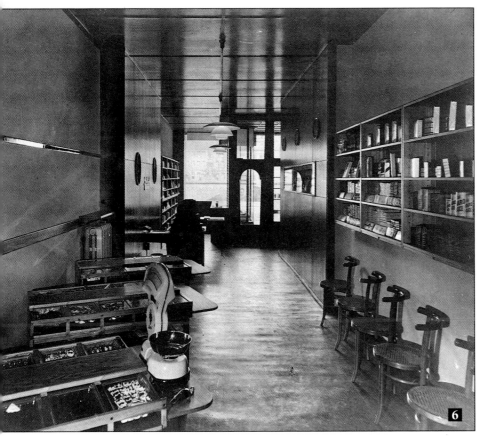

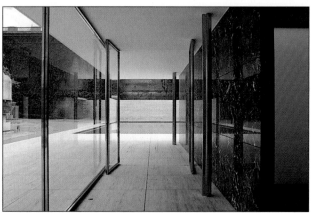

Mies van der Rohe's exquisite German Pavilion (**1**), built for the Barcelona World Exhibition in 1929, sums up the qualities of his work: clarity of structure, purity of composition and luxury of materials. It confirmed his standing as an architect of international importance.

3

1

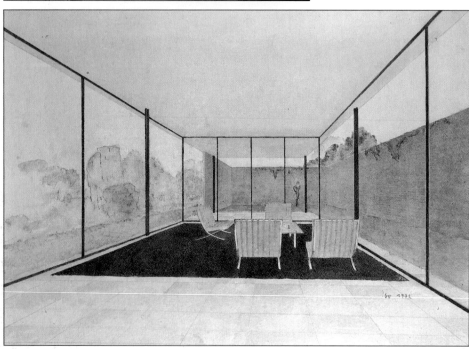

2

Bauhaus architecture students worked very much in Mies's shadow. Heinrich Bormann's architectural interior (**2**) (1932) is entirely in the style of Mies, and furnished with his Barcelona chairs. The issues of mass-housing were pushed to one side. Mies asked the students to concentrate on the design of single houses, maintaining that if they could solve the design problems of a small house, they would be able to tackle larger projects.

Mies designed his first glass skyscrapers in 1920–1, in response to a competition for a corner site on Friedrichstrasse in Berlin (**3**). Ever at the forefront of architectural thinking, he realised that by using an internal skeleton, the outside walls could be visibly relieved of their load-bearing function. The undulating curves of this model were designed to create a play of reflections of the city in which its stood; the old way of defining mass through light and shadow was no longer relevant.

In 1927 Mies was put in overall charge of the Weissenhof estate in Stuttgart, which was a forum of progressive architecture in Europe, with buildings contributed by Le Corbusier, Walter Gropius, Bruno Taut, Hans Sharoun, J.J.P. Oud and many others. The brief was to provide middle-class housing, and to demonstrate up-to-date building techniques. Mies's model for the disposition of the buildings survives (4). The white walls and flat roofs earned Weissenhof the highly pejorative name "Arab village" among conservatives.

Students under Mies were still interested in building systems. The entry by Rudolf Ortner (5) in a competition called The Growing House in 1931–2, shows the core of a house, which could be expanded according to need.

The Tugendhat House (6) was built in 1930 on a steeply sloping site overlooking the city of Brno in Czechoslovakia. It may be seen as an attempt to transpose the spatial concept of the Barcelona Pavilion into a domestic context. The large living space offered a panoramic view of the city below.

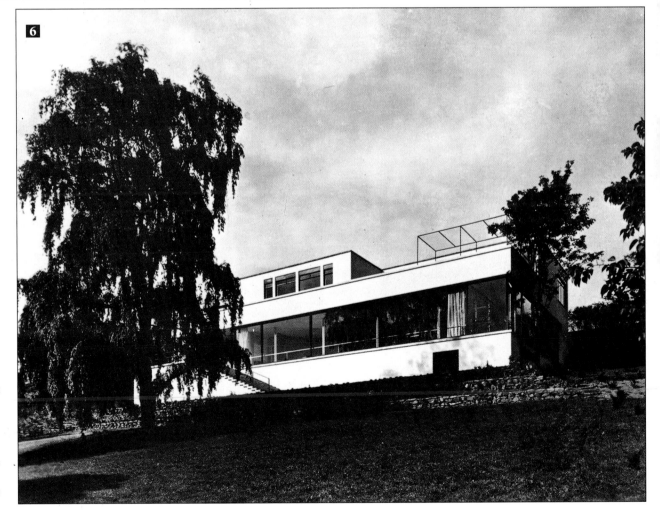

The Bauhaus wallpapers (1), manufactured by Rasch Brothers from 1930 onward, provided cheap, unobtrusive texture and pattern for the modern interior, and they were a good source of income for the school. Grete Reichart's experimental sample (2) shows the importance placed on texture.

3

2

1

4

The Bauhaus exhibition in 1923 gave Oskar Schlemmer the opportunity to design reliefs and murals in the vestibule and stairwell of the workshop building in Weimar (4, 5 and 6). He took what he regarded as the most important theme – Man. His highly stylised figures were deliberately destroyed in 1930, but have since been restored.

5

6

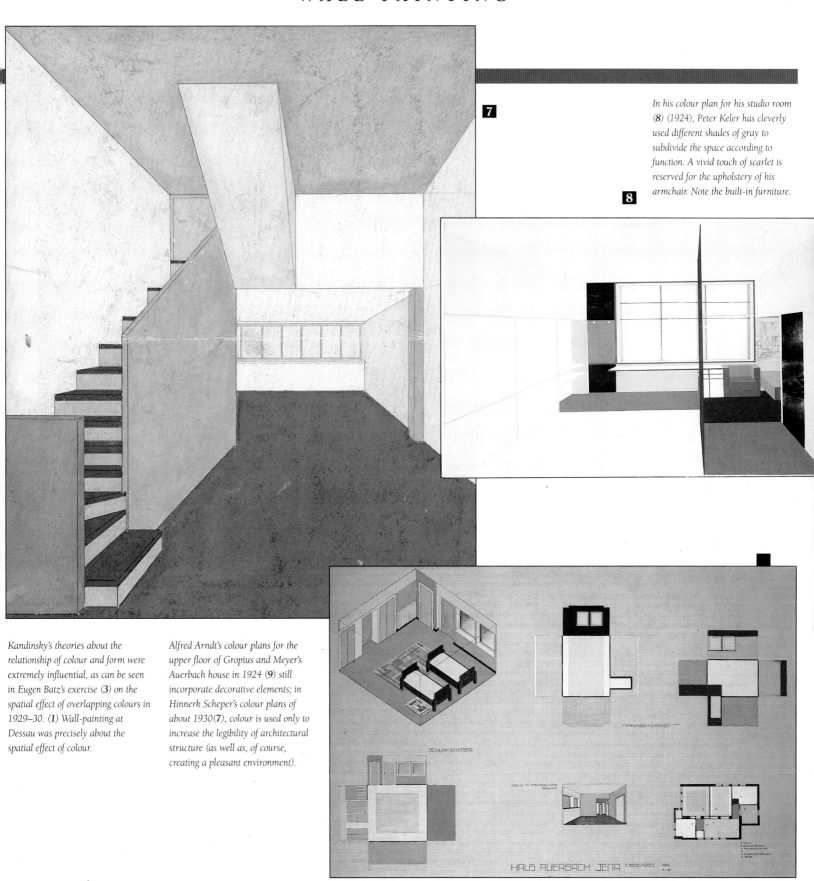

In his colour plan for his studio room (**8**) (1924), Peter Keler has cleverly used different shades of gray to subdivide the space according to function. A vivid touch of scarlet is reserved for the upholstery of his armchair. Note the built-in furniture.

Kandinsky's theories about the relationship of colour and form were extremely influential, as can be seen in Eugen Batz's exercise (**3**) on the spatial effect of overlapping colours in 1929–30. (**1**) Wall-painting at Dessau was precisely about the spatial effect of colour.

Alfred Arndt's colour plans for the upper floor of Gropius and Meyer's Auerbach house in 1924 (**9**) still incorporate decorative elements; in Hinnerk Scheper's colour plans of about 1930(**7**), colour is used only to increase the legibility of architectural structure (as well as, of course, creating a pleasant environment).

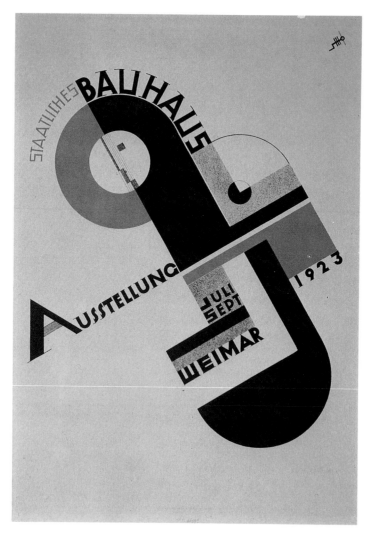

Poster for the Bauhaus Exhibition, Joost Schmidt, 1923.

CHAPTER • SIX

GRAPHICS

GRAPHICS

The innovations made in graphic design at the Bauhaus are among its most radical contributions to 20th-century design. In the interests of economy, it abolished use of capital letters, despite the fact that the German language demands them not only at the beginning of a sentence but also for every noun. It developed sans serif typefaces for international use at a time when Gothic typefaces were still widely used in the German-speaking world. It used graphic elements, such as rules and points, in an autonomous way, intended to enhance communication, and its sophisticated approach to advertising and exhibition design broke new ground.

1

Like Breuer's "African" chair (page 66), this book binding (1), probably made by Anni Wotitz in 1923, draws on the alternative tradition of an imagined Africa, with its boldly painted wooden spine, deliberately crude stitching, rows of tiny beads, and fibrous fabric on the front and back. The treatment does, however, match the content: Carl Meinhoff's "African Tales" (published Jena 1921). The way in which the different characteristics of the materials are highlighted has parallels with many of the materials exercises in Itten's compulsory preliminary course. As a book binding, it is worlds apart from the rational aura of the Bauhaus Books series, which began in 1925.

At the Weimar Bauhaus, there was neither a commercial art workshop nor a typographic printing press. However, a printing workshop and a book-binding workshop provided training in their respective crafts. The printing workshop was inherited from the Weimar Academy of Fine Art, along with the Craft Master, Carl Zaubitzer, a craftsman of traditional outlook. The artist Lyonel Feininger (1871–1956) was appointed as Form Master. The Bauhaus book-binding workshop arose through the co-operation of Otto Dorfner, one of the best-known book-binders in Germany, whose workshop was in Weimar. Paul Klee became the Form Master in 1921, but the workshop was dissolved in 1922, when Dorfner chose to discontinue the arrangement.

It should be emphasised that the printing workshop's function was the reproduction of graphic plates, such as lithographs, woodcuts and etchings. It produced four significant (and collectable) portfolios called New European Graphics, which included contributions from virtually the entire European avant-garde. One portfolio, the Meistermappe, was devoted to the work of the Bauhaus masters. The workshop also printed work for individual portfolios by Schlemmer, Marcks, Feininger and Kandinsky (Kleine Welten).

In order to earn money, the workshop also took on printing jobs with few artistic pretensions, a number of which came from the Weimar Government. For example, directly after the war, large quantities of material in memory of the fallen were ordered by the Ministry of State, and in 1921 the Department of Culture ordered certificates of honour for personal heroism. The workshop also printed bookplates and business stationery, and from 1923 onward, as part of the production drive on Bauhaus toys following the Bauhaus Exhibition, it was persuaded to reproduce lithographically thousands of coloured rings for Ludwig Hirschfeld-Mack's optical colour mixers.

The workshop was often in crisis as the apprentices were impatient of so much repetitive work and longed for more artistic tasks. It also faced serious difficulties with the printing unions, who, fearing state-subsidised competition, resented the workshop's existence and attempted to the exact union dues from the penniless apprentices.

However, despite the lack of a typographic workshop or letterpress equipment, a number of ad-hoc typographic experiments took place. In the early days, Johannes Itten's expressive and unorthodox use of typographic and calligraphic forms brought out the talents of students such as Friedl Dicker and Peter Röhl. Highly individual work was inspired by the twin influences of Dada (collage, freedom and lunatic juxtapositions) and De Stijl (orthogonals, bold colour and strong asymmetry). The postcards produced for the Bauhaus Exhibition show the full range of expression. In 1923 the student Herbert Bayer was commissioned by the State Bank of Thuringia to design some bank notes. These clear, measured designs turned out to be as ephemeral as his playful party invitations. German currency was at its nadir, and his notes, for denominations of one million, two million and two billion marks, were drastically devalued even

2 **3**

before the ink was dry.

It was László, Moholy-Nagy (who had no formal connection with the printing workshop) who introduced the elements of what is now thought of as Bauhaus typography, albeit with a greater emphasis on the picturesque than was later to be allowed by Herbert Bayer at Dessau. Moholy-Nagy devised striking advance publicity material for the Bauhaus books, which were to include titles not only by the Bauhaus masters, but also by international figures such as Mondrian, Malevich and Le Corbusier. Moholy-Nagy's advertisements owed much to constructivism and, in particular, the influence of De Stijl. He designed page layouts as pictorial compositions, using accented elements such as rules, points and bold colour. He articulated the constituents, insisting on their separateness, in just the same way as the furniture and pottery workshops were doing. While the results are attractive and lively, there is often more form than function. Although Moholy-Nagy claimed he was aiming for optimum legibility (function), it was fundamentally a formalistic approach. It was also guaranteed to upset traditionalists, particularly when sections of text were set at right angles.

The person responsible for the coming of age of Bauhaus typographic design was Herbert Bayer (1900–85), who had already distinguished himself at Weimar. After the move to Dessau, he was appointed leader of the new workshop, which he declared was for "typography and advertising art." No need was felt for a book-binding workshop; the Bauhaus was now aiming for mass production and mass circulation. There was little room either for limited editions or graphic art.

Although he had learned a lot from Moholy-Nagy and De Stijl, Bayer set out to develop a more systematic, restrained approach, which would befit an age of the mass rather than the individual, and the international rather than the national. Working to a strict grid and using only DIN format paper sizes (A4, A5 and so on), he created the public image of the Bauhaus, through its stationery,

its price lists, its catalogues and other publications. He chose to work with sans serif typefaces. This not only minimised the association with hand-written characters (the individual) but also with specific national characteristics. One of the best-known typefaces he developed, which was in fact rarely used except in exhibition displays, was called the Universal. It was one of a number he designed in 1925–7, which also included a contourless shadow type for advertising purposes.

Emergency banknotes (2) were designed in 1923 for the Thuringian Government.

Marianne Brandt's collage (3) called "The Rebirth of Beauty" (1927) uses photographic collage to ironic effect.

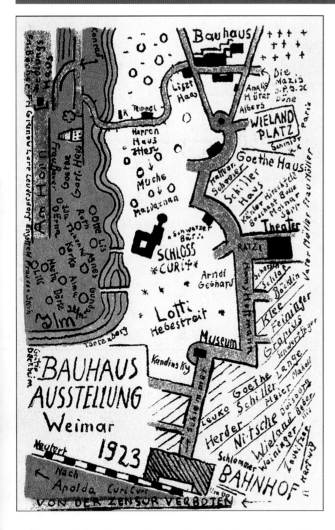

BAUHAUS
AUSSTELLUNG
Weimar
1923

Kurt Schmidt's postcard (1) was one of a series of twenty cards designed by masters and students to publicise the Bauhaus Exhibition of 1923. It is typical of one of the early types of graphic design at the Bauhaus. It is a deliberately personal, hand-drawn map of the town (which no one would dream was to scale), crammed with points of interest. These include not only the famous Goethe and Schiller houses, but also Itten's workshop, called the "Temple".

1

2

Significant innovations also took place in advertising design. Like book design, it was conceived in terms of striving for effective communication. At Weimar, Bayer and others had boldly applied constructivist principles to the field, but at Dessau, new elements were added. Bayer, who considered himself a painter above all, incorporated into his commercial work a surrealist sensibility. This led him to make imaginative use of photography. In particular, he developed a method of printing photographic elements over strange colours to give an alienating effect.

This work had an enormous influence on the German advertising industry, and its importance was immediately recognised. In 1927, for instance, the Association of German Advertising Specialists held its training conference at the Dessau Bauhaus. The importance of its work in advertising is also indicated by the fact that when Joost Schmidt (1892–1948) succeeded Bayer as leader of the workshop in 1928, it became

Always aiming for consistency, in each piece of work he confined himself to a single typeface and used different weights and modest amounts of colour to denote the relative importance of different sections of the text. Pages that included a great deal of information were arranged visually in terms of the information's relative importance. Crucial information would, for instance, be placed in a box or printed on a block of colour.

The most controversial element in the corporate image he created for the Dessau Bauhaus was Kleinschreibung, (literally, small writing), which meant abolishing all capital letters. Bayer argued that the upper case was not pronounced and that having two alphabets rather than one was a waste of time, work and money and made life unnecessarily complicated for everyone from school children and typists to businessmen and typesetters. This radical stance did nothing to endear the Bauhaus to the outside world; it was seen as a deliberate blow to the heart of German *Kultur*, and its enemies on the Right used it as a supreme example of the Bauhaus's hateful "Culture Bolshevism."

Moboly-Nagy designed this highly disciplined cover for Albert Gleizes' Kubismus (2). It clearly communicates that it is book number 13 of the Bauhaus Books series, as the title is set into a block filled with the repeated word "Bauhausbücher," beneath the enormous numeral. The publisher is relegated to the back. Each title had a different cover design, but the sense of series had to be maintained. In this design, there is no illustration whatsoever; only typographic elements are used.

known as the *Reklame-Abteilung* (Advertising Workshop). Under Schmidt, its curriculum was thorough and focused. It included everything from technical studies and advertising theory to photography and life-drawing. The discipline of typography became an important part of the general Bauhaus education, and two terms of the preliminary course were devoted to it.

Under Schmidt, exhibition design became an important area for the advertising workshop, and it worked on a number of important external commissions, often in collaboration with other Bauhaus workshops such as carpentry, textiles and metal. In Schmidt's view, the purpose of exhibitions, like advertising, was to inform and influence the public. Bauhaus exhibition designs such as the Junkers & Co stand at the Berlin Gas and Water exhibition, The People's Dwelling in Leipzig, The Contemporary Housewife in Dessau and the Deutsche Werkbund stand at the Living Space and Workspace exhibition at Breslau, created quite an impact, particularly because they contained unusually large amounts of detailed, matter-of-fact information about the subject. They were

3

JOOST SCHMIDT

Joost Schmidt (1893–1948) became Oskar Schlemmer's most talented student in the sculpture workshop. Born in Lower Saxony, he studied painting at the Academy of Art in Weimar. After active service (including being wounded and captured in World War I), he returned to Weimar to join the Bauhaus. As well as turning his hand to graphic design, Schmidt worked on Gropius's Sommerfeld villa in Berlin (1921). In 1925 he was appointed head of the sculpture workshop, and after Herbert Bayer's departure in 1928, he also took charge of the graphics workshop, having previously given a special course in typography. Nicknamed "Schmidtchen", he was universally well loved at the Bauhaus and was one of its most versatile teachers.

After the Bauhaus was closed down in 1933 he worked for the architect Hugo Haring in Berlin, as well as teaching at the progressive Reimann School. The National Socialist regime deprived him of his job, but he earned money by doing odd jobs and devoted himself to investigations of colour and perspective.

In 1944 he was called up to serve in the army once more, and in 1945 he was appointed professor at the Academy of Art in Berlin, where he gave a preliminary course for architects. He died in Nuremberg in 1948.

Joost Schmidt designed the label for this typewriter ribbon box (3) in 1924–5. Paul Henss was a Weimar firm, and Schmidt designed not only its logo, but all its publicity material (4) is the first page of Moholy-Nagy's 1923 invitation to subscribe to the Bauhaus Books. It shares with (3) an ad hoc approach to typographic design.

4

also unusual in the way that they incorporated both graphic and photographic material. In 1929 Walter Peterhans (1897–1960) was appointed to lead a new workshop for photography. Photography had long been a consuming interest at the Bauhaus, and it had been fuelled by the presence of Moholy-Nagy and his wife Lucia, who were outstanding and inventive photographers. Peterhans's photography workshop had a close relationship with advertising and exhibition design, which continued to be taught right up until the dissolution of the Bauhaus. There was, however, increasing friction between Mies van der Rohe and a number of dissident students who made it clear that they resented doing so many commercial projects, especially since Mies had abolished the system whereby students received a proportion of the profit from their work.

Despite this ending, the developments in graphic design made at the Bauhaus were, and continue to be, internationally important. When the National Socialists assumed power in Germany in 1933, Teutonic Gothic type became their house style, and the forced emigration of progressive designers from Germany resulted in the widespread dissemination of the Bauhaus influence. In subsequent years, Bayer's attitude to the upper case has still been regarded as too radical to be widely applied, but freedom of page layout and typography has been enhanced by recent technological developments such as electronic page composition. The influence of the Bauhaus's innovations in graphic design is so diffuse that it is now hard to pinpoint.

Theaterzettel der Dresdner Uraufführung des „Rosenkavalier"

4 **5**

The boldness of Russian Constructivist graphics was a source of inspiration for the Bauhaus. El Lissitzky's cover for the catalogue of the First Russian Art *exhibition (*1*), held in Berlin in 1922, demonstrates both its boldness and its wilfulness.*

The handbill for the premier of Richard Strauss's opera Der Rosenkavalier (2) *is an example of the typographic confusion which the Bauhaus graphics workshop sought to eradicate.*

One of the features of Dada was its love of nonsense poems. Kurt schwitters's poem Cigarren (4) *(1918–1922), published in an anthology called* Die Neue Anna Blume, *shows bis technique of making pictorial compositions of decomposed words and syllables. Together with Kate Steinitz and Theo Van Doesburg, Schwitters took this further in* Die Scheuche Marcher (The Scarecrow) (3) *(1925).*

Surrealism was an important influence on Bauhaus advertising design at Dessau. max Ernst's "Of this men shall know" (5) (1923) shows the surrealist's love of mysterious landscapes and perplexing juxtapositions.

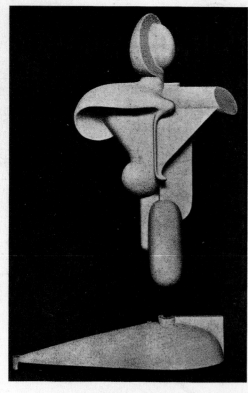

When Joost Schmidt took over the design of the Bauhaus journal in 1929, he altered the design of the title, removing the last serifs on the "a"s and reversing it out. Different types of information (title, illustration, technical details) were confined to separate areas. The title page of 1929/4 (1) features Oskar Schlemmer's Freiplastik G.

This spread from the 1927 Bauhaus book International Architecture (4), designed by Moholy-Nagy, demonstrates how typographic elements were used to enhance legibility: bold rules, different typefaces and weights, and boxes.

Typography became an important discipline at Dessau, and two terms of the preliminary course were devoted to it. As in other areas of design, the goal was to return to first principles, and to reassess typography rationally in terms of effective communication. Several attempts were made to design new typefaces, including Josef Albers' design for stencil lettering (2) in 1926. Aiming for improved legibility at a distance (particularly for posters), Albers constructed his typeface from three basic geometric shapes: the square, the triangle as half of the square and the quarter section of a circle with the same radius as the side of the square. Each element making up the letters remains separate. He believed his system achieved economy and clarity.

Herbert Bayer, as well as developing what he called the Universal Type, designed a contourless shadow script (3). Its dramatic effect was intended for use in posters and prospectuses. One of the purposes of these new typefaces was to eradicate national characteristics in typographic design so facilitating effective international communication.

Bayer's masterly cover for the Bauhaus journal (1928/1) (5) shows the elements with which Bauhaus designers worked: the T-square, the primary solids, which cast their shadow over the contents of the journal, and the artistic sensibility, which has organised the composition for maximum effect and atmosphere. It is also a very clever piece of design, subtly using the magazine itself as the subject matter of its cover.

5

TYPOGRAPHY

Oskar Schlemmer's cover design (1) for the year book Utopia. Documents of Reality (1921) is a good example of the subjective, freehand approach to typography which prevailed in the early years. Under the powerful influence of Johannes Itten, the aim was to find forms which expressed content as fully as possible. The effects were frequently haphazard and idiosyncratic.

At Dessau, typography became more disciplined and collage became the preferred medium for experimental juxtapositions of different kinds of lettering. Lou Scheper's collage (2) (about 1927) is an amusing, but evidently heartfelt, tribute to the artist Florence Henri, who became very popular with the students during her brief stay at the Dessau Bauhaus. (Henri's name is pasted in at the top right-hand corner.)

The cover design for Hölderlin's Patmos (**3**) (1922) is composed from the letters of the title. The cover, made of coloured calf's leather glued on parchment, is by Franz Singer or Friedl Dicker.

The design of Johannes Itten's essay "Analysis of Old Masters" (**4**) in the 1921 Utopia yearbook, by Itten and Friedl Dicker, attempts to synthesise typography and content to convey maximum meaning.

Lyonel Feininger created a unique personal typographic style for the portfolio New European Graphics, 1921, of which (**5**) is the title page.

Eberhard Schrammen's woodcut (**6**) for the title page of the journal Der Austausch in May 1919 shows the strong Expressionist vein in early Bauhaus work.

Friedl Dicker's program design (**7**) for the first Bauhaus Evening with the poet Else Lasker-Schüler is a typically exuberant example of early Weimar typography.

Gerd Balzer's typography exercise (**8**) (1929) was done as part of Joost Schmidt's compulsory typography course.

Herbert Bayer's dadaistic invitation to the Weimar Bauhaus's farewell party in March 1925 (**9**) comes complete with black-edged message of condolence.

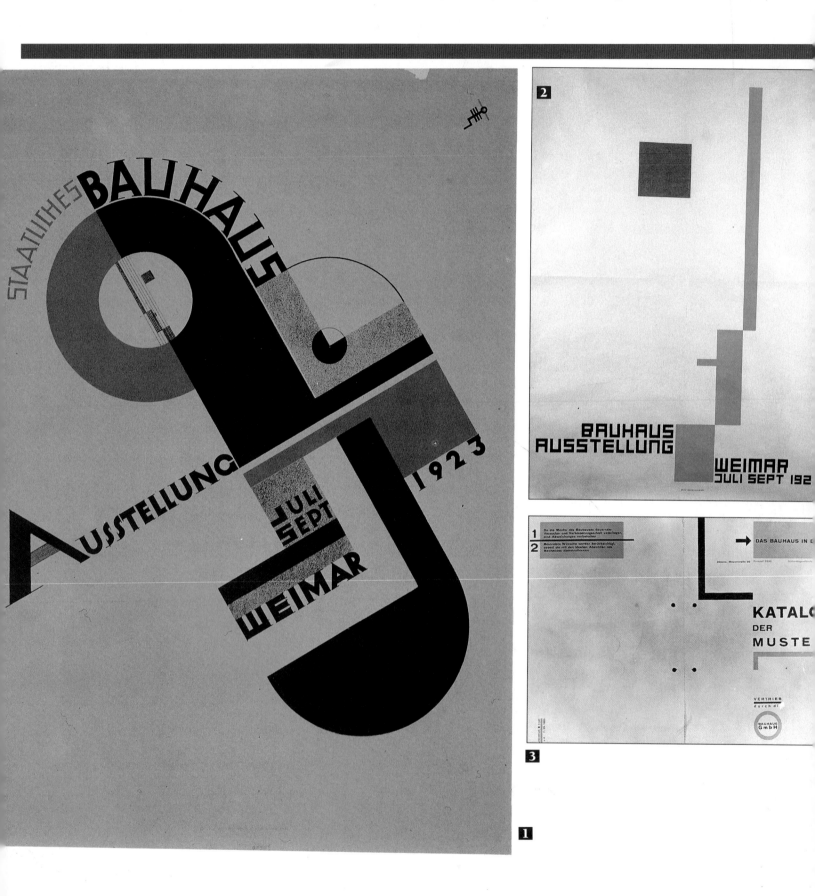

The Bauhaus Exhibition of 1923 was the school's first major entry into the public arena. The publicity for the exhibition (**1, 2**) incorporated the geometricized profile which Schlemmer had devised for the Bauhaus seal in 1922. In Fritz Schleifer's lithographed poster (**2**), the profile is reduced to a red square and four blue oblongs; it reappears at the hub of Joost Schmidt's better-known dynamic diagonal composition in red and black (**1**).

Herbert Bayer was responsible for creating a consistent Bauhaus house style from 1925 onward. Everything from the Bauhaus catalogue (**3**) (1925) to the director's letterhead (**4**) (1929) expressed the Bauhaus "corporate image". Bayer achieved this by using only DIN format paper sizes, working to a strict grid and confining himself to two colours (black and red), and a single typeface.

Paul Klee's lithographed postcard (**5**) was one of a series of twenty designed by teachers and students to publicise the 1923 Bauhaus Exhibition.

Herbert Bayer (1900–85) had a decisive influence on the development of typographic and advertising design. Born in Haag, Austria, he trained in an applied arts studio in Linz. He worked for the architect and designer Emanuel Margold before enrolling at the Bauhaus in 1921. He entered the wall-painting workshop and also experimented in graphic design. After travelling for a while in 1923–4, he returned to the Bauhaus in 1925 as the head of the graphics workshop.

In 1928 Bayer moved to Berlin. For the next 10 years, with the typical versatility of the successful Bauhaus graduate, he worked as a commercial artist, photographer, painter, display designer and typographer, becoming director of the Dorland advertising agency and art director of Vogue magazine.

In 1938 he immigrated to the US, where he collaborated with Walter and Ise Gropius in arranging the Museum of Modern Art Bauhaus exhibition of that year. He acted as a consultant for Wanamaker's department store and for J. Walter Thompson advertising agency among other work. Bayer moved to Aspen, Colorado, in 1946 and continued to work in a wide range of fields, including painting.

BAUHAUS BOOKS

The Bauhaus Books, edited by Gropius and Moholy-Nagy, were published by the Albert Langen Press in Munich. Fourteen volumes appeared between 1925 and 1931, and they were important ambassadors for the Bauhaus in the outside world. All but one of the covers of the paperback editions and the identical jackets of the bound editions were designed by Moholy-Nagy, who was also responsible for the typographical layout of all but two. Their striking covers were created from a combination of graphic, typographic and photographic material.

The titles included works by Bauhaus masters, such as Klee's *Pedagogical Sketchbook* (**2**) (*1925*), *Kandinsky's Point and Line to Plane* (**8**) (*1926*) *and two books by Moholy-Nagy: Painting, Photography, Film* (**10**) (*1925*) *and From Material to Architecture* (**12**) (*1929*). *They also included books featuring Bauhaus*

work: An Experimental House from the Bauhaus (**3**) (*about the Haus am Horn*), New Work from the Bauhaus Workshops (**7**) and The Bauhaus Stage (**4**). *However, the series also contained works by members of the international avant-garde, such as Piet Mondrian's* New Design (**5**), *Theo van Doesburg's*

Basic Concepts in the New Art and Design (**6**), *Kasimir Malevich's* Non-objective World (**11**) *and J.J.P. Oud's* Dutch Architecture (**9**).

LÁSZLÓ MOHOLY-NAGY

Moholy-Nagy (1895–1946), sculptor, painter, designer and photographer, was born in Hungary and began painting while convalescing from wounds received in World War I. Impressed by German Expressionists and the Russian avant-garde, in 1919 he formed a group called Ma ("Today"). After two years in Vienna, he met the constructivist El Lissitzky in Dusseldorf, before moving to Berlin where, like several other Bauhaus masters, he exhibited at Herwarth Walden's Sturm gallery.

In 1923 Gropius appointed him head of the Bauhaus metal workshop, and he made important contributions to the development of the preliminary course, which he took over from Itten. His appointment was controversial, however, as he was a committed constructivist, whose uncompromising stance was declared by his uniform of boiler suit and steel-rimmed glasses. He scornfully rejected the idea of divine inspiration of art, of individual genius and of art as private property.

He was a tremendous polymath. Introduced to photography by his first wife, Lucia, he experimented with techniques for abstract photography (photograms). He also did typographic design and co-edited the Bauhaus books. His paintings are balanced compositions of geometric elements, deliberately blandly executed and entirely reproducible, with pseudo-scientific titles.

In 1928 he moved to Berlin and became involved in experimental film and stage design for the State Opera and for Piscator. Before emigrating to the US in 1937, he travelled widely in Europe, working on animated documentary films in London in 1935–7. He became director of the New Bauhaus school in Chicago in 1937, and following its closure because of financial difficulties in 1938, he opened his own Institute of Design in Chicago, which he directed until his death in 1946.

Herbert Bayer designed the first major Bauhaus publication The State Bauhaus in Weimar 1919–1923, *which was the catalogue accompanying the school's first major public exhibition in 1923. Its format is square, which is unusual. As the title page (1) shows, although Moholy tended to claim functional reasons for his designs, his approach at this stage was largely picturesque. Although heavier type is used to emphasise the most important elements – "Bauhaus" and "1919–1923" – many elements are obviously formalistic. Overlapping the large B, and the S of "Staatliches", for example, is something that he probably would not have done later.*

Moholy-Nagy's typographic design for Gropius' Bauhaus Buildings in Dessau (2 and 3) in 1930 is much more measured and sober. On the title page (2) only one (lower case) typeface is used, in two different weights.

2

STAATLICHES
BAUHAUS
WEIMAR
1919
1923

WEIMAR - MÜNCHEN

BAUHAUSVERLAG

1

The cover design for Bauhaus Buildings in Dessau (3) runs along a bold diagonal across both the front and the back, using axiometric drawings of the Törten estate. A stencil typeface is used for the title. Other essential information is enclosed in a box.

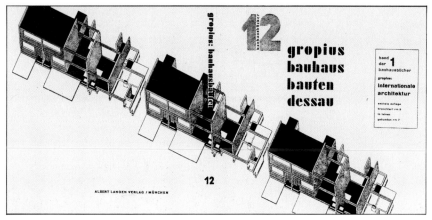

3

For party invitations, such as Franz Ehrlich's ingenious folding invitation to the Bauhaus carnival celebrations in March 1930(**1**), fantasy was allowed to run wild.

Such was the importance of advertising design at the Bauhaus, that when Joost Schmidt became leader of the graphics workshop in 1928, it was re-named the advertising department. Sophisticated techniques were developed, many involving the use of photography and photomontage. In 1930 Schmidt designed two brochures for the Dessau tourist office (**3** and **4**), using classical pillars to symbolise the historic aspect of the city and a Junkers airplane to symbolise its principal modern industry.

Alfred Arndt's 1922–3 poster for the Co-op bakery (2), with its red square and blue circle on a yellow background, clearly subscribes to Kandinsky's theories about form and colour. Another Co-op poster (5), in red and black, is quieter on the eye. It ask "Are you a member?"

Moboly-Nagy's photomontage Transforming (1925) (6) was adapted in 1927 to create a poster for the Schocken department store, in which a figure with upraised hands (Marcel Breuer) says "Stop! have you been to the Schocken Department Store yet?", and a path beckons toward the shop.

Joost Schmidt's 1931 advertising material for Bauhaus wallpapers (7, 8, 9), shows a roll of wallpaper unfurling and, reflected in a metallic ball, an empty room, ready for wallpapering with the reflected slogan, "The future belongs to Bauhaus wallpapers."

Herbert Bayer designed a number of startling constructivist kiosks, including a newspaper kiosk (1) (1924). With its tremendous height and bright blocks of colour, it is about as obtrusive as a kiosk could be. The words and the arrow leave no one in doubt as to where to buy a paper.

Similarly, Bayer's cigarette booth (2) is crowned by an enormous, smoking cigarette. The use of collage adds to the vividness of the designs, while the figure of the man indicates the scale.

Joost Schmidt's advertising department received a number of important commissions to design exhibitions, including the canned goods manufacturers' stand at the International Hygiene Exhibition in Dresden in 1930 (3) and the Junkers stand at the Gas and Water exhibition in Berlin in 1929 (4). These exhibition stands were unusual both in their use of graphic and photographic material and in the amount of detailed information presented to the public. The tinned goods stand has a scientific, objective feel to it, and the film strip lends it a documentary quality.

PHOTOGRAPHY

Photography was a consuming
interest at the Bauhaus.
Photomontage techniques were used
to amuse and subvert, as in Marianne
Brandt's Matter of Taste (**2**) (1926).
Otto Umbehr's Raving Reporter (**1**)
(1926), a portrait of the Austrian
reporter Egon Erwin Kisch, is

4

5

composed of the tools of his trade: a gramophone born for his ear, a camera for his eye, a pen for his arm and a typewriter for his thorax – the modern media man.

Walter Peterhans' studies of everyday objects and materials frequently took a surrealist turn, as in his Portrait of the Beloved (3) (1929), a disturbing collection of feathers, hair, netting and a staring nipple/eye.

Moholy-Nagy's seemingly informal compositions strongly influenced photographs such as Hajo Rose's Bauhäusler (6) (1930), in which one student is casually walking out of the frame. Edmund Collein's Friend in Simultaneous Exposure (4) (1928) creates mystery and atmosphere.

This c.1930 study (5) from Albers' preliminary course (see page 16) is an exercise in manipulating and transforming photographic images. Repeating, compressing and stretching images (largely taken from magazines) could result in the illusion of movement.

Peterhans encouraged the students to use photography for careful observation, and they produced work focusing on everyday life, such as Detail of an Ashtray (7).

6

7

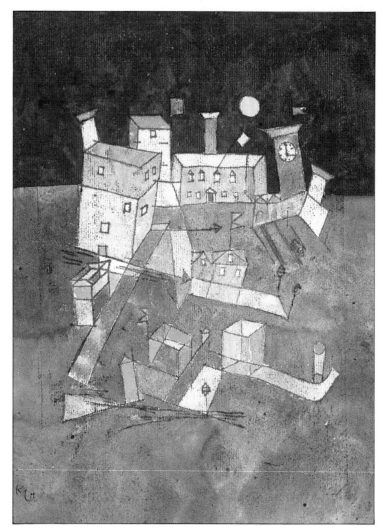

Partie Aus G, Paul Klee, 1927.

CHAPTER • SEVEN
PAINTING AND SCULPTURE

PAINTING AND SCULPTURE

The Bauhaus masters included some of the most distinguished painters of this century, and their courses on the elements of form were of central importance to the school. However, painting itself was not part of the curriculum until the very last years, and it was even regarded as something of an illicit activity in some quarters. Once the overall goal of the Bauhaus had been defined as the development of a design language for industrial manufacture, easel painting could be seen as a personal indulgence. It also suffered by association with the bourgeois art market. Despite all this, painting remain a subject of passionate interest for all BauhÑusler and, in accordance with Gropius's original concept, it was a tremendous source of inspiration for all the activities of the Bauhaus.

The Bauhaus was founded during a period of great artistic innovation, exploration and questioning; indeed, it was a time of total re-assessment of the fundamentals of visual art. Both directly before and after World War I, Berlin was at the hub of the international avant-garde. Culturally, it was very close to the Soviet Union. In particular, Berlin's Der Sturm Gallery, to which many of the Bauhaus masters had affiliations, was a meeting point for innovators of all persuasions, from expressionism, to futurism to constructivism and suprematism.

The painters at the Bauhaus can be grouped into three generations, which did not necessarily correspond to age. The students jokingly referred to Paul Klee, Wassily Kandinsky and Lyonel Feininger as the "Old Masters."

Their painting has a strong spiritual dimension, marked by a desire to see through the physical to achieve the metaphysical,

1

In this view of the stone-carving workshop in 1923 (**1**), one of Schlemmer's studies for his abstract figure "Freiplastik G" is in the right foreground, opposite Kurt Schwerdtfeger's sandstone "Architectural Sculpture". Reliefs by Joost Schmidt can be seen in the background.

2

The woodcarving workshop, also seen here in 1923 (**2**), contains on the one hand, a chest by Lily GrÑf, decorated with constructivist patterns based on squares and right angles, and on the other hand, a deliberately primitive, emotive totem pole (at the back behind the workbench).

and, as Klee put it, to make visible the invisible. Feininger was allowed to be present at the Bauhaus with no formal teaching duties; the influence of his work and his personality was, however, strong. Both Kandinsky and Klee were asked by Gropius to give courses on the elements of form. The two artists were very different in their approach. Although Kandinsky's approach to art was deeply spiritual, his concern was to convey its objective laws. He had a lawyer's logical discipline, and his pronouncements to the students were dogmatic.

Klee, on the other hand, was more tentative in his analysis of the roots of formal creation. While Kandinsky was admired and respected, Paul Klee was worshipped. A great deal of imitative

medium. He did paint, in a severe constructivist manner, and his compositional concerns with balance and movement were transmitted to the students directly through his teaching on the preliminary course. Josef Albers, too, carried his formal interests into the preliminary course. (Alber's later work in the United States was important in the development of what came to be called Op Art.) Herbert Bayer, who regarded his painting as more important than his achievements in graphic design, worked in a surrealist vein, which became a popular area for student painters at Dessau. The youngest generation was composed of students such as Max Bill, Fritz Winter, Eugen Batz and Werner Drewes, for whom painting remained an important means of experiment and expression.

Among the painters at the Bauhaus there was of course a tremendous diversity of approach, but all of them, whether abstract or figurative, shared an interest in elementary forms. These could either be interpreted mathematically, as the Platonic absolutes of the circle, square and triangle, or in terms of the primeval roots of every living organism. The results could either be proudly "objective" or deeply "subjective."

The theoretical position of art at the Bauhaus was always difficult, as the Bauhaus was constantly in danger of being accused of formalism in design. In 1930 Ernst Kallai, editor of the Bauhaus Magazine, wrote an article called "Ten Years of Bauhaus", in which he castigated the contemporary popular misrepresentation of the Bauhaus ideals by a superficial marketing gimmick called "Bauhaus style", which by then was all the rage. He also took the opportunity to question the validity of painting

work blossomed in their shadow. Johannes Itten's and Georg Muche's meditative, mystical works also fall into this generation, along with Schlemmer's explorations of the human figure in space. Schlemmer held well-attended life-drawing classes in the evenings, and at Dessau, in 1928, he devised an important, broad-based anthropological course, called Man, which was obligatory for third-year students.

The younger generation of painter-masters included Moholy-Nagy, Josef Albers and Herbert Bayer. László Moholy-Nagy's conception of art and the artist was far removed from that of the Old Masters. He was scornful of the spiritual and the individualistic and of any artist competent only to work in one

Lyonel Feininger's woodcut "Gelmeroda" (3) (1919) was one of many in which he turned to the Thuringian countryside and villages for subject matter.

The systematic study of colour played an important role at the Bauhaus from the outset. Karl Cieluszek's colour study (4) of about 1929 compares the theories of Goethe and Ostwald.

at the Bauhaus. In a list of "Bauhaus style" characteristics (including tubular steel, lower case letters and ladies' underwear with "contemporary Bauhaus-style geometrical designs"), he also includes the following: "No painting on the wall: Bauhaus style. Incomprehensible painting on the wall: Bauhaus style."

In Kallai's view there was an inequality in the partnership that Gropius had tried to establish between art and industry (represented in his Weimar slogan "Art and Technology: a New Unity"). Art had become such a guilt-laden activity that it was either falsely excluded or surfaced only in what he called dreams and conjurer's tricks. Representation had been corralled into the realm of photography, while the few painters brave enough to

1

Ludwig Hirschfeld-Mack's preliminary course study (1) of 1922 investigates the effects of the same pictorial elements in both positive and negative form. Hirschfeld-Mack became extremely interested in effects of contrast and colour and designed one of the Bauhaus's most popular educational toys, the spinning colour mixers, which demonstrated various colour theories by spinning disks of coloured paper.

look Nature in the face felt the need for spiritually protective goggles.

When Hannes Meyer became Director, the painters were immediately on the defensive. In fact, during Meyer's directorship, painting classes by Kandinsky and Klee were timetabled for the first time. This was not, however, a victory for painting. It represented, rather, its marginalization and removal from the heart of Bauhaus work. Sculpture, on the other hand, had an official position at the Bauhaus. In Weimar it took the form of stone and wood carving, which corresponded to craft disciplines. The carving workshop was among the first to open, and its initial leader was the former sculpture master at the Weimar Academy of Fine Art, Richard Engelmann. In 1920 Engelmann was succeeded by Johannes Itten who remained Form Master until 1922 (despite attempts by Gropius to break his hegemony). Until 1922 the two sections for wood and stone remained separate, with separate Craft Masters, plus a plaster-casting shop. In 1921 Josef Hartwig

was appointed Craft Master for both stone and wood, and the integration was completed in 1922 when Schlemmer became Form Master for both.

The Schlemmer/Hartwig partnership was generally successful, despite certain difficulties in the workshop. Hartwig understood Gropius's instructions to mean that he was to train the students in the skills of carving, turning and casting, and to prepare them for collaborative work with other workshops. The students, on the other hand, complained about the repetitive nature of the training and thought they were there to learn how to be sculptors. They were often involved in mundane commissions for other workshops, including making architectural models and plaster moulds for the pottery and stage workshops.

There were, however, more artistic tasks: the major work of the early years was the execution of Walter Gropius's expressionistic design for a memorial to those who died in the uprisings of March 1920. The workshop was also involved in preparing the reliefs

Heinrich Busse's woodcarving exercise (**2**) is a first attempt at working with woodcarving tools, and discovering what marks they are capable of making in soft wood. As always with early Weimar work, the influence of Itten's preliminary course is strong: the exercise has become an abstract composition of juxtaposed textures with strongly contrasting visual and tactile qualities.

2

3

that Schlemmer designed for the vestibule of the workshop building in 1923, which were intended to show the use of sculpture as an element of a total architectural concept. Schlemmer also explored the abstract possibilities of the human figure in three-dimensional sculpture. There was a parallel in such work with the theories of the New Architecture: instead of a single, static viewpoint, the viewer had to move around to appreciate multiple viewpoints.

One of the more talented students, Joost Schmidt, orchestrated the dramatic, semi-abstract woodcarvings executed in the Sommerfeld house. When the Bauhaus moved to Dessau, Schmidt was appointed leader of the workshop and it became a more attractive proposition for students. Its name was changed to "sculpture workshop," and it offered an exacting and stimulating exploration of the spatial relationships of three-dimensional forms. Schmidt's systematic methods aimed to develop very refined visual thinking. As a teacher, he was greatly appreciated.

Since, as we have seen, artistic work in two dimensions was a source of anxiety and heart-searching at the Bauhaus, Schmidt's sculpture workshop provided a valuable arena for formal experimentation.

Herbert Bayer's composition "B.N." (**3**) in ink, water-colour and tempera of about 1928 reflects not only his preoccupation with typography, but also his interest in surrealism, elements of which he was able to incorporate in his advertising design to great effect.

4

5

The upheavals of the Russian Revolution stimulated, on one hand, hectic collages and photomontages, full of images lifted from the "real" world, such as Yuri Rozhkov's illustration for Mayakovsky's poem "To the Workers of Kursk" (**1**) (1923) and, on the other hand, highly abstract work, such as Kasimir Malevich's Dynamic Suprematism (**4**) 1915.

In western Europe the questions that had been raised before World War I by the pioneering experiments of Cubism were still being answered in a variety of ways. Georges Vantongerloo's sculpture Interrelation of Volumes (**2**) (1919) represents the formal, constructivist impulse. Emil Nolde's Portrait of a Woman (**3**) (c.1912) represents the German Expressionists' approach.

In Italy the Futurists sought to capture the dynamism, speed and noise of the modern world. Gino Severini's painting Suburban Trains arriving in Paris (**6**) (1915) captures the fragmentation of experience inherent in high-speed travel, with partial glimpses, through puffs of steam, of roofs, trees, advertising images and telephone lines, symbols of modern high-speed communication. Georgio de Chirico's painting The Painter's Family (**5**) (1926), on the other hand, is a surrealist retreat from modern life into a world of private meaning and more obscure iconography. The allusions to classical antiquity may be seen as part of a wider return to classical themes in the mid-1920s.

6

KLEE

PAUL KLEE

A highly respected and much loved teacher, Paul Klee (1879–1940) was born near Bern, Switzerland. He trained in Munich and travelled in Italy and Paris. During these early years, he was wary of colour and developed a graphic style that was influenced by Blake, Beardsley and Goya, and that produced minutely detailed anatomical drawings and satirical etchings. He settled in the lively artistic centre of Munich in 1906, and from 1911 he was associated with the Blaue Reiter group, which included Kandinsky.

In 1914 he travelled to Tunisia and was overwhelmed by colour and by the tumbling cuboid forms of the buildings. On his return, his palette became brighter, and his experience of Tunisian architecture helped him to define his relationship with Cubism.

He was a strongly intuitive, poetic artist, who was also highly musical. Teaching at the Bauhaus from 1920 to 1931 forced him to analyse the processes of creation, and a number of his teaching notebooks and theoretical writings have been published. In addition, he acted as Form Master for the Weimar textile workshop.

After leaving the Bauhaus, he taught at Dusseldorf Academy before the political situation forced him to return to Bern in 1933. No fewer than 102 of his paintings were confiscated from German galleries by the Nazis. His late work, a shadowy world inhabited by angels and demons, bears the marks of his final illness and despair.

1

2 **3**

When Paul Klee began teaching at the Bauhaus, it was the first time he had had to explain his creative processes. This experience, and the experience of being at the Bauhaus, had a significant effect upon his work. It enhanced his interest in architectural forms, which was first awakened in North Africa, and explored again in Partie aus G (The Party from G) (**3**) (1927, water-colour and oil). Klee's compositions grew organically, and he continued to work on them until he felt they had grown into something worthwhile, when he gave them a (generally mysterious) title. In this case, we could be looking at the route taken by a tourist party through a Tuscan village. Klee's systematic lessons on colour gradations found their way into a number of compositions, including his water-colour Szene unter Mädchen (Scene with Maidens) (**1**) of 1923. This is one of a number of vaguely theatrical or operatic pieces. The girls' pleated dresses lend them a classical feeling. Klee's tempera picture Variation II (**2**) was one of a portfolio of variations on a newspaper picture made by seven of the Bauhaus masters for Gropius' birthday in 1924.

KANDINSKY

Jocular Sounds (1) (1929, oil on cardboard) refers to Kandinsky's deep interest in correspondences between different senses, and the specific characteristics of different sensory impressions.

In Kandinsky's untitled water-colour of 1925 (2), it is interesting that the circle is red, which contradicts his seemingly dogmatic views, expressed elsewhere, that the blue corresponded to the circle, and red to the square.

WASSILY KANDINSKY

Wassily Kandinsky (1866–1944) taught at the Bauhaus from 1922 until 1933. He was born in Moscow and abandoned a distinguished legal career to train as an artist in Munich. He became a member of a number of progressive groups and in 1911 was one of the founder members of the Blaue Reiter ("Blue Rider") group. His theoretical turn of mind was married to a highly Romantic interest in synaesthesia – correspondence between the senses – and in other forms of transcendentalism. He became editor of the Blaue Reiter almanac and published the theoretical work *Concerning the Spiritual in Art* in 1912.

His early, more accessible work drew on memories of Russian folk art and impressions of German Art Nouveau (Jugendstil). In 1910 he crossed the border into the world of pure form and colour and produced what may be regarded as the first abstract paintings.

During World War I, he returned to Moscow and became involved at the highest levels in the new state's cultural politics, establishing the Moscow Institute of Art and Culture in 1920. In 1921, disillusioned with the situation in the Soviet Union, he returned to Germany and became Form Master for the wall-painting workshop at the Bauhaus, where he gave important courses investigating visual problems (particularly colour) and in analytical drawing. He was greatly respected, although some students found his ideas both over-complex and dogmatic.

In 1933 he emigrated to France, where he spent the last decade of his life working privately.

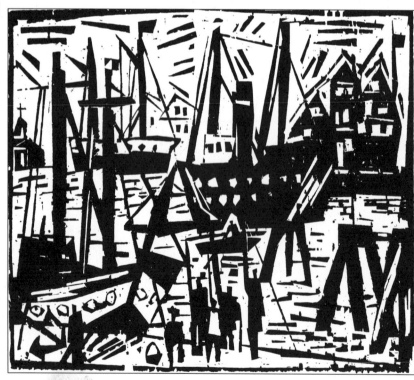

Feininger worked successfully in ink and water-colour, as in "Barkentine" of 1924 (**1**).

Lyonel Feininger's highly stylised, lively woodcut, "Harbor with Ships and Men" (**2**) (1919) hints at his former career as a successful cartoonist. When he joined the Bauhaus in 1919 at the age of 48, he had only been painting seriously for 12 years.

Feininger's "Bird Cloud" (**3**) of 1926 (oil on canvas) is a particularly beautiful example of his hard-won style. Sky, cloud, sea and sand are treated as iridescent planes of colour. A small white figure gives the scene a monumental sense of scale and space.

Georg Muche painted abstract compositions at an early date, exhibiting at the Sturm gallery in Berlin in 1926 and subsequently teaching at the Sturm school. His Abstract Composition (*1*) (1916, oil on canvas) is a good example of the richness and complexity of his compositions, which frequently have an unearthly quality.

2

Two Buckets (*2*) (oil on hardboard) is a later painting – 1923 – stylised rather than abstract. Like many of the younger painters at the Bauhaus, Muche was open to a great number of influences. This painting bears the marks of Cubism others have their origins in surrealism.

MOHOLY-NAGY AND ALBERS

A18 by Moholy-Nagy (1927) (**1**) draws heavily on Russian Constructivist painting for its vocabulary of overlapping geometric forms. However, Moholy-Nagy added the element of transparency in order to make more subtle explorations of pictorial space. A18 is a typically "objective" label for one of his pictures; "A" indicates that the painting is oil on canvas.

Moholy-Nagy's Circle Segments (**2**) of 1921 is an uncompromising composition: a black segment superimposed on a white segment, almost but not quite a semicircle, painted in tempera on raw, exposed canvas. Like many of the paintings at the Bauhaus, it explores the power of the basic geometric elements.

Homage to the Square: Against Deep Blue (1955) (**3**) was painted by Josef Albers as one of a major series, beginning in 1949. Like each one of the series, it is a meticulously conceived work, painted as evenly and accurately as possible in oil on smooth composition board, in order to demonstrate the properties and interactions of pure colour.

All the Bauhaus painters shared an interest in the elementary forms, whether these were interpreted as the primary geometric forms or as the primary organic roots of creation. Florence Henri's Non-objective Composition (1) (1926, oil on board) is strongly Cubist in its composition and tonal range, and it was, indeed, illustrated in the Bauhaus Book Kubismus, organised by Albert Gleizes. Henri was an established artist, but at the Bauhaus she was drawn away from painting toward photography.

The roots of Johannes Berthold's Abstract Composition (2) (1930, pastel on paper) seem to lie not in Cubism but in the shimmering excitement of futurism.

1

2

3

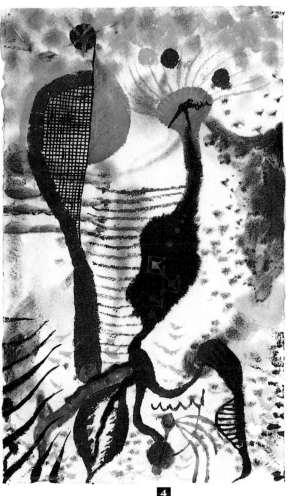

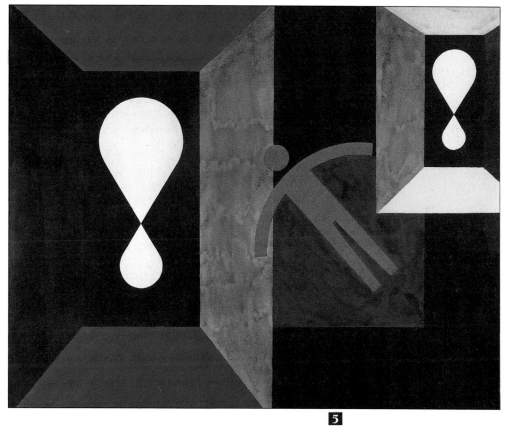

Werner Drewe's emotive Aggression (**3**) (1932, oil on hardboard) betrays an influence much closer to home: the boldness of Kandinsky's compositions. Similarly, Paul Klee's work seems to have inspired the other-worldly quality of Marcel Breuer's untitled water-colour of 1922 (**4**).

The strangeness of Karl Hermann Haupt's Red Man (**5**) (c.1925, gouache and water-colour on paper) lies in his exploitation of the way in which certain colours recede, while others advance, characteristics that Kandinsky endeavoured to formulate into rules in his teaching. The effect of Haupt's scene is very spatial.

Photomontage was another creative outlet for the students. Paul Citroen's Metropolis (**6**) of 1923 is an early example of this Dada-inspired technique at the Bauhaus. Citroen's use of advertising brand names such as Gillette and ODOL (a breath freshener) is a particularly Dadaistic touch. The double-edged excitement of the seething modern city was a pertinent theme in the 1920s; Fritz Lang's film Metropolis was made in 1925–6.

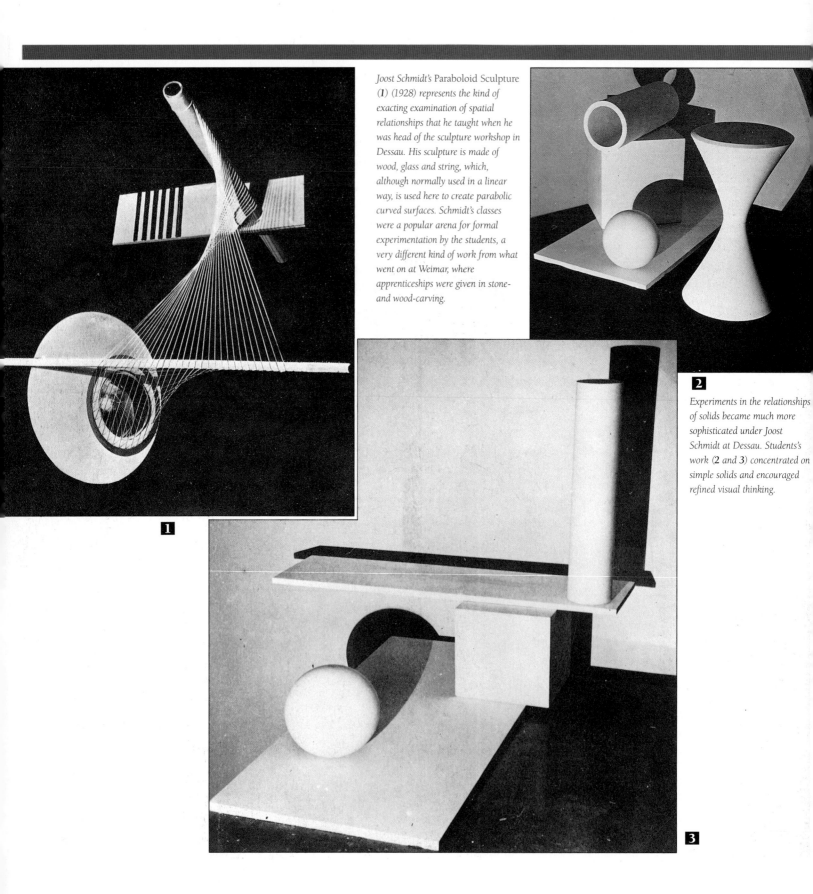

Joost Schmidt's Paraboloid Sculpture (1) (1928) represents the kind of exacting examination of spatial relationships that he taught when he was head of the sculpture workshop in Dessau. His sculpture is made of wood, glass and string, which, although normally used in a linear way, is used here to create parabolic curved surfaces. Schmidt's classes were a popular arena for formal experimentation by the students, a very different kind of work from what went on at Weimar, where apprenticeships were given in stone- and wood-carving.

2

Experiments in the relationships of solids became much more sophisticated under Joost Schmidt at Dessau. Students's work (2 and 3) concentrated on simple solids and encouraged refined visual thinking.

1

3

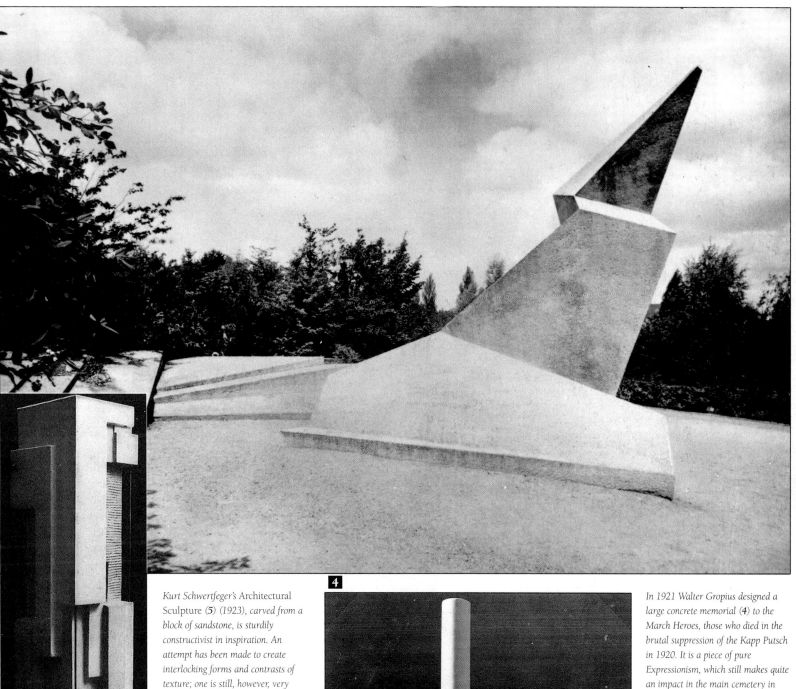

Kurt Schwertfeger's Architectural Sculpture (**5**) (1923), carved from a block of sandstone, is sturdily constructivist in inspiration. An attempt has been made to create interlocking forms and contrasts of texture; one is still, however, very much aware of the outline of the original block.

5

This exercise (**6**) in creating three-dimensional, sculptural form is achieved by rotating simple elements such as rings and rods.

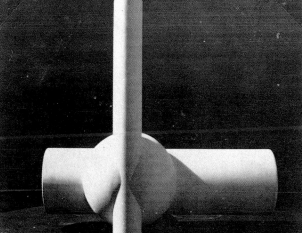

In 1921 Walter Gropius designed a large concrete memorial (**4**) to the March Heroes, those who died in the brutal suppression of the Kapp Putsch in 1920. It is a piece of pure Expressionism, which still makes quite an impact in the main cemetery in Weimar. The upward movement of the sculpture could equally well represent the continuing struggle of the oppressed as the lightning-bolt ferocity of the events it commemorates.

6

THE STAGE

Although the connection between the stage and industrial design is not an obvious one, the stage workshop nevertheless played an important role in the culture of the Bauhaus. It provided an arena for the exploration of issues that concerned everyone in all the different disciplines. One of these was abstraction, which the stage workshop saw in terms of stripping away inessentials to reach purity of expression. It was thought possible to devise a system whereby the means of expression were used in their pure form to become not just the vehicles but the content of the work. Since the broad concerns of architecture permeated every Bauhaus workshop, another crucial issue was space. The Bauhaus stage had a strongly architectonic quality, a desire to define and elaborate space. At the centre of this space stood man – not the individual, finite man, but the generalised, universal Man.

Set against these deeply serious concerns (and, in fact, inextricably wound up in them) was the Bauhaus love of parody, satire, improvisation and dressing up. It can be disconcerting to find that former students of the Bauhaus remember not so much the great theoretical debates that took place, nor what they were taught, but the parties. The major ones were spectacular and thematic; the whole school threw itself into the task of creating a total fantasy environment for the occasion, as well as devising invitations, costumes and masks. Impromptu entertainments would consist of Napoleon, Goethe and a dog exchanging nonsense with Frau von Stein (Goethe's mistress), Voltaire and Bismarck.

There was also a strong interest in music at the Bauhaus, which was perhaps not surprising given the interest in geometry and the patterns of mathematics. Two of the Masters, Paul Klee and Lyonel Feininger, were accomplished musicians. Wassily Kandinsky was fascinated by *synaesthesia*. A number of attempts were made to analyse the systematic yet deeply affecting compositions of J. S. Bach. There were a number of connections with the musical avant-garde; the Bauhaus Exhibition week in 1923, for instance, included performances of pieces by Stravinsky (*The Soldier's Tale*), Busoni and Hindemith. An impromptu Bauhaus band was formed, and it was soon in demand all over Germany for its dance music, which was a heady mixture of jazz, fragments of Slavonic folk songs, chair pounding, foot stamping and revolver shots. An old piano donated to the stage workshop was converted into a noise factory by sticking thumbtacks into the hammers and covering the strings with paper, nails, screws and other objects. The resulting sound was reported to lie somewhere between a harpsichord and a motorcycle. At Dessau, Gropius's wife, Ise, bought a phonogram and employed a dancing teacher to teach the Charleston.

The Bauhaus stage began work with the appointment of Lothar Schreyer in the summer of 1921. Schreyer (1886–1966) was a poet, painter and dramatist steeped in the expressionist theatre. He had long been closely connected with Herwarth Walden's trailblazing Sturm gallery and was Director of the Sturm Theatre, which was at that stage called the Kampfbühne (Battle Theatre).

Although it is hard to gauge the precise character of expressionist drama from scripts and photographs, it is safe to say that it was highly charged and emotionally raw. The syntax of plot was dissolved, leaving symbolic gestures and stammered outpourings. Schreyer himself regarded his plays, such as *Man* and *Crucifixion*, as sacred dramas, 20th-century mystery plays

1

Masks were one of the many devices used to depersonalise the figures of the Bauhaus stage (1). The dance pantomime Company of Mask was one of the most influential pieces on the Bauhaus stage's repertoire for their 1929 tour of Germany

with explicitly religious content. He became absorbed in devising elaborate systems of notation, or scores, for dramatic performances.

Schreyer's presence at the Bauhaus was short-lived. In 1923 his proposed play for the Bauhaus Exhibition, *Mondspiel* ("Moonplay"), was rejected by Masters and students alike at a trial performance. Oskar Schlemmer (1888–1943) was asked to take his place, and was not reluctant to do so. His major theatrical work, the *Triadic Ballet*, had just been performed for the first time, and he had already been involved in theatrical projects at the Bauhaus. These had been experiments in dance and comedy, which were areas Schreyer did not address.

The roots of Schlemmer's theatre also lay in expressionism. Although it was by no means religious drama, elements of cultic theatre were used to great effect. These included the use of masks, and the universal Everyman figure. Although ultimately of serious intent, Schlemmer's theatre differed from most expressionist drama in its formal, objective quality and in the way it incorporated the grotesque and the comic.

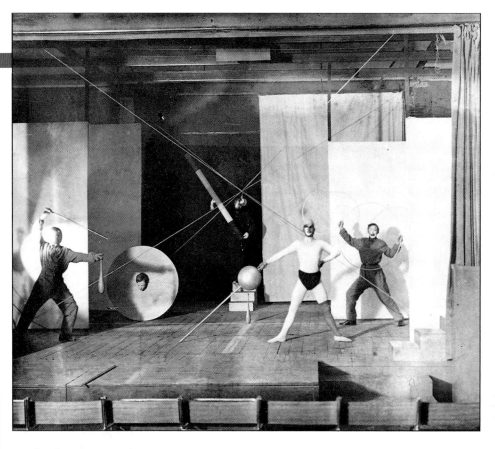

2

3

In his diary for September 1922, Schlemmer expressed his view of the theatre as follows: "The theatrical dance today can again become the starting point for a regeneration. Unencumbered by tradition...the dance is independent and predestined to gently drive into the senses whatever is new...The dance, according to its origin, becomes Dionysian and pure feeling, symbol for the balancing of polarities."

Schlemmer's major work, which was performed and revised between 1922 and 1932, was the *Triadic Ballet*, so called because it was built around a system of three. There were three sections, which Schlemmer thought of in terms of three different musical

Oskar Schlemmer's short piece Equilibristics *(3) (1927) was an example of what Schlemmer called the theatre of "motion-mathematics, of the mechanics of joints and numerical rhythmics and gymnastics." The theme was balance, elaborated with the help of elemental props (hoops, bats, rods and steps).*

4

Lothar Schreyer devised this extraordinary score (2), which attempts to encompass words, tone rhythm and movement, for his play Crucifixion *in 1920. This copy is inscribed "For Walter Gropius. Long live the Bauhaus stage!" (4) shows the projection booth for Ludwig Hirschfeld-Mack's Reflected Light Compositions in about 1924 (Hirschfeld-Mack is seated at the piano). The effect produced was one of luminous abstract shapes moving to music.*

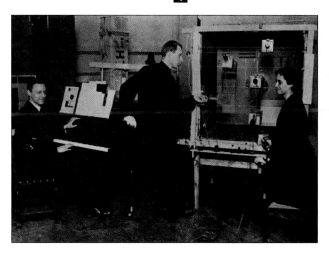

2

1

movements, and 12 dances were danced in 18 different fantastical costumes by three dancers, two male and one female. Schlemmer himself was an outstanding dancer and appeared in his own productions. The effect of the costumes was always abstract and sometimes comic. The body shapes were anti-naturalistic and larger than life. It was visual theatre rather than literary, highly stylised dance, elaborating the relationship of human figures to the space around them. There was no narrative and no human emotion.

In Schlemmer's view, the main reason Schreyer had to leave was that the students were highly sceptical of anything that hinted at pathos and ethics; they responded instead to parody, satire, ridicule and the grotesque. The stage workshop's comic sketches inherited their mocking, challenging quality from Dada cabaret, which had flourished in Switzerland and Germany during the war (although it had little of German Dada's explicit political content). In the Bauhaus sketches, elements of the traditional theatre were mocked by, for instance, having characters carrying little signs saying "interval," "climax," "passion" and so on.

Schlemmer's *Figural Cabinet* was a farce poking fun at the contemporary blind faith in progress and systemisation. It contained a wealth of extraordinary characters, one of whom, the Master, gesticulated wildly and made telephone calls; Schlemmer explained wryly that the character was dying a thousand deaths from self-inflicted gunshots and from worrying about the function of the functional. This was a very apposite affliction for a Bauhaus character.

A group of students, including Xanti Schawinski (who later taught at Black Mountain College in the United States), Kurt Schmidt and F.W. Bogler, threw their energies into sketches in which the comedy was largely visual. All the characters, such as circus artistes on horseback and the Rococo Cocotte, were played

3

(1) shows Lothars Schreyer's costume design for the central figure of one of this mystical primitivistic plays, called Man *(1922): He considered that in order to unite all the elements of the stage and exploit their full potential, the human figure had to combine "psychic-ecstatic, artistic-eccentric and mechanical-puppet functions". Costume was to be one of the chief means of dissolving the natural form of the body.*

Kurt Schmidt's The Man at the Control Panel *(2) (c.1924) was one of a number of pieces dealing with the relationship of man and machine; in this case the machine triumphs over its creator. The image of the man at the control panel recurs in Fritz Lang's film,* Metropolis *of 1925–6. The costumes were intended to give the dancers an abstract, robotic quality.*

(3) is a photograph by Lux Feininger of assorted members of the Bauhaus stage on the roof of the Bauhaus building in about 1927. Not only did the dancers wear masks, but their bodies were depersonalised by kapok padding.

by men in outrageous, semi-abstract costumes. One of the key issues was the mechanical theatre, which could be used to take anti-naturalism to its limits, and eradicate the individual in favour of the universal. Kurt Schmidt's *Man at the Switchboard* was a pantomime on the theme of the power of electricity. The costumes and movements were such that the actors were dissolved into an assembly of machine parts suggesting coils, tension, speed and control.

During the Bauhaus Exhibition in August 1923, Kurt Schmidt and Georg Teltscher staged their *Mechanical Ballet*, in which abstract, two-dimensional forms were moved by invisible dancers in a rhythmic dance to the beat of a kettledrum. *The Reflected Light Compositions* of Ludwig Hirschfeld-Mack and Kurt Schwertfeger involved no actors at all, consisting purely of the movement of overlapping coloured shapes projected onto a screen, aiming to achieve a synthesis of the form, colour and music. The pursuit of the mechanical also led to experiments with puppets. In 1924 Kurt Schmidt collaborated with T. Hergt to create abstract marionettes for a play called *The Adventures of the Little Hunchback*. Interesting plans were devised for mechanical, multi-purpose stages. As it was, the Weimar Bauhaus had no stage of its own, and performances took place in the German National Theatre in Weimar or in the Municipal Theatre in Jena, which Gropius and Meyer had remodelled.

The situation was remedied when Gropius incorporated a double-sided stage in the new school building in Dessau, thereby allowing the workshop to develop in ever-more inventive ways. According to its prospectus for 1926–7, it offered training for "painters and technicians, actors, dancers, and stage directors in practical and theoretical collaboration for the common objective of the new stage form." This included making masks, costumes, properties; the study of mechanical, visual and acoustic conditions of stage performance; stage design; exercises in directing; movement; and group and solo interpretation. No appropriate craft qualification was available at Weimar, but at Dessau, stage workshop graduates were eligible for the Bauhaus Diploma.

The central element in the performances at Dessau was the relationship of the human figure to space. The *Space Dance* explicitly used the figure to map out spatial co-ordinates. In the *Slat Dance*, long batons were attached along the axes of the dancer's body, so that each gesture was seen as sweeping lines through space. The spatial interest gave many of the pieces a strongly architectonic character. In the pantomime *Treppenwitz*, for instance, the whole action was based around a flight of stairs.

Xanti Schawinsky experimented with abstract, geometric stage compositions, which he called the *Spectodrama*. He pooled his ambitious ideas for the theatre as an area of philosophical and formal experimentation with Schlemmer, and they collaborated on a series of pieces called *Gesture Dances*. These featured three characters – the Superior, the Cool and the Hot – who communicated via gestures and meaningless syllables and strategic props. Their body forms were deliberately anti-naturalistic, being padded with kapok to resemble the figures in Schlemmer's painting.

Kandinsky and Moholy-Nagy also became involved in stage productions. In 1929, Kandinsky designed and directed a production at the Friedrich Theatre in Dessau, which was based on Mussorgsky's *Pictures at an Exhibition* (its theme of the correspondences between music and painting being of keen interest to him). Like many of his contemporaries, Moholy-Nagy was convinced of the need to put an end to the proscenium arch through which the audience peeks at the action. To this end he drew up technically very ambitious plans for the Total Stage. In 1929 he designed a production of Offenbach's *The Tales of Hoffman*. Its uncompromising radicalism proved controversial in the deeply conservative area of opera. This and other stage work by Moholy-Nagy had considerable influence on the wider development of stage design.

The Bauhaus plays toured widely and were an important element in the public image of the Bauhaus. The major tour took place in 1929 just before Schlemmer's resignation brought the stage workshop to a close. By this time it had established itself as one of Germany's most important and innovative experimental theatres.

BIBLIOGRAPHY

I have selected from the large amount of Bauhaus literature the sources that I have found most useful in writing this book. Key texts for someone approaching the subject for the first time are listed first. I have also included selection of texts for further reading.

Key texts
Bauhaus-Archiv Museum. Sammlungskatalog, Berlin 1981.

Bayer, Herbert, Gropius, Walter & Ise (eds), *Bauhaus 1919-1928,* MOMA, New York 1938, 1972; London 1975.

Brüder Rasch. Material Konstruktion Form 1926-1930, Edition Marzona, Düsseldorf 1981.

Gropius, W. & Moholy-Nagy, L. (eds), *Neue Arbeiten der Bauhauswerkstätten* (Bauhaus Book 7), Munich 1925, Florian Kupferberg reprint, Mainz & Berlin 1981.

Naylor, Gillian, *The Bauhaus Reassessed. Sources & Design Theory,* London 1985.

Whitford, Frank, *Bauhaus,* London 1984.

Wingler, Hans M., *Das Bauhaus,* Bramsche & Cologne 1962 & subsequent editions; English edition, *The Bauhaus,* Cambridge, Mass. & London 1969 & subsequent editions.

Wolfe, Tom, *From Bauhaus to our House,* London 1981.

Supplementary texts
Bauhaus magazine (available as Kraus reprints).

Dearstyne, Howard & Spaeth, David (ed), *Inside the Bauhaus,* London 1986.

Droste, Magdalena, *Gunta Stölzl. Weberei am Bauhaus und aus eigener Werkstatt,* Bauhaus-Archiv, Berlin 1987.

Form und Zweck. Zeitschrift für industrielle Gestaltung, 6/1976 & 3/1979.

Franciscono, Marcel, *Walter Gropius & the Creation of the Bauhaus in Weimar. The Ideals & Artistic Theories of its Founding Years,* Urbana 1971.

Friedman, Barry, *The Bauhaus: Masters and Students,* New York 1988.

Gropius, Walter, *Bauhausbauten Dessau,* Fulda 1930; Florian Kupferberg reprint, Mainz 1974.

Gropius, W. & Moholy-Nagy, L. (eds), *Staatliches Bauhaus Weimar 1919-1923, Weimar & Munich 1923;* Kraus reprint, Munich 1980.

Hahn, Peter (ed), *Bauhaus Berlin,* Bauhaus-Archiv Berlin, Weingarten 1985.

Hirschfeld-Mack, Ludwig, *The Bauhaus: an Introductory Survey,* London 1963.

Hirning, Jutta, *Bauhaus Weimar Werkstattarbeiten,* Kunstsammlungen zu Weimar.

Naylor, Gillian, *The Bauhaus,* London 1968.

Neumann, Eckhardt (ed), *Bauhaus and Bauhaus People,* New York 1970; German edition, *Bauhaus und Bauhäusler, Bekenntnisse und Erinnerungen,* Bern and Stuttgart 1971.

Schädlich, Christian, *Bauhaus 1919-1933,* Dessau 1983.

Scheidig, Walter, *Bauhaus Weimar 1919-1924, Werkstattarbeiten,* Leipzig & Munich 1966; English language edition, *Crafts of the Weimar Bauhaus,* London 1967.

Schlemmer, Tut (ed), *Oscar Schlemmer: Briefe und Tagabücher,* Munich 1958; English language edition, *The Letters and Diaries of Oskar Schlemmer,* Middletown, Conn. 1972.

Wick, Rainer, *Bauhaus-Pädagogik,* Cologne 1982.

Further reading
Banham, Reyner, *Theory and Design in the First Machine Age,* London 1960 and subsequent editions.

Baroni, Daniele, *Rietveld Furniture,* London 1978 (Milan 1977).

Benton, Tim & Charlotte, & Sharp, Dennis, *Form and Function. A Source Book for the History of Architecture and Design,* London 1975.

Blaser, Werner, *Mies van der Rohe. Furniture and Interiors,* London 1982.

Campbell-Cole, B. & Benton, T. (eds), *Tubular Steel Furniture,* London 1979.

Fifty Years of the Bauhaus, Royal Academy of Art, London 1968.

Gay, Peter, *Art as Act. On Causes in History – Manet, Gropius, Mondrian,* New York 1976.

Graeff, Werner, *Zweckmäßiges Wohnen für jedes Einkommen,* Potsdam 1931.

Gropius, W., *Apollo in the Democracy. The Cultural Obligation of the Architect,* New York 1968.

Gropius, W., *The New Architecture & The Bauhaus,* London 1935; Cambridge, Mass. 1965.

Hüter, Karl-Heinz, *Das Bauhaus in Weimar. Studie zur gesellschaftpolitische Geschichte einer deutschen Kunstschule,* Berlin 1976.

Issacs, Reginald, *Walter Gropius. Der Mensch und sein Werk,* Volume 1, Berlin 1983; Volume 2, Berlin 1984.

Itten, Johannes, *Gestaltungs – und Formenlehre. Mein Vorkurs am Bauhaus und später,* Ravensburg 1963, 1975.

Lang, Lothar, *Das Bauhaus 1919-1933, Idee und Wirklichkeit,* Berlin 1966.

Lotz, Wilhelm, *Wie richte ich meine Wohnung ein? Modern Gut mit welchen Kosten?* Berlin 1930.

Moholy-Nagy, L., *Malerei, Fotographie, Film* (Bauhaus-Book 8), Munich 1925.

Muche, Georg, *Blickpunkt Sturm Dada Bauhaus Gegenwart,* Munich 1961.

Read, Herbert, *Art & Industry. The Principles of Industrial Design,* London 1934.

Rotzler, Wilhelm, *Johannes Itten. Werke und Schriften,* Zurich 1972.

Schädlich, Christian, *Bauhaus Weimar 1919-1925. Tradition und Gegenwart,* Weimar 1979.

Schmidt, Diether, *Bauhaus,* Dresden 1966.

Schnaidt, Carl, *Hannes Meyer. Bauten, Projekte und Schriften,* Stuttgart 1965.

Taut, Bruno, *Die neue Wohnung. Die Frau als Schöpferin,* Leipzig 1924.

Wilk, Christopher, *Marcel Breuer. Furniture & Interiors,* London 1981.

Wingler, Hans M. (ed), *Kunstschulreform 1900-1933,* Berlin 1977.

Winkler, Klaus-Jürgen & Meyer-Bergner, Lena (eds), *Hannes Meyer. Bauen und Gesellschaft. Schriften, Briefe, Projekte,* Dresden 1980.

Wissenschaftliche Zeitschrift der Hochschule für Architektur und Bauwesen, Weimar, 1976 5/6 & 1979 4/5.

INDEX

CREDITS

Quarto would like to thank the following for providing photographs, and for permission to reproduce copyright material. Whilst every effort has been made to trace and acknowledge all copyright holders, we would like to apologise should any omissions have been made.

Key: a: above; b: below; l: left; r: right; c: centre

Abbreviations: BAMG: Bauhaus-Archiv, Museum für Gestaltung; BD: Wissenschaftlich-kulturelles Zentrum Bauhaus Dessau; Friedman: Barry Friedman Ltd., New York; HAB: Hochschule für Architektur und Bauwesen; KW: Kunstsammlungen zu Weimar

p.2 KW
p.5 KW
p.8 Professor Kurt Kranz
p.10 HAB
p.11 ET Archive/BAMG
p.12 HAB
p.13 bl & c BD br Friedman
p.15 BAMG
p.16 BAMG
P.17 al BD bl BAMG bc HAB
p.18 KW
p.20 BAMG
p.21 l BAMG R Friedman
p.22 BAMG
P.23 L Friedman r BD
p.24 al Angelo Hornak ar Sotheby's bl Courtesy of the Trustees of the Victoria & Albert Museum br Friedman
p.25 al Friedman ar Angelo Hornak/Ian Bennett b Courtesy of The Trustees of the Victoria & Albert Museum
p.26 BAMG R photo Lepkowski, Berlin
p.27 l Friedman r HAB
P.28 a BAMG b KW
p.29 al BD ar BAMG bl Friedman br BAMG
p.30 KW
p.31 al KW ar & br BAMG bl Friedman
p.32 al, bl, KW ar Friedman
p.33 al BD ar KW br BAMG
p.34 l BAMG r Friedman
p.35 l HAB r BAMG
p.36 a BAMG b Friedman
p.37 l HAB c & r BAMG
p.38 HAB
p.39 BAMG
p.40 KW
p.42 BAMG
p.43 BD
p.44-45 BD
p.46 al, ar, b Friedman c BD
p.47 l Courtesy of the Trustees of the Victoria & Albert Museum ar Courtesy of the Trustees of the British Museum/Museum of Mankind c Gerhard Marcks-Stiftung, Bremen b BD
p.48 a br BAMG bl BD
p.49 BAMG
p.50 l BD r BAMG
p.51 BAMG
p.52 Friedman
p.53 a & bl BAMG br KW
p.54-55 BAMG
p.56 BAMG
p.57 KW
p.60 BAMG
p.61 Alexander von Vegesack
p.62 l BAMG r Alexander von Vegesack
p.63 l & a Rat Der Stadt Dessau, Stadt Archiv b Alexander von Vegesack
p.64 ar Hunterian Art Gallery, University of Glasgow Mackintosh Collection b Sotheby's
p.65 a Alexander von Vegesack bl Museum of Modern Art, Oxford br Angelo Hornak
p.66 l Friedman r BAMG

p.67 al Alexander von Vegesack r & bl BAMG
p.68 l KW r BAMG
p.69 al & ar BAMG b Friedman
p.70 l BAMG r Friedman
p.71 a BAMG b BD
p.72 Alexander von Vegesack
p.73 l Alexander von Vegesack r Friedman
p.74 al BD r & b HAB
p.75 al & bl HAB ar BD br Friedman
p.75 a & br BAMG bl KW
p.76 a & br BAMG bl KW
p.77 a BAMG b KW
p.78 Friedman
p.79 BAMG
p.80 KW
p.82 BAMG
p.83 Dr. Ingrid Radewalt
p.84-85 Dr. Ingrid Radewalt
p.86 l Philip Granville Collection/photo Eileen Tweedy r BAMG
p.87 al BAMG bl Courtesy of the Hungarian National Tourist Office/Danube Travel r Christie's Colour Library
p.88 l BAMG r Dr. Ingrid Radewalt
p.89 Dr. Ingrid Radewalt bl BAMG
p.90 l & br KW ar Friedman
p.91 al Friedman ar & b Dr. Ingrid Radewalt
p.92 Friedman
p.93 a Friedman b Dr. Ingrid Radewalt
p.94 l Friedman r BAMG
p.95 l & c Dr. Ingrid Radewalt r KW
p.96 Dr. Anna Rowland
p.98 BAMG
p.99 a HAB b BAMG
p.100 BAMG
p.101 Rasche Tapenfabrik, Bramsche
p.102 l Courtesy Sankosha Japan, ex-Philip Granville Collection c Ed Teitelman r © Michael Frank b Alistair Duncan/photo Randy Juster
p.103 al © Michael Frank ✉ ‡ & ◆ Architectural Association ✍ Philip Granville Collection/photo Eileen Tweedy
p.104-105 BAMG
p.106 BAMG
p.107 HAB
p.108 a BD b ET Archive/BAMG
p.109 a & r BAMG bl ET Archive c & br © Michael Frank
p.110 a BAMG b © Michael Frank
p.111 a & bl HAB br BAMG
p.112-113 BAMG
p.114 HAB
p.115 BAMG
p.116 HAB
p.117 a a BAMG b HAB
p.118 a Chloë Alexander b Friedman BAMG
p.119 al & b BAMG ar Friedman
p.120 al Friedman c BD ar Kunstverlag Weingarten/© C.V. Polling 'Kandinsky Unterricht am Bauhaus' b Dr. Anna Rowland
p.121 BAMG
p.122 BAMG

p.124 BAMG
p.125 l KW r BAMG
p.126-7 BAMG
p.128 l David King Collection ar 'Opera' Magazine br Philip Granville Collection/photo Eileen Tweedy
p.129 l Philip Granville Collection/photo Eileen Tweedy r Tate Gallery, London
p.130-131 BAMG
p.132 l KW r Friedman
p.133 al, ar, cl & br BAMG cr KW bl Friedman
p.134 l & br BAMG ar Friedman
p.135 BAMG
p.136 l David King Collection r BAMG
p.137 l David King Collection r BAMG
p.138 BD
p.139 a BD b BAMG
p.140 al BD ar, bl & br BAMG
p.141 a & r BAMG bl The J. Paul Getty Museum
p.142-143 BAMG
p.144 l & br BAMG a Friedman
p.145 al & bl BD ar & br BAMG
p.146 Christie's Colour Library
p.148 a BAMG b HAB
p.149 l BD r Friedman
p.150-151 BAMG
p.152 l David King Collection ar The Tate Gallery, London ar Philip Granville Collection/photo Eileen Tweedy
p.153 The Tate Gallery, London
p.154 Christie's Colour Library
p.155 l ET Archive/BAMG r Christie's Colour Library
p.156 Courtesy of (The Busch-Reisinger Museum) Harvard University: Purchase in memory of Eda K Loeb & Association Fund
p.157 BAMG
p.158 a Christie's Colour Library b BD
p.159 Courtesy of (The Busch-Reisinger Museum) Harvard University, Purchase in memory of Eda K. Loeb
p.160 Friedman
p.161 BAMG
p.162 l Courtesy of (The Busch-Reisinger Museum) Harvard University, Museum Purchase r Christie's Colour Library
p.163 Courtesy of (The Busch-Reisinger Museum) Harvard University, Anonymous Gift
p.164 a Friedman b BAMG
p.165 al & b BAMG ar Friedman
p.166-167 BAMG
p.168 BD
p.169 l & br BAMG ar BD
p.170 BAMG
p.171 BD

179

*"The Bauhaus was not an
institution...it was an idea"*

LUDWIG MIES VAN DER ROBE